CHANGING THE EARTH

TO

Harry Callahan

AND

Frederick Sommer

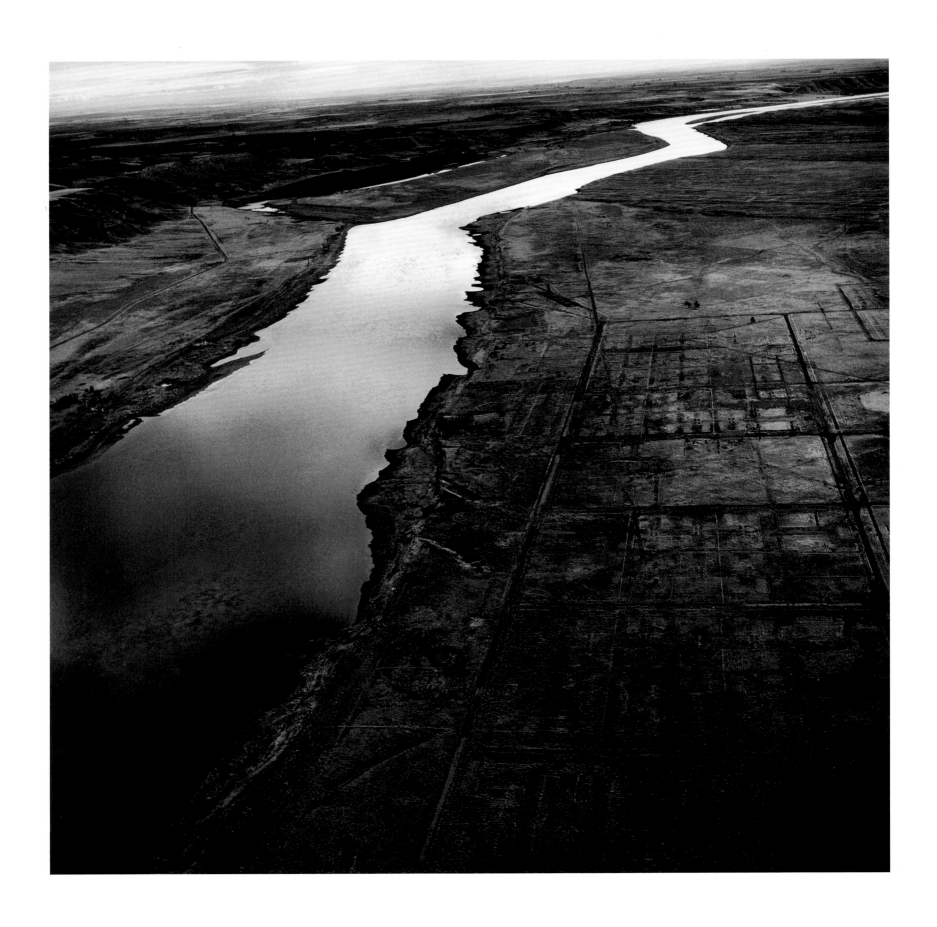

Old Hanford City Site and the Columbia River, Hanford Nuclear Reservation near Richland, Washington, 1986

EMMET GOWIN
CHANGING THE EARTH
AERIAL PHOTOGRAPHS

JOCK REYNOLDS

WITH AN ESSAY AND INTERVIEW BY

TERRY TEMPEST WILLIAMS

AND

PHILIP BROOKMAN

YALE UNIVERSITY ART GALLERY

IN ASSOCIATION WITH

THE CORCORAN GALLERY OF ART AND

YALE UNIVERSITY PRESS

This is the gift of a landscape photograph, that the heart finds a place to stand.

In a landscape photograph, both the mind and heart need to find their proper place. Before the landscape we look for an invitation to stand without premeditation. It is always, in some sense, our home. At times, we may also look for an architecture of light and a poetry of atmosphere which welcomes the eye into a landscape of natural process. It may also be the map—the evidence of the thing itself; may it also, always be a vision of the double world—the world of appearances and the invisible world all at once. Even when the landscape is greatly disfigured or brutalized, it is always deeply animated from within. When one really sees an awesome, vast, and terrible place, we tremble at the feelings we experience as our sense of wholeness is reorganized by what we see. The heart seems to withdraw and the body seems always to diminish. At such a moment, our feelings reach for an understanding.

This is the gift of a landscape photograph, that the heart finds a place to stand.

EMMET GOWIN, APRIL 1994

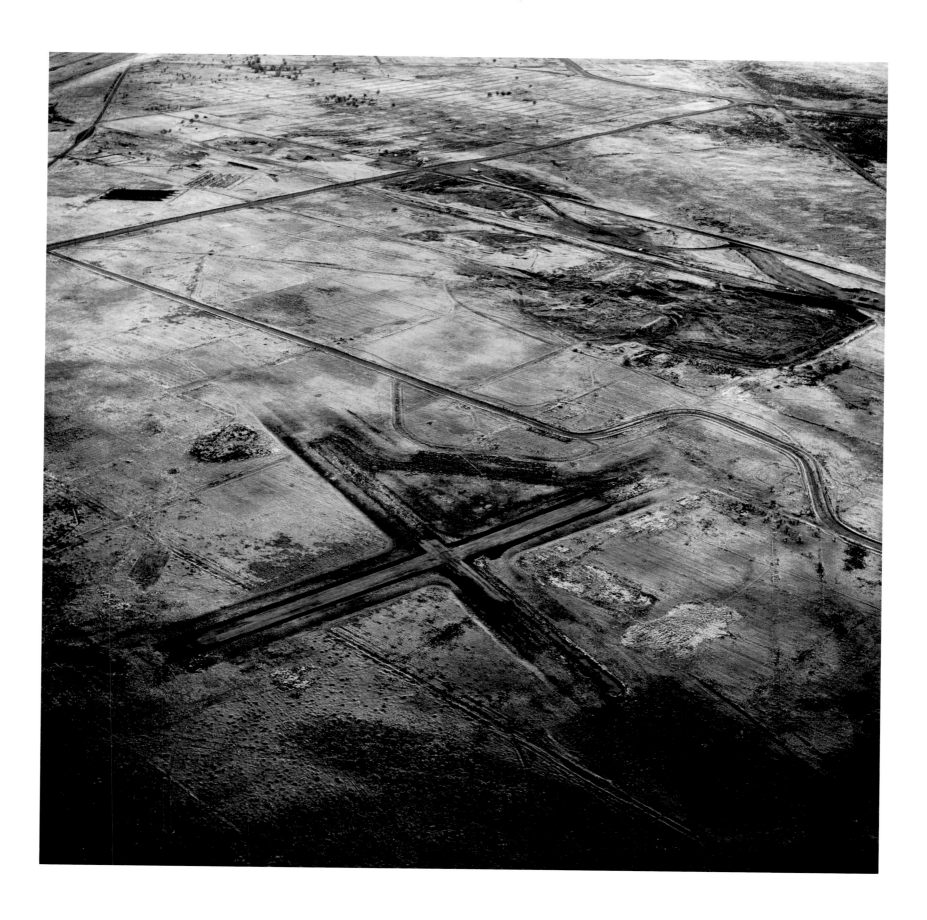

Abandoned Air Strip, Old Hanford City Site, Hanford Nuclear Reservation near Richland, Washington, 1986

5

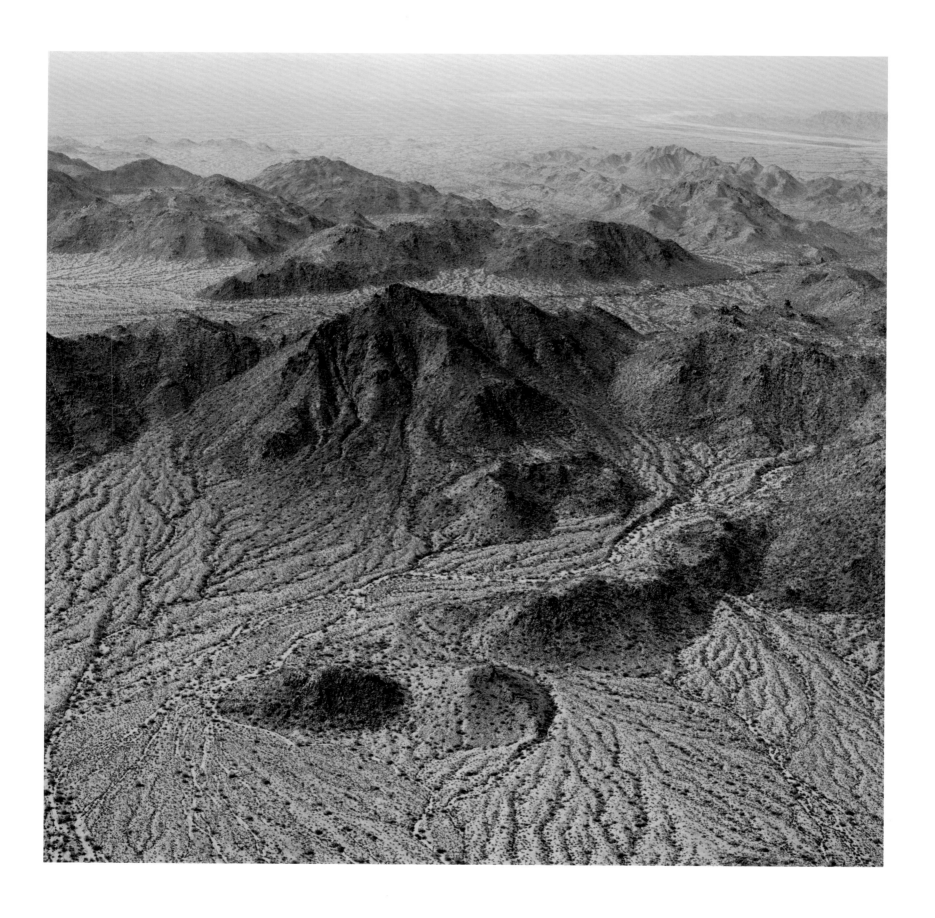

Natural Drainage Systems near the Palo Verde Nuclear Power Station, Arizona, 1988

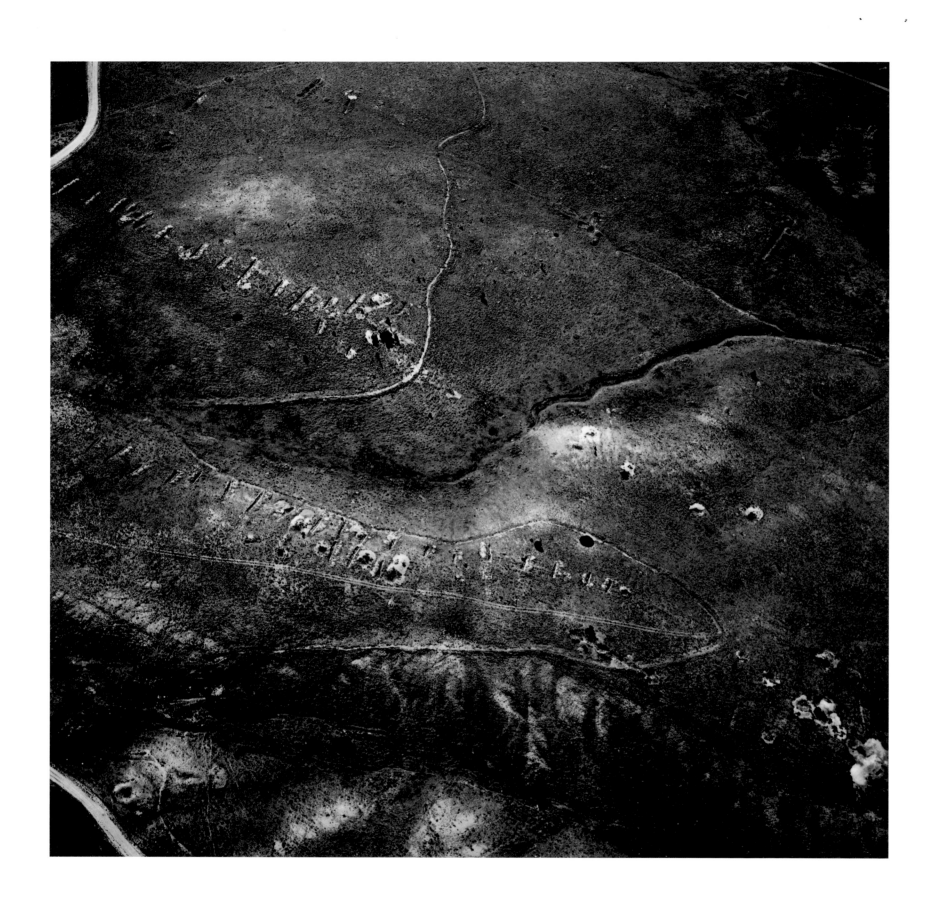

Mining Exploration in Two Centuries, Butte, Montana, 1988

8

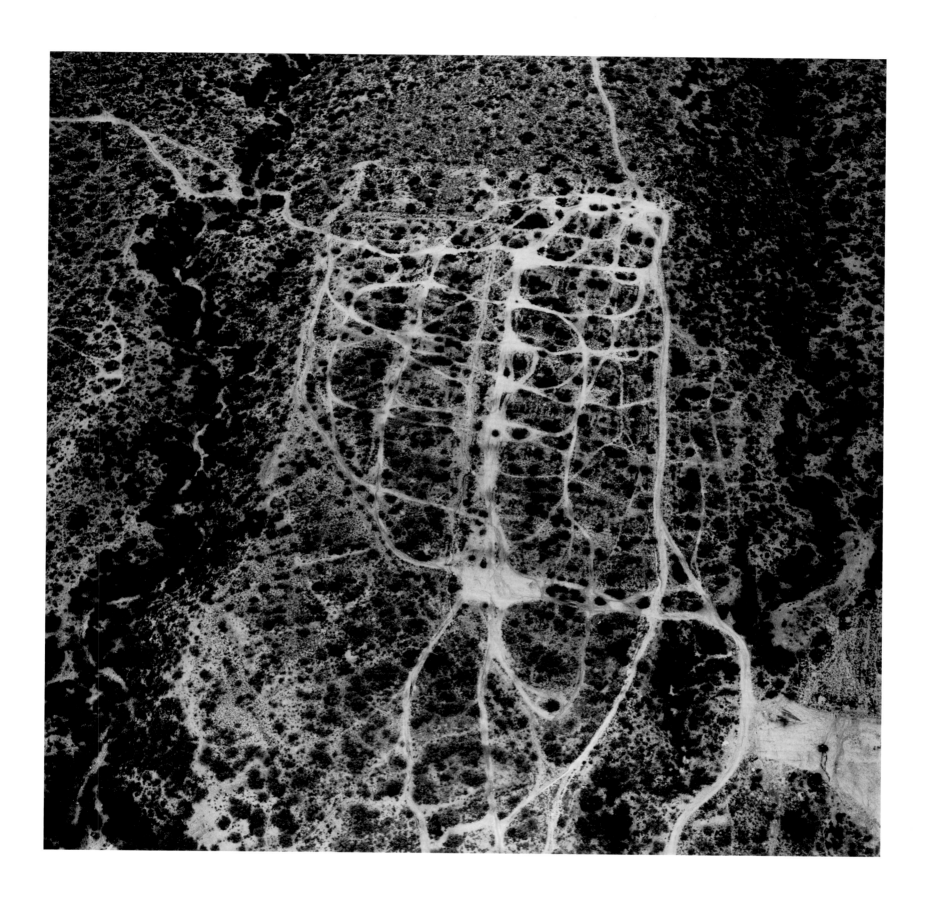

Traffic Pattern, Abandoned Trailer Park, San Carlos Apache Reservation near Globe, Arizona, 1988

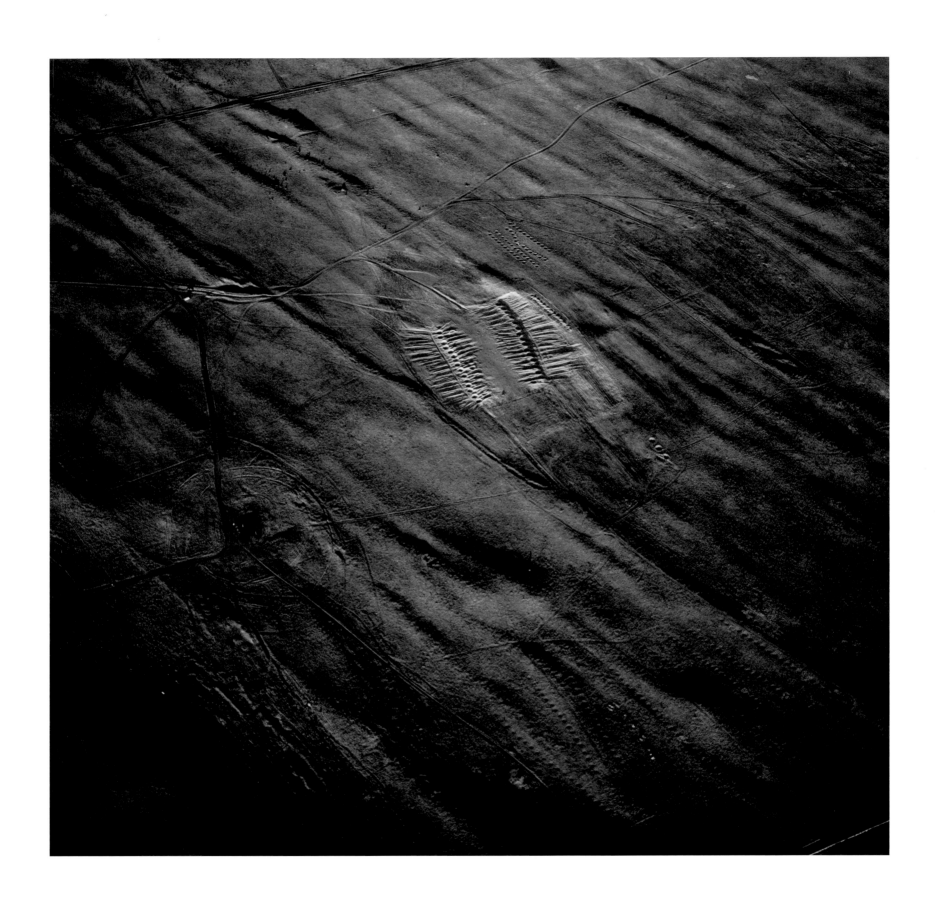

Glacial Furrows and Bomb Disposal Craters, Umatilla Army Depot, Hermiston, Oregon, 1991

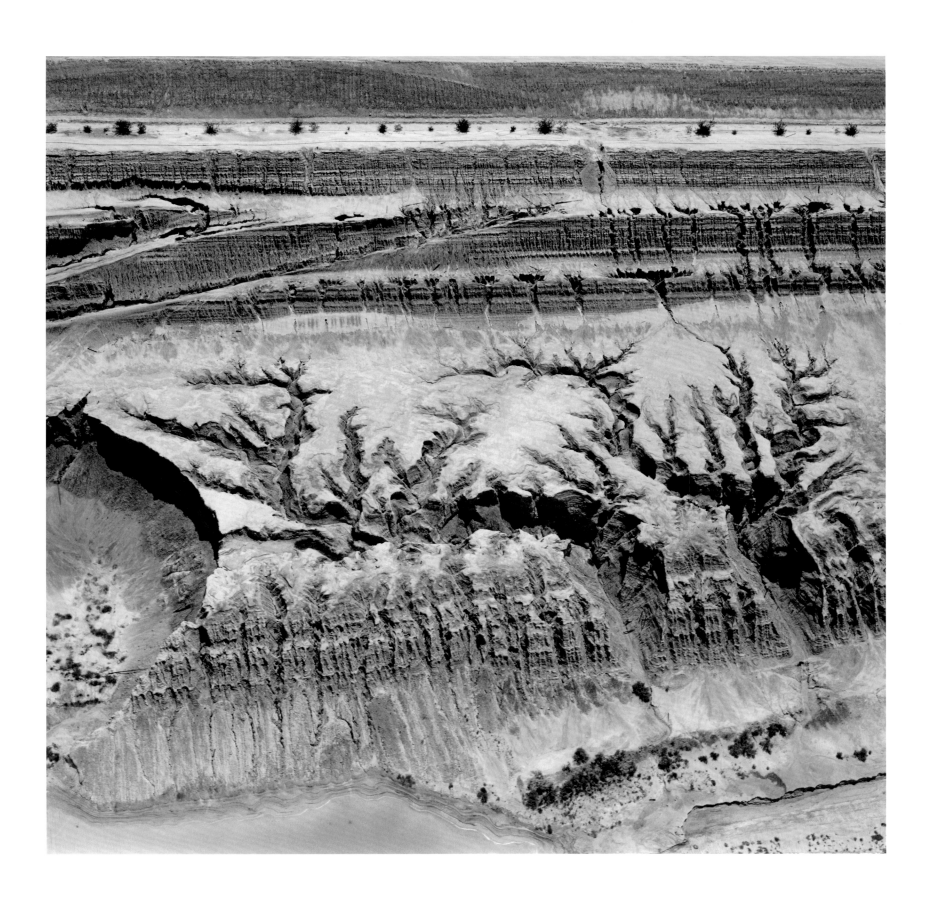

Erosion in the Side of a Silver Ore Tailing near Bayard, Grant County, New Mexico, 1987

11

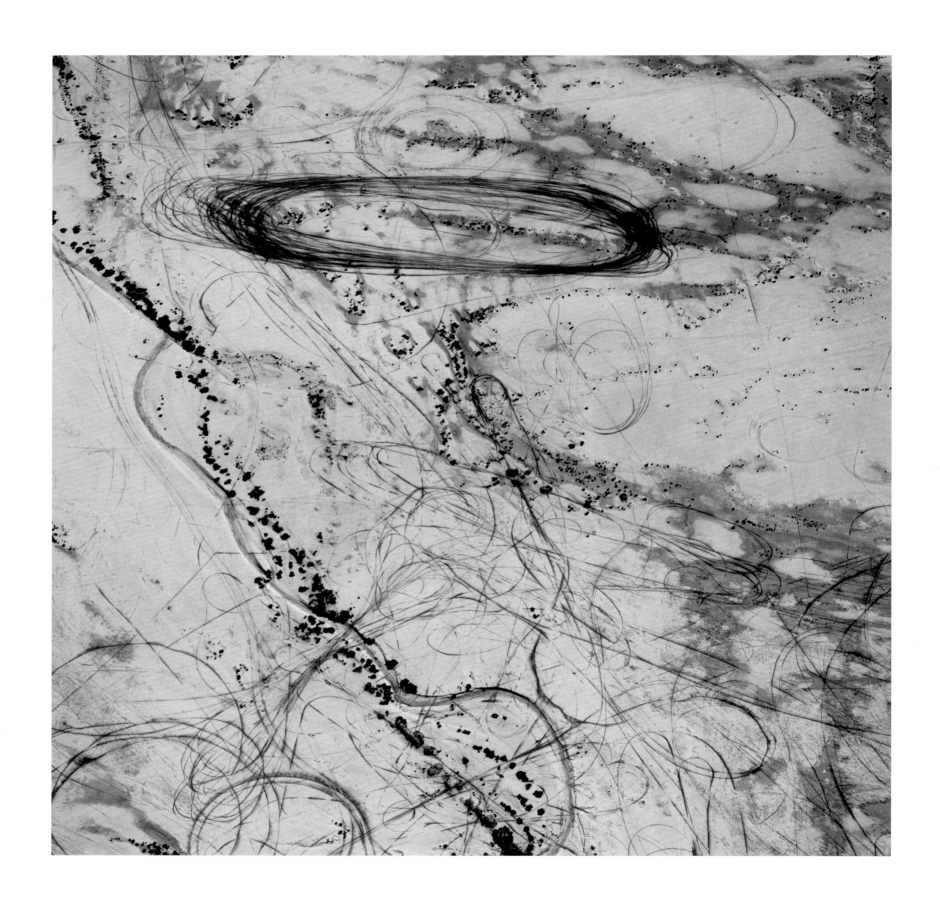

Off Road Traffic Pattern along the Northwest Shore of the Great Salt Lake, Utah, 1988

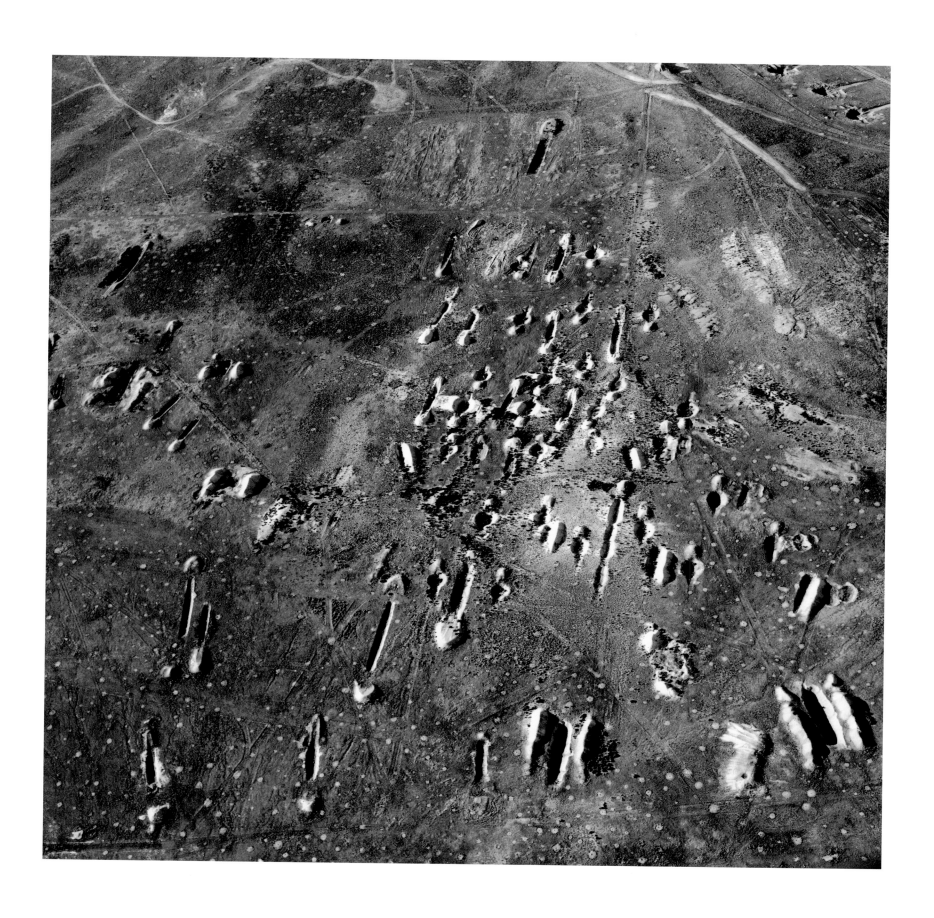

Weapons Disposal Trenches, Tooele Army Depot, Utah, 1991

13

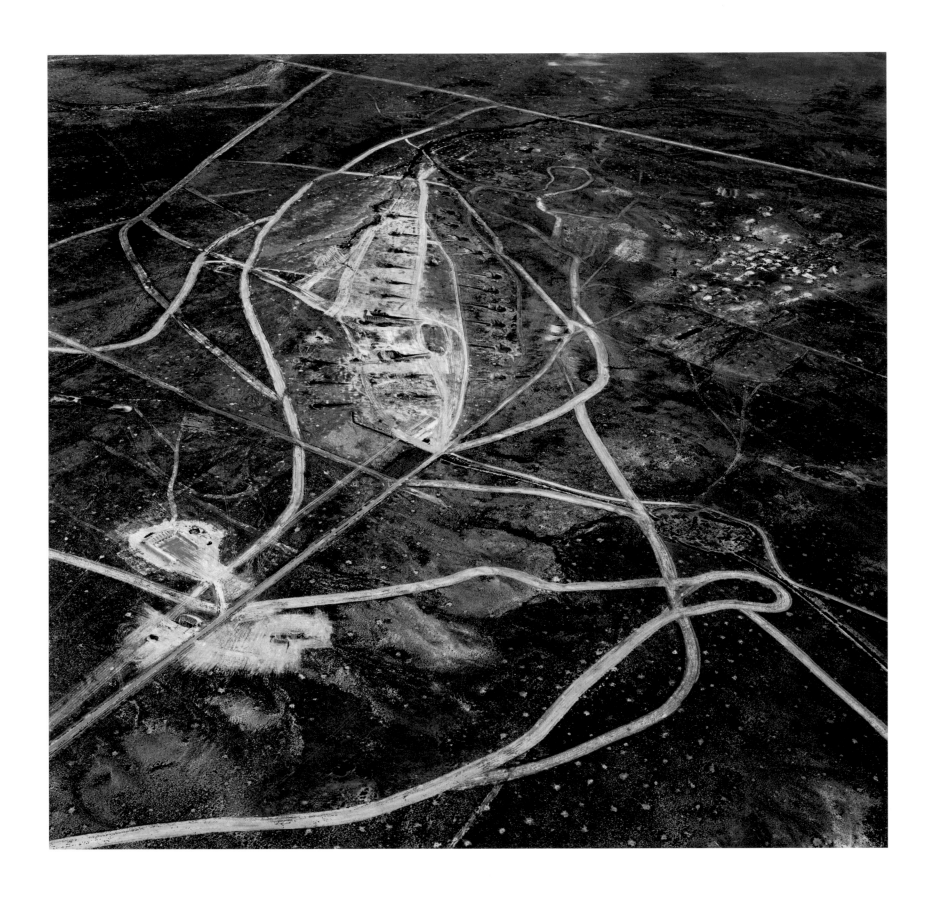

Bomb Disposal Complex, Tooele Army Depot, Utah, 1988

14

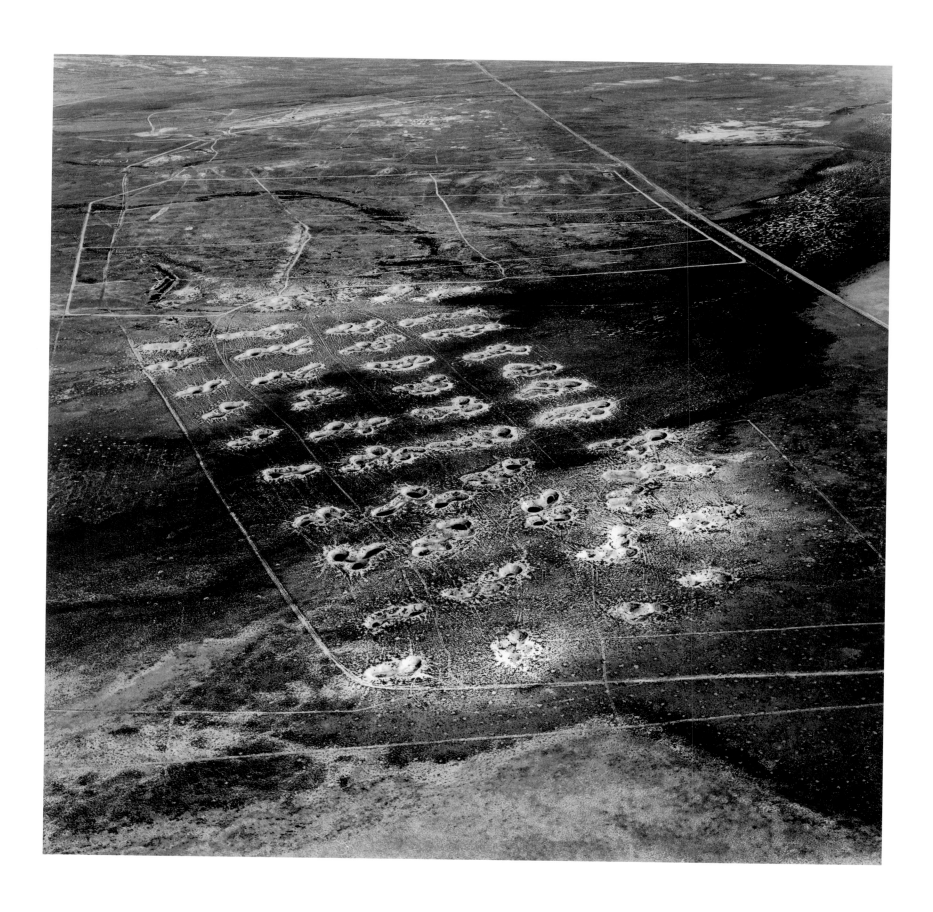

Bomb Disposal Site, Tooele Army Depot, Utah, 1988

15

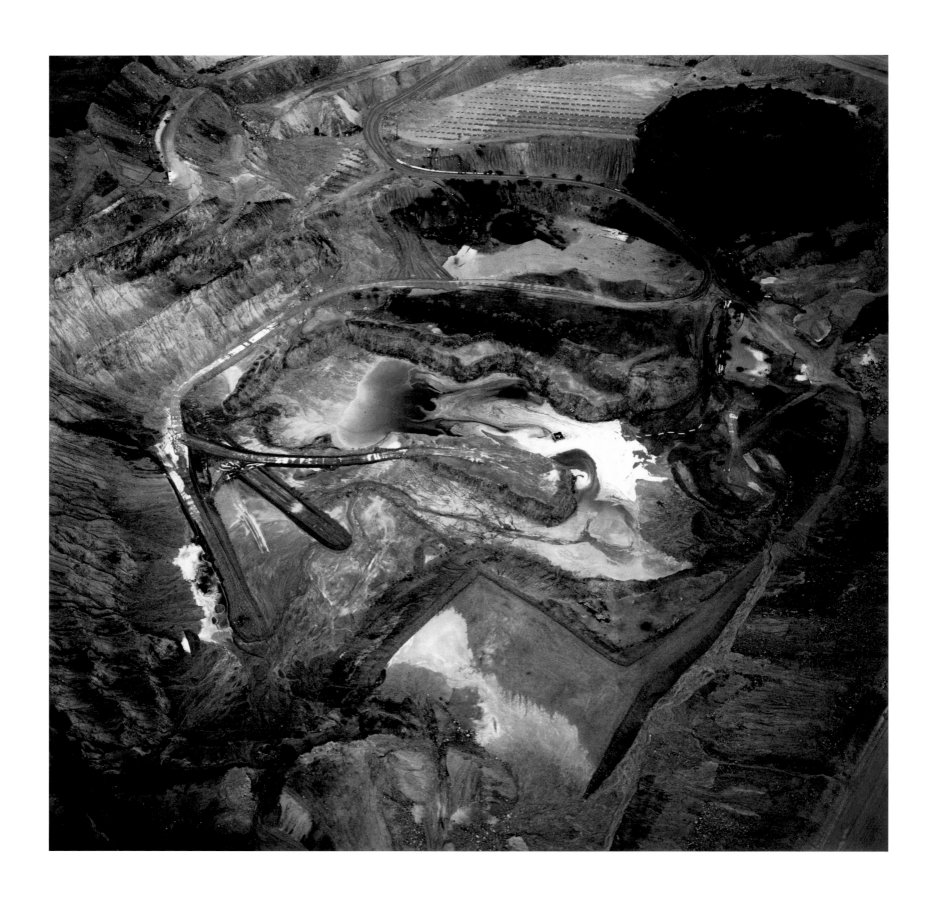

Copper Mining, Globe, Arizona, 1988

16

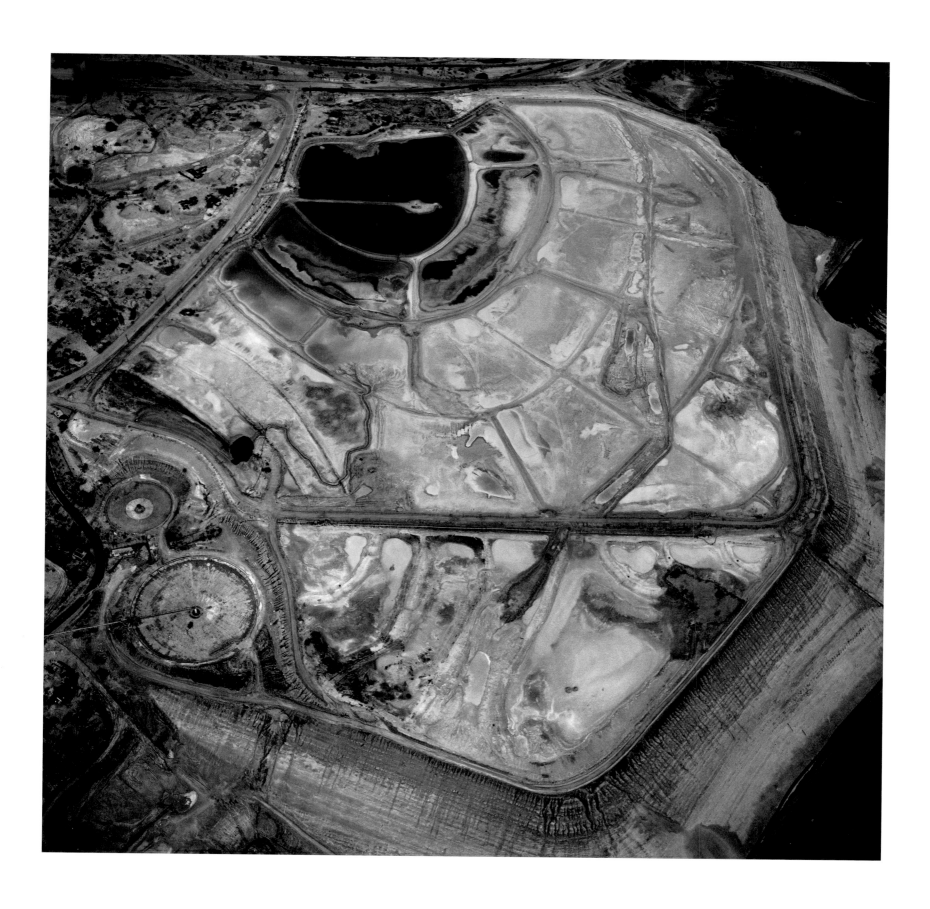

Copper Ore Tailing, Globe, Arizona, 1988

17

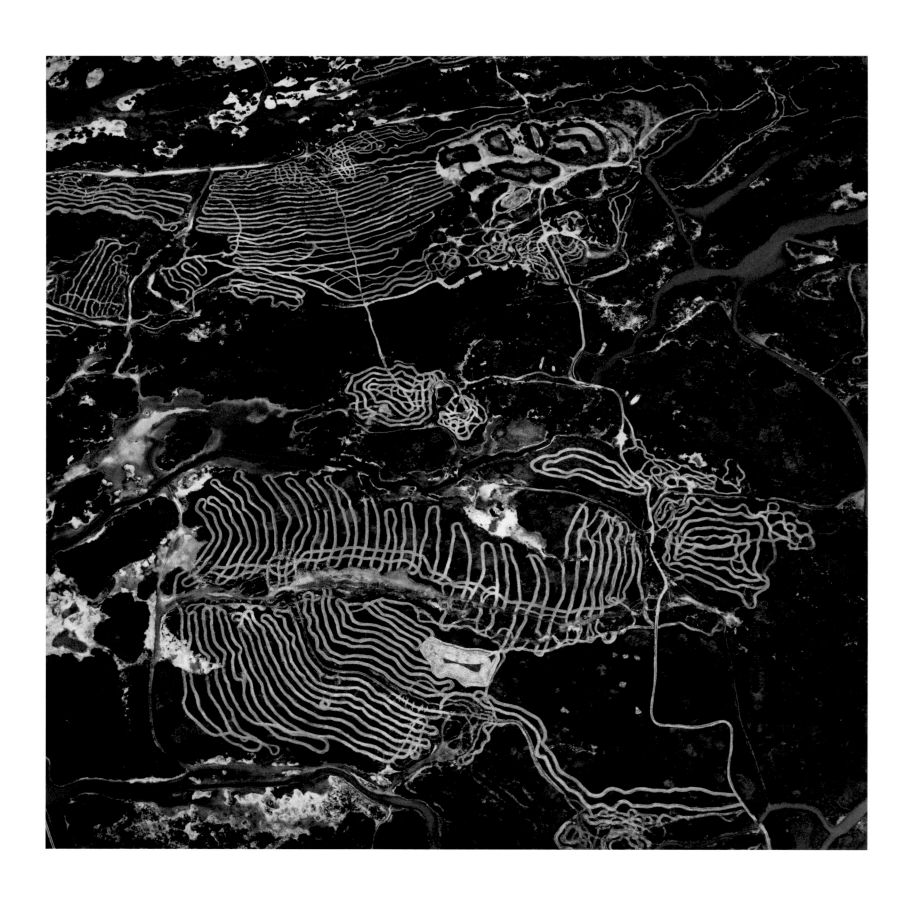

Waterfowl Nesting Site and Wetland Area Restoration near Sutter Buttes, California, 1993

18

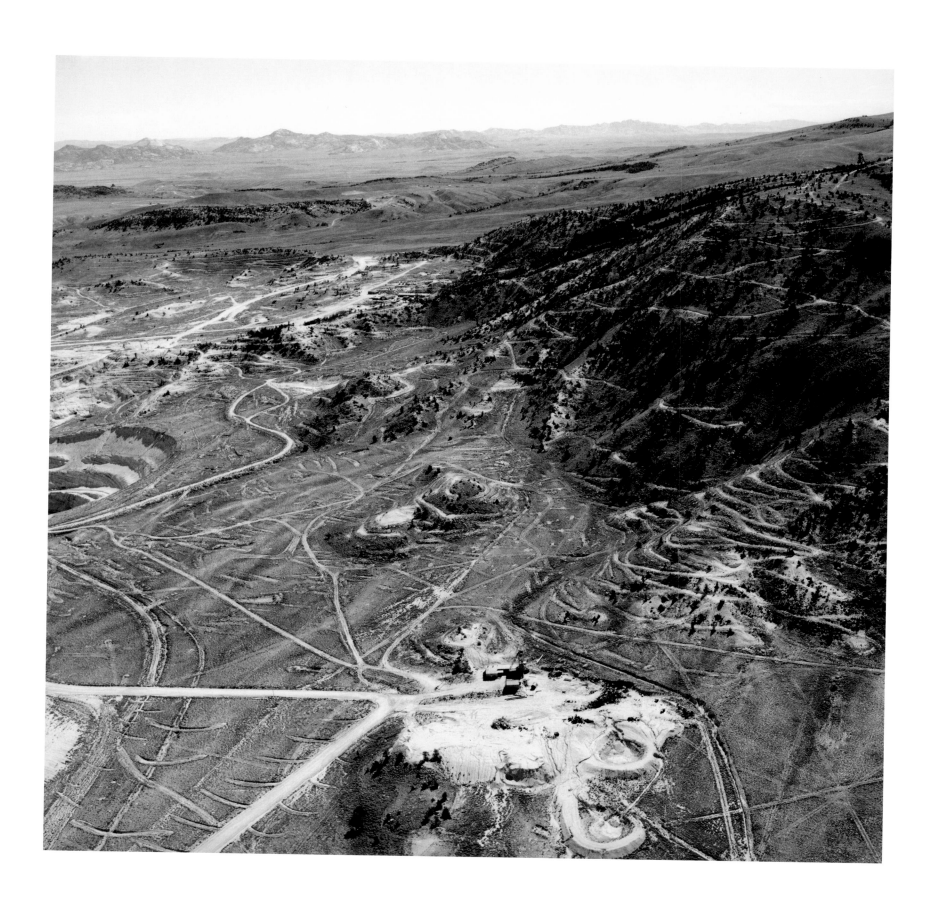

Uranium Exploration, Gas Hills, Wyoming, 1989

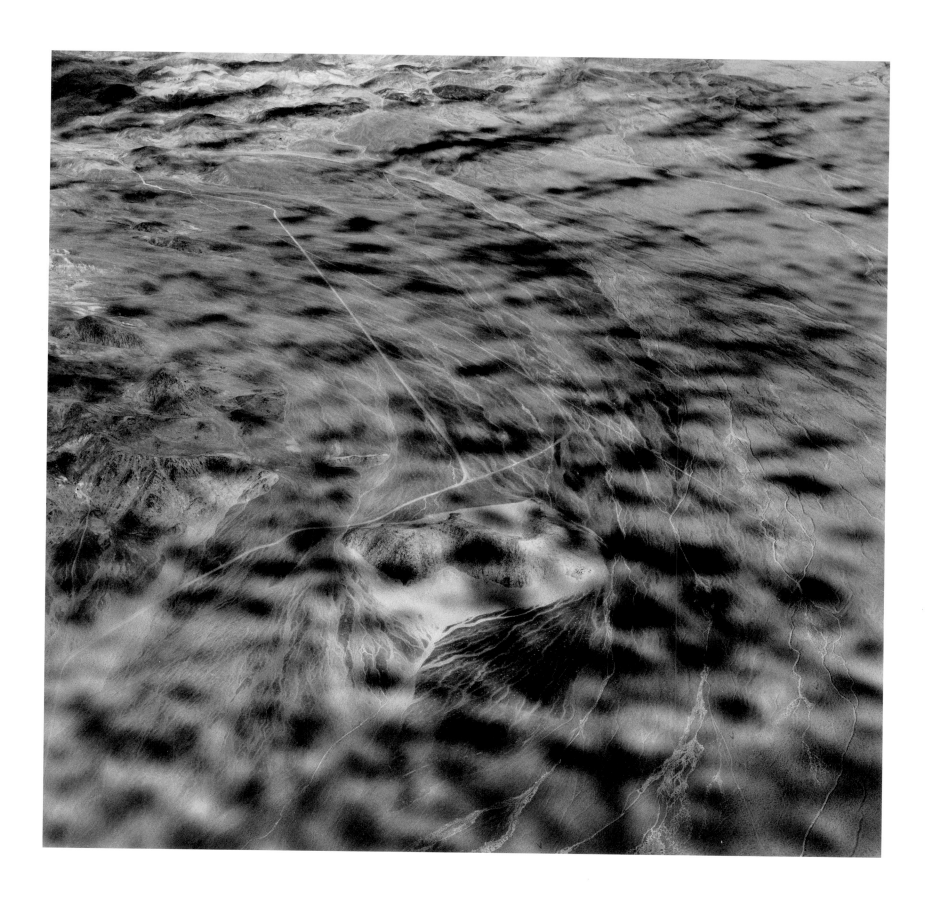

Cloud Shadow over the Desert, near the Round Mountain Mining District, Nevada, 1988

23

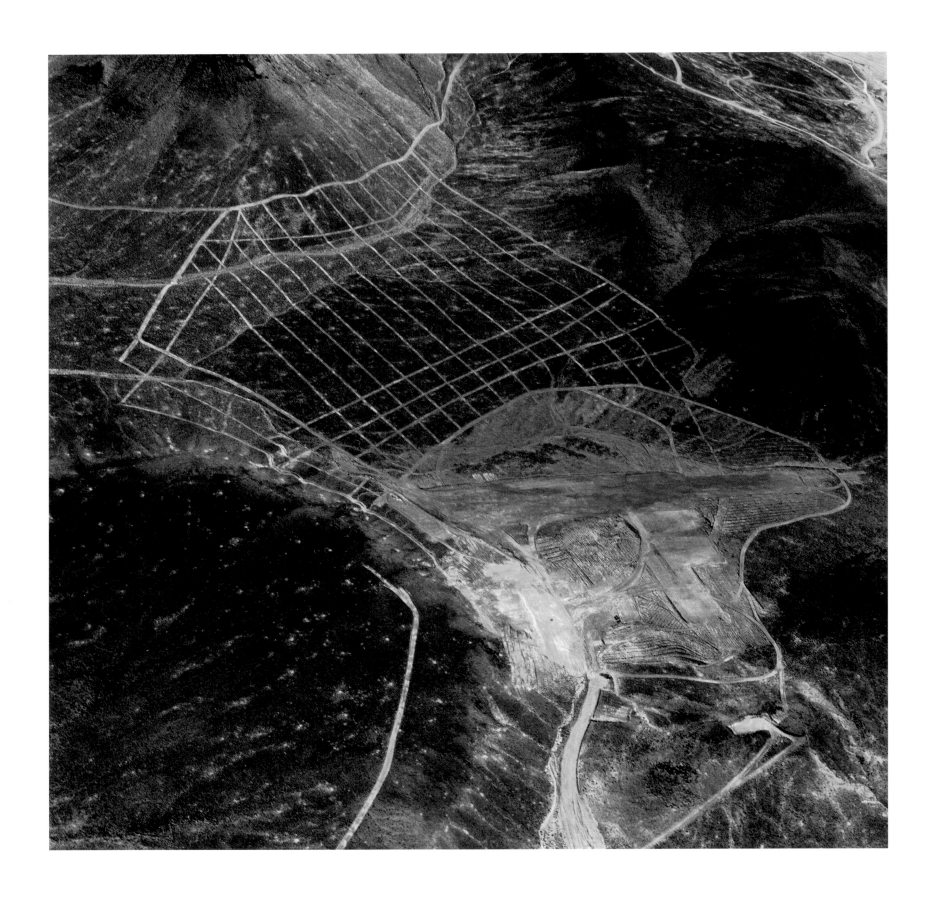

Grid on Landscape, Hawthorne Army Depot, Hawthorne, Nevada, 1987

22

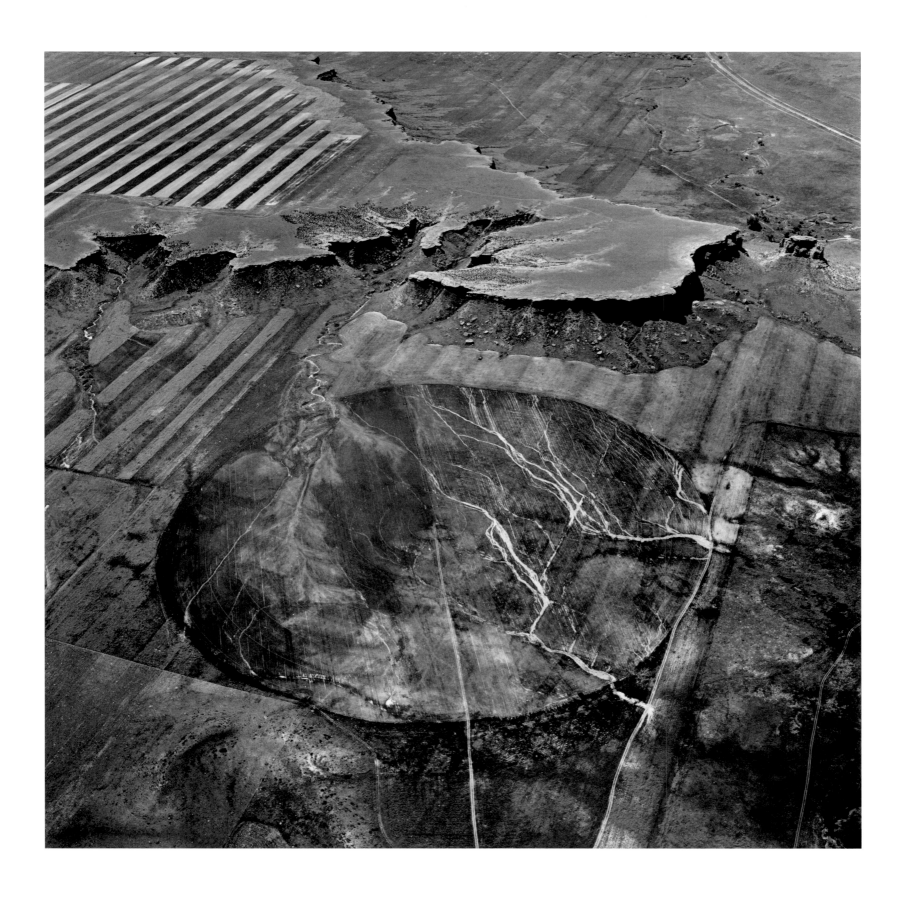

The Buffalo Jump Called Chugwater and an Irrigation Pivot near Wheatland, Wyoming, 1991

23

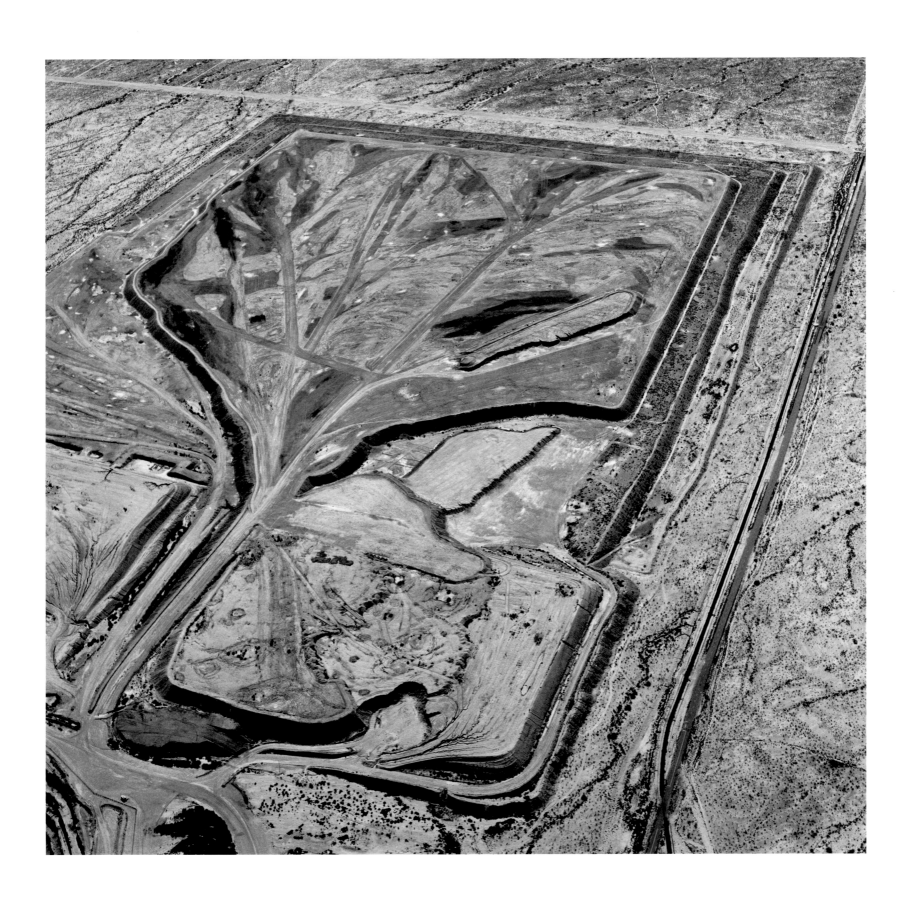

Copper Ore Tailing, Waste from the Casa Grande Mine, Arizona, 1988

24

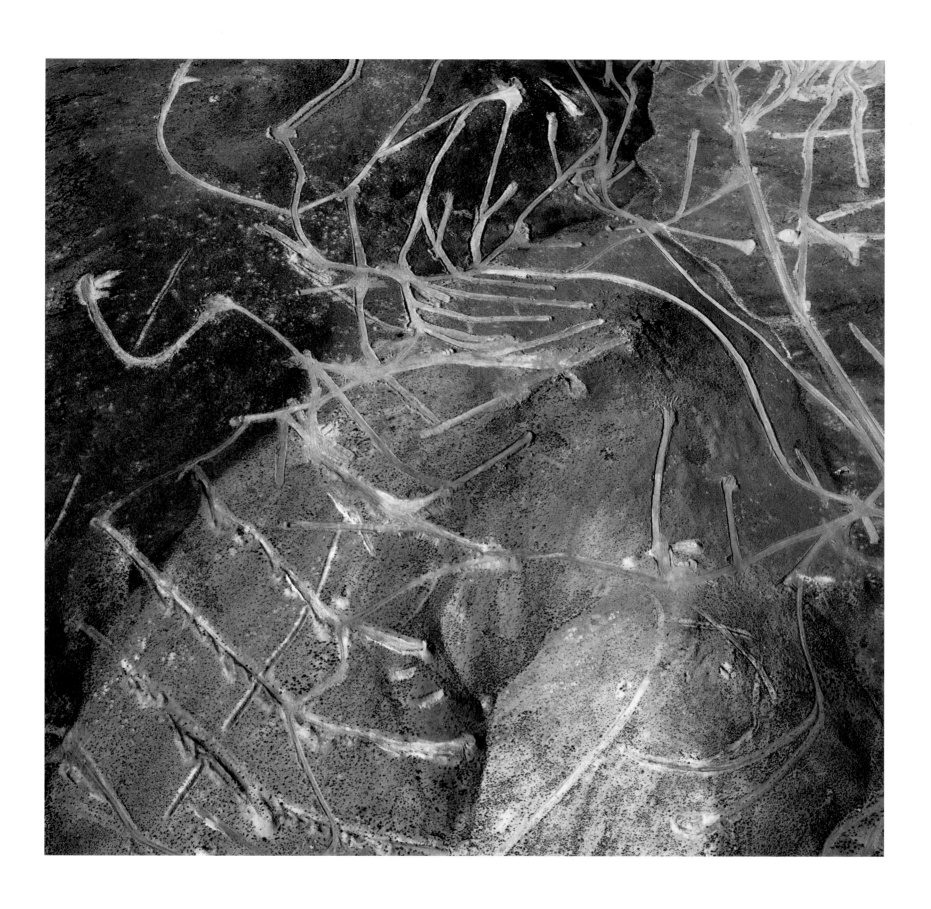

Mining Exploration near Carson City, Nevada, 1988

25

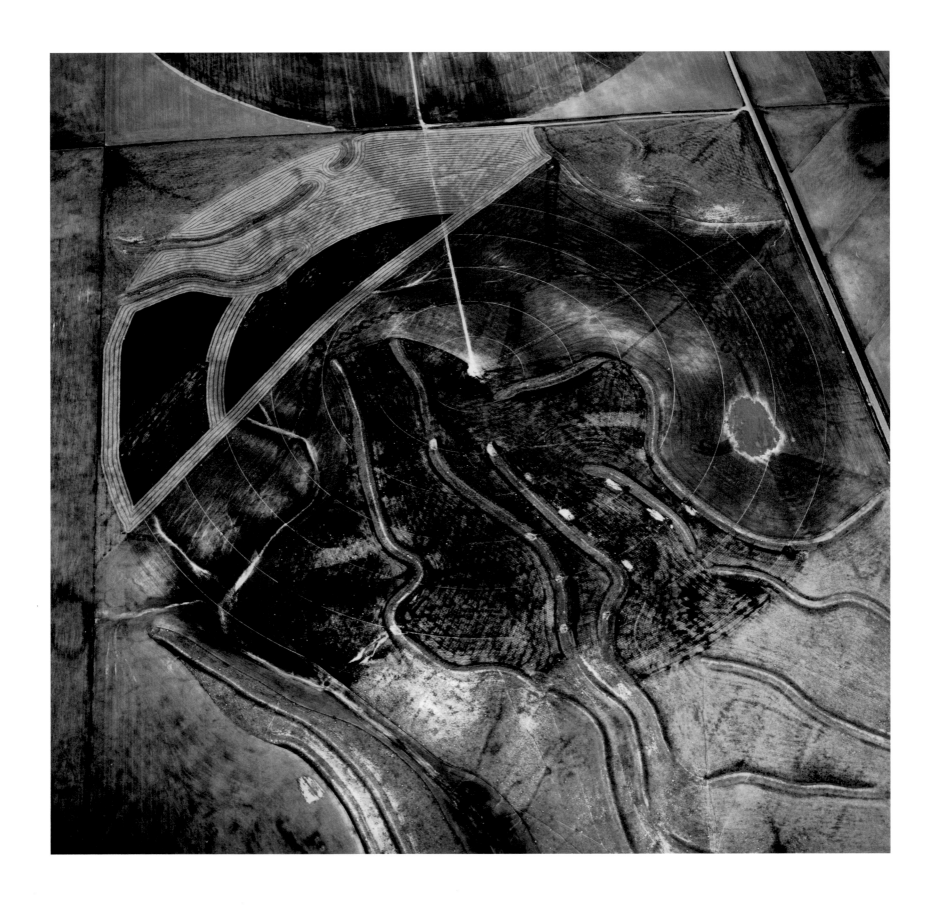

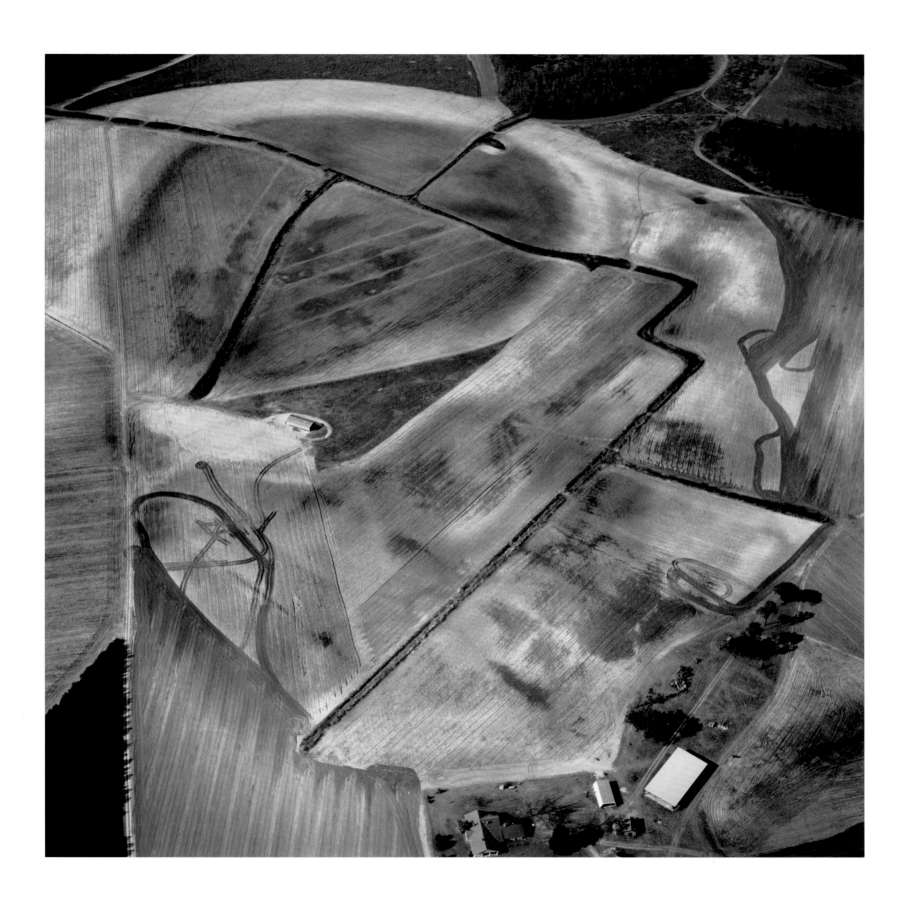

Drainage Ditch in a Low Agricultural Field near the Savannah River Nuclear Reservation, South Carolina, 1992

27

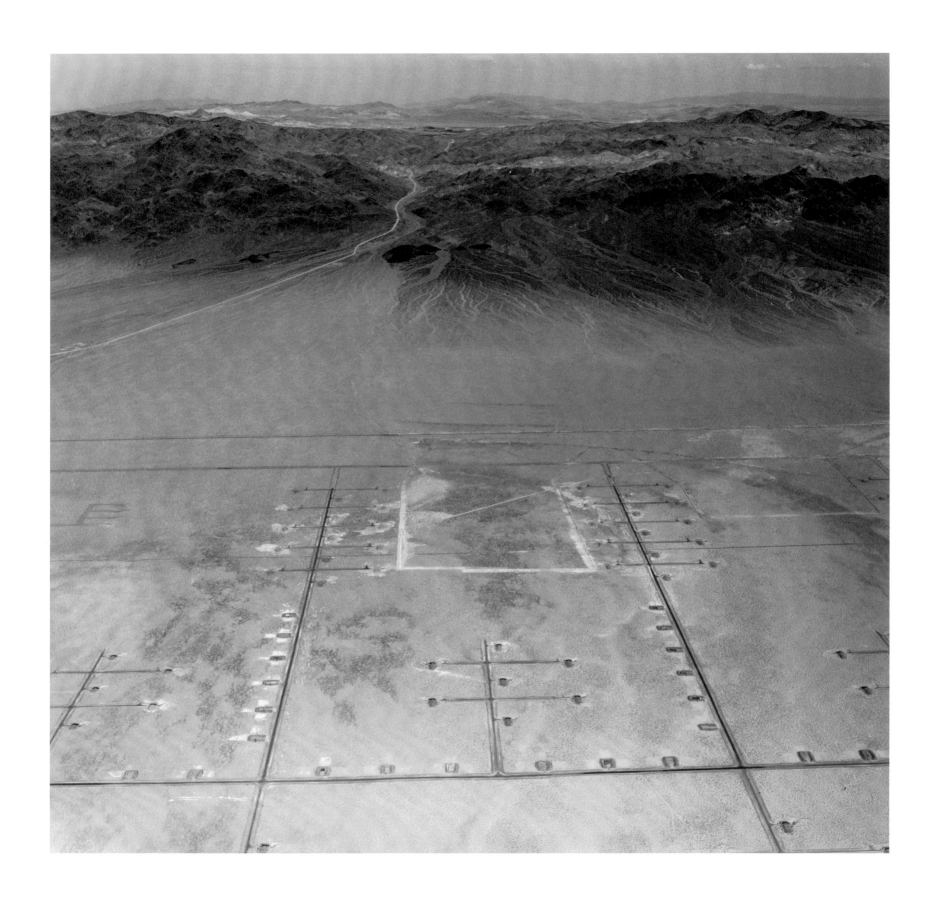

The Edge of the Hawthorne Army Depot, Looking East toward the Grabbs Valley Range, Nevada, 1988

28

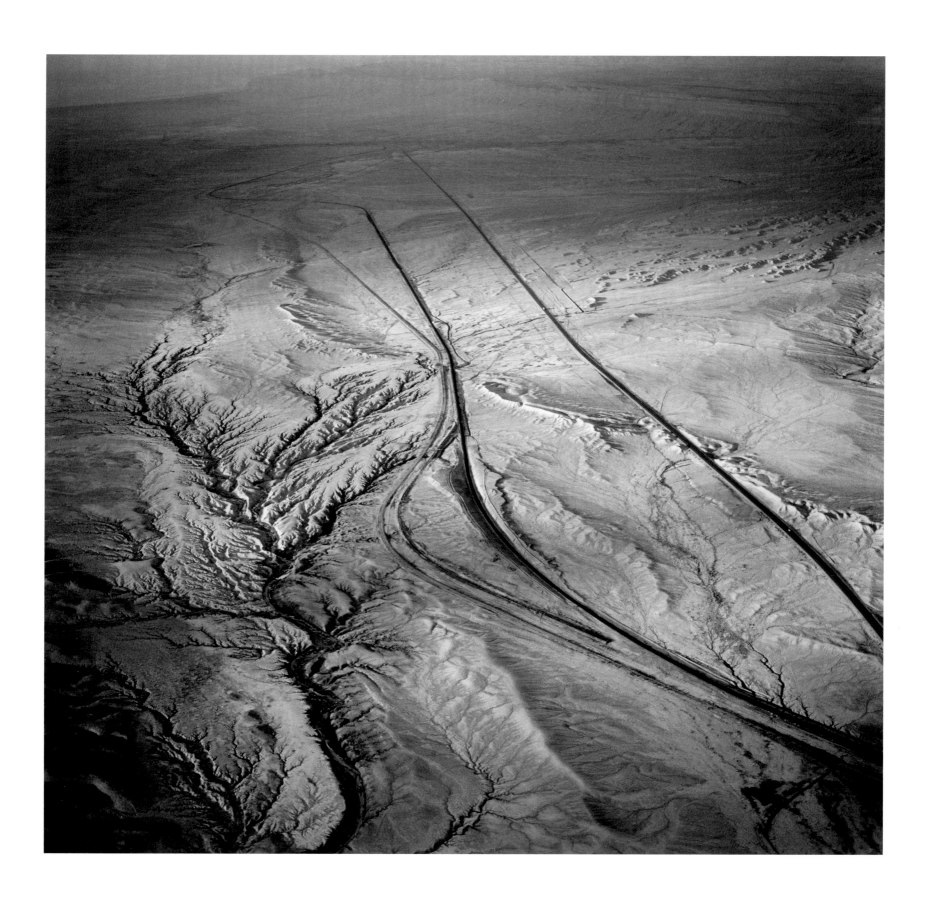

Erosion, Highway Route 6 and Rail Cut, Looking North from Green River, Utah, 1988

29

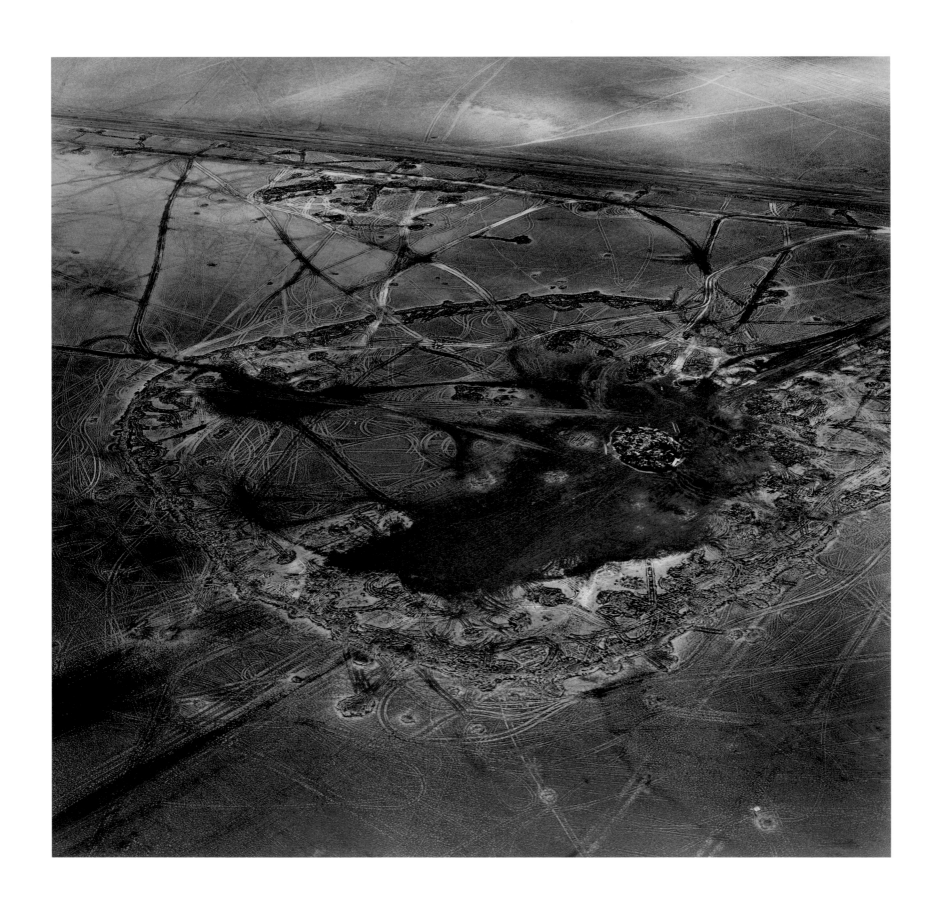

Iraqi Traffic Patterns and Troop Placements, Bubiyan Island, Kuwait, 1995

30

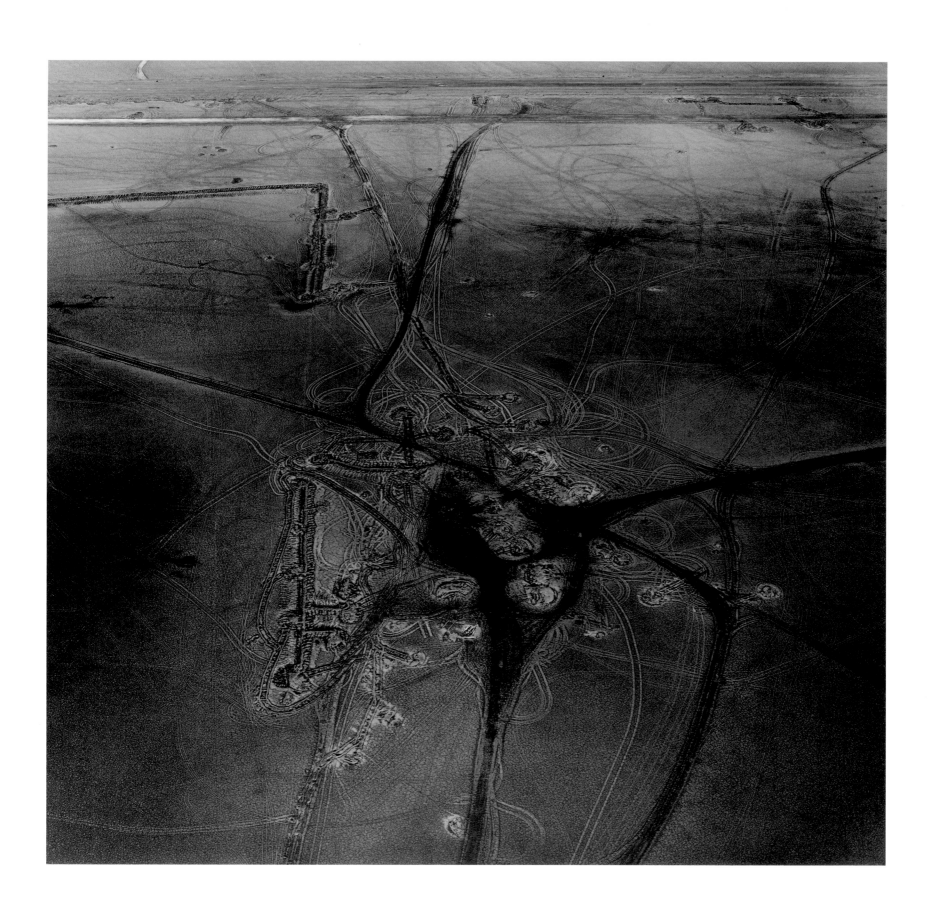

Iraqi Traffic Patterns and Troop Placements, Bubiyan Island, Kuwait, 1995

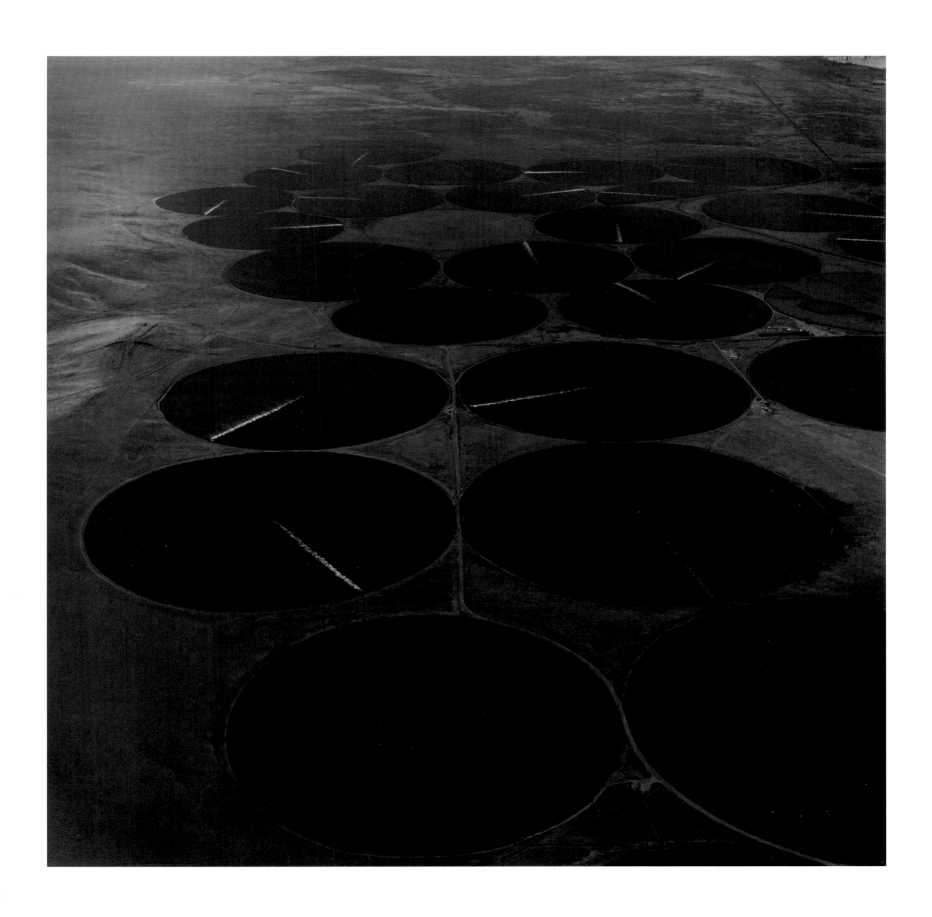

Pivot Irrigation near the One Hundred Circle Farm and the McNary Dam on the Columbia River, Washington, 1991

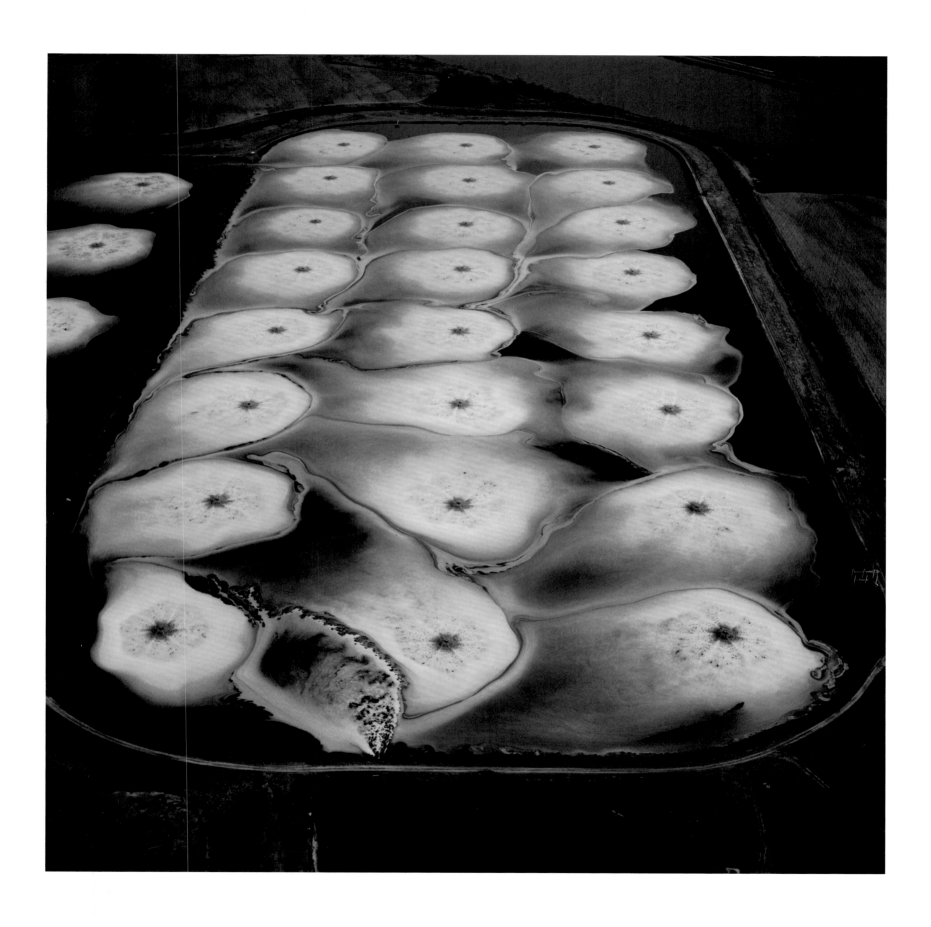

Aeration Pond, Toxic Water Treatment Facility, Pine Bluff, Arkansas, 1989

35

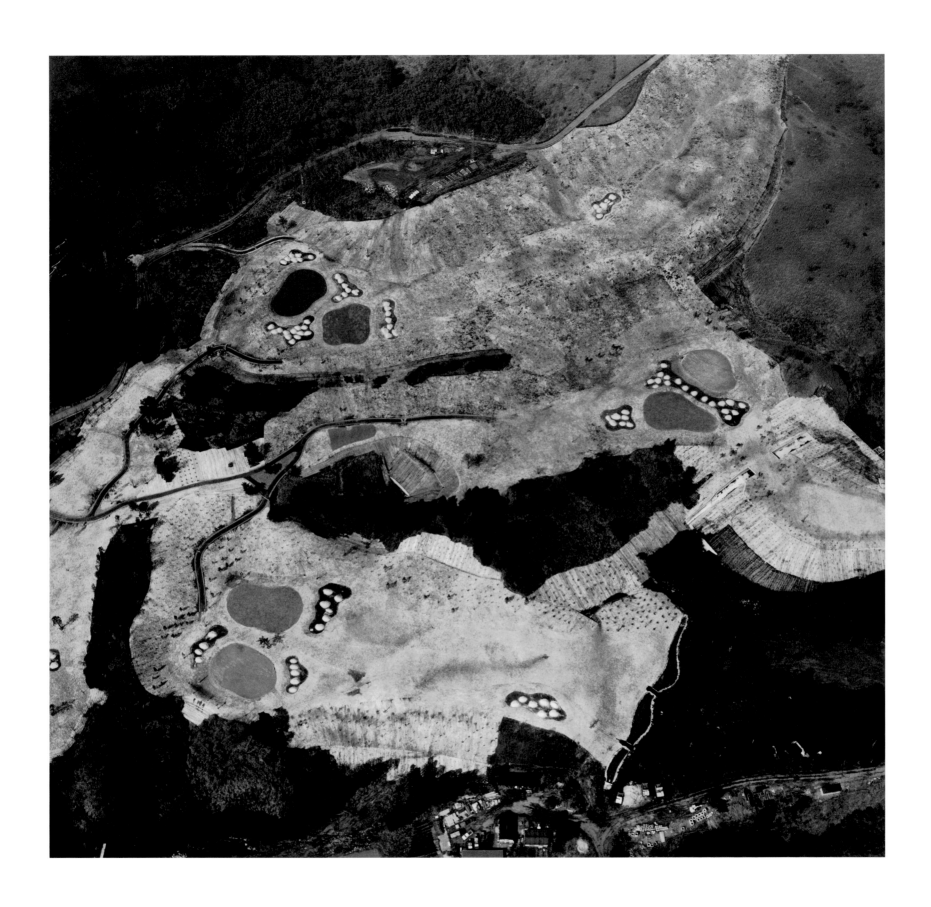

Golf Course under Construction, Mount Aso, Kyushu, Japan, 1992

36

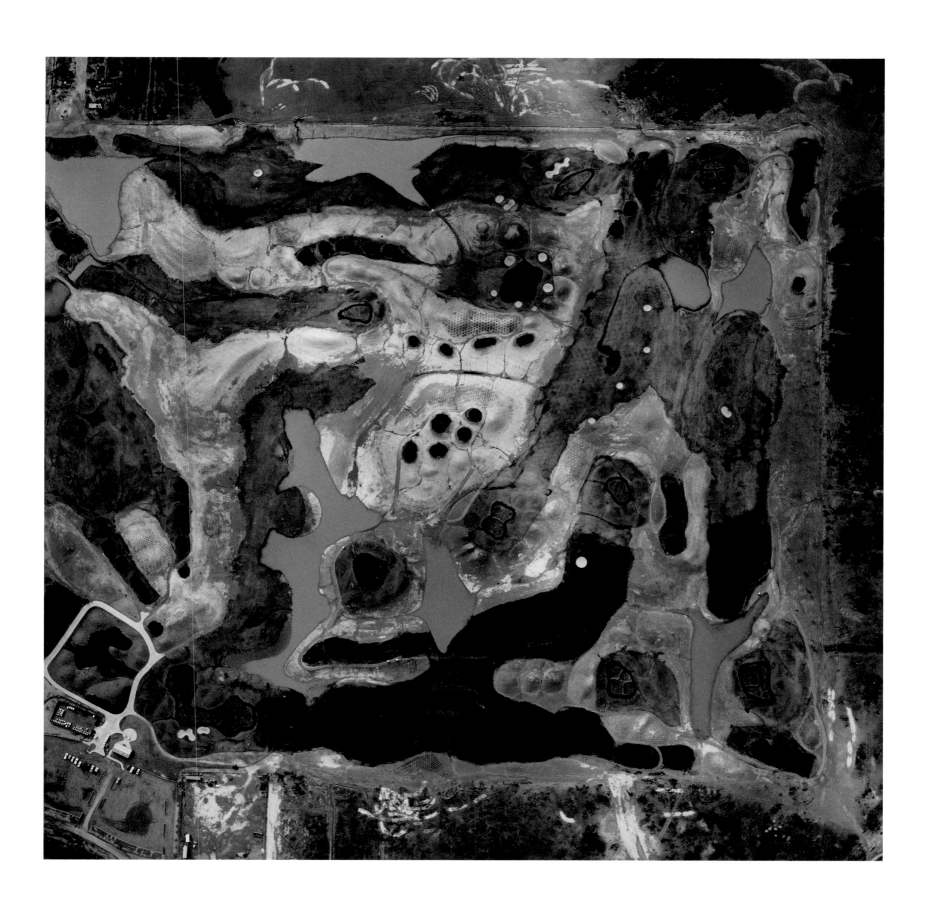

Golf Course under Construction, Arizona, 1993

37

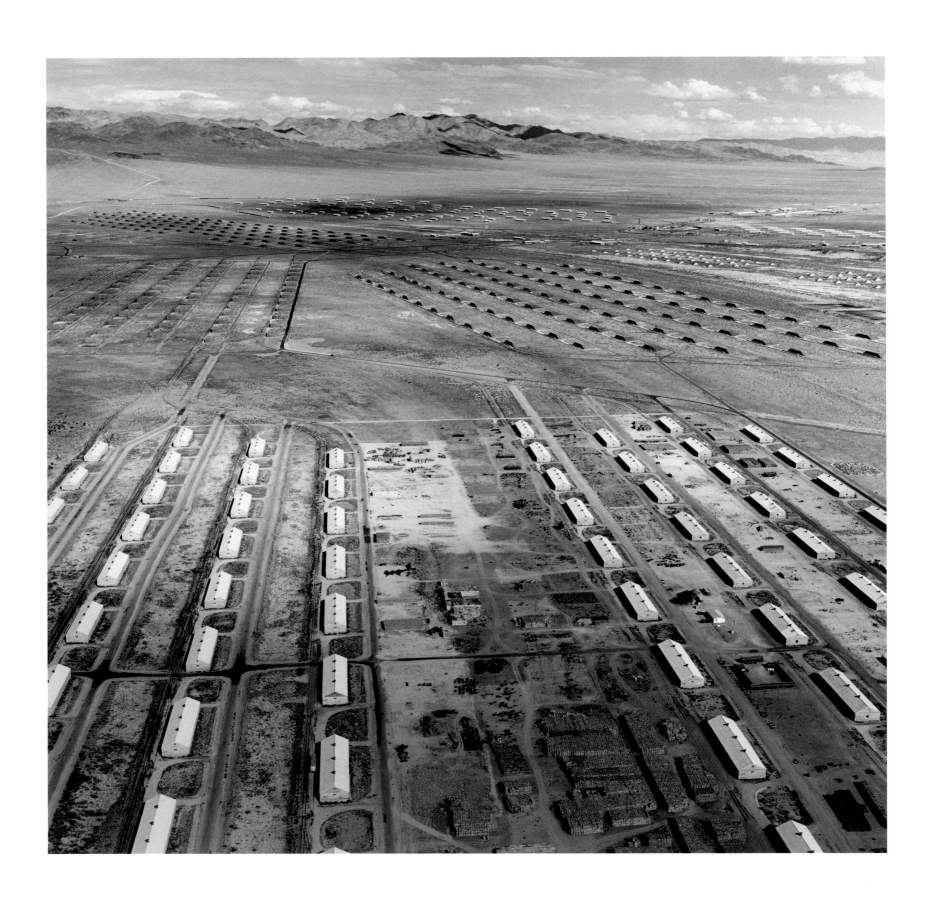

Assembly Buildings and Munitions Storage, Hawthorne Army Depot, Nevada, 1988

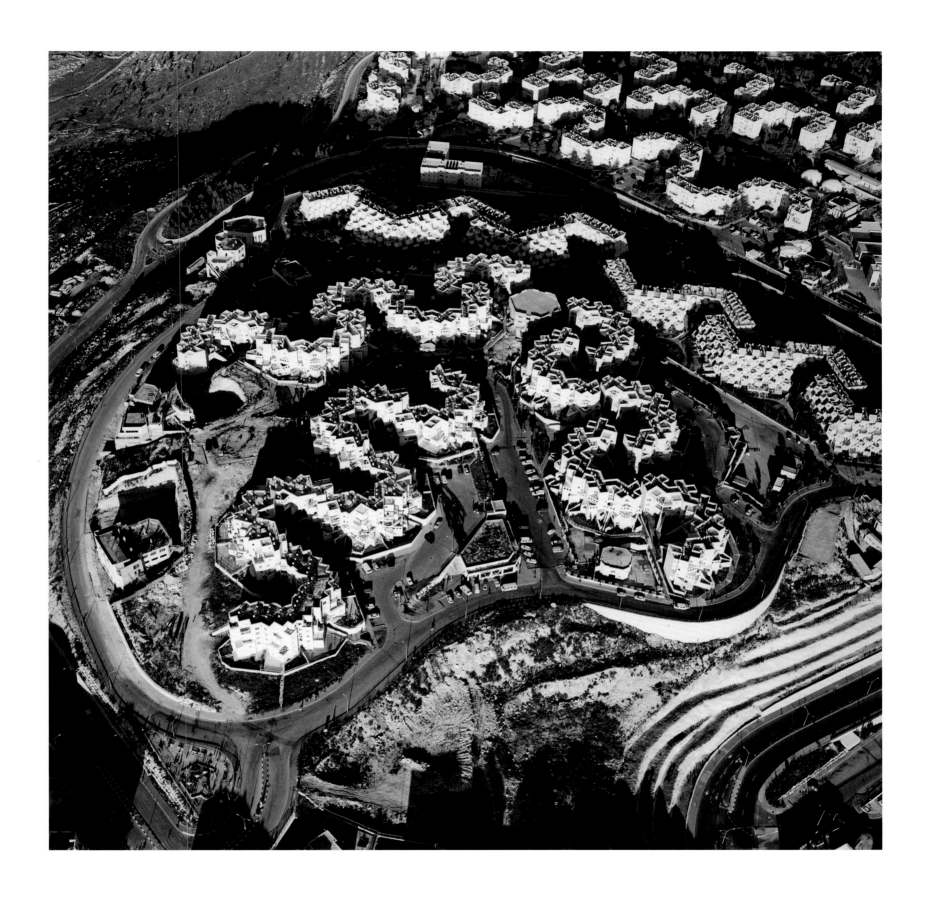

Israeli Suburban Settlement, Ramot 06, Jerusalem, 1995

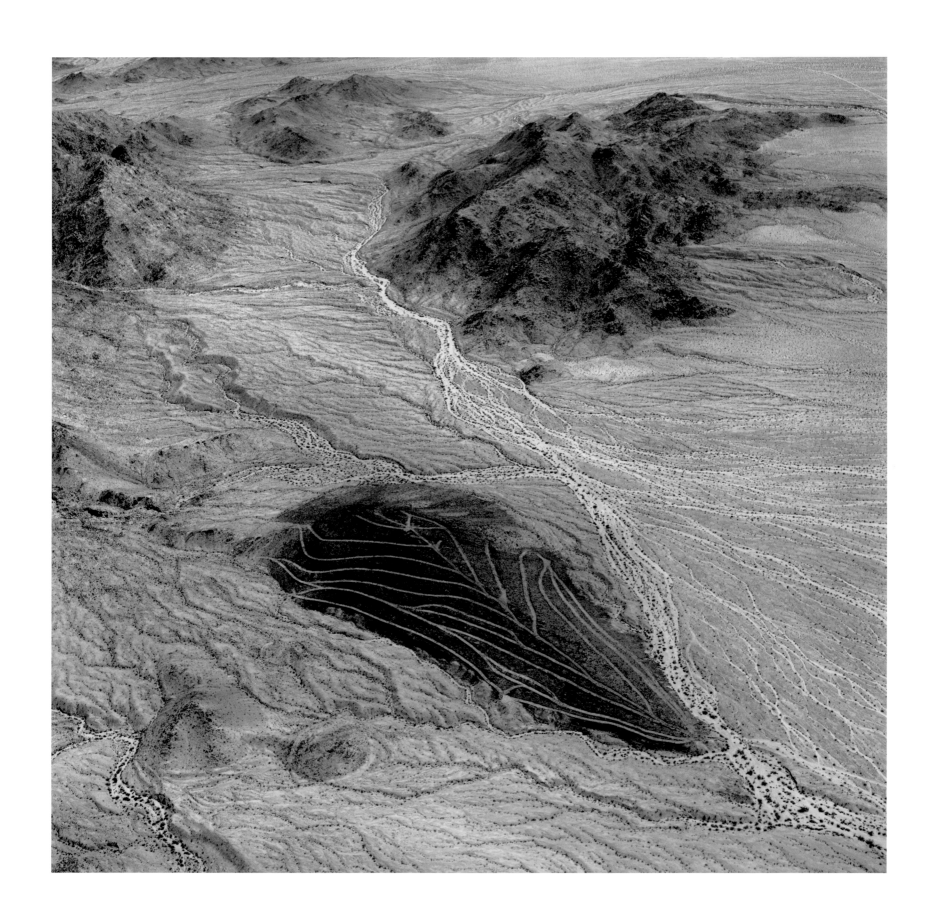

Mining Exploration in the Mojave Desert, California, 1989

40

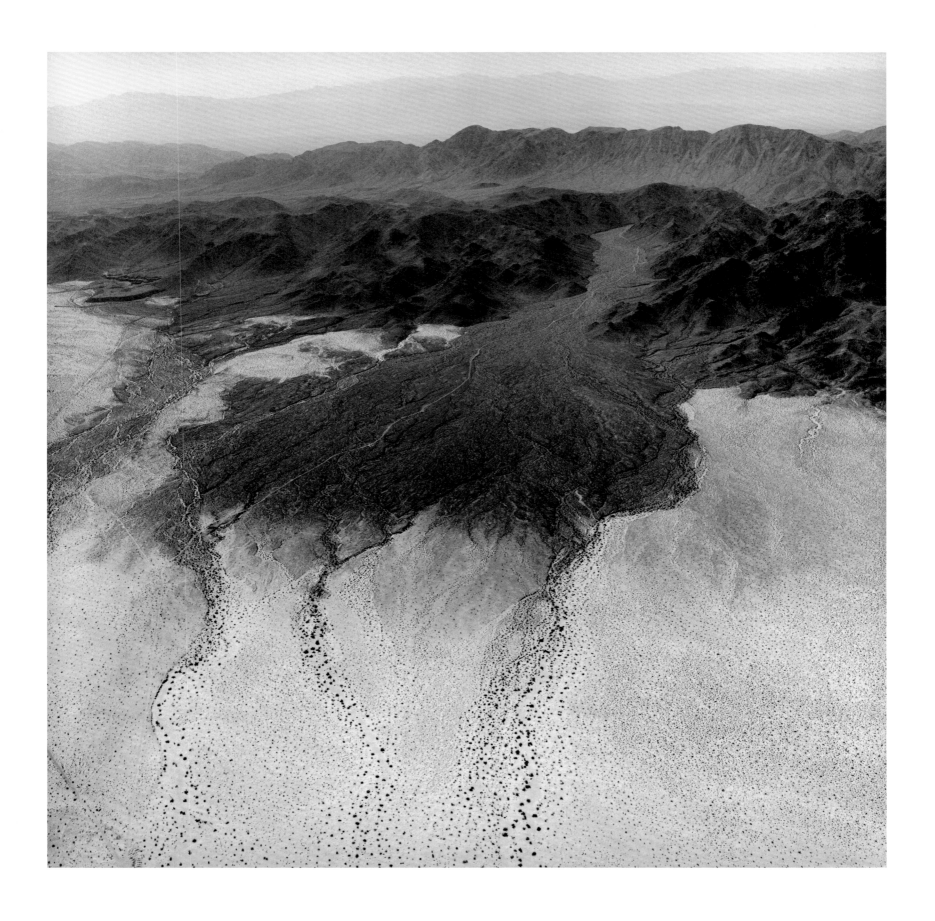

Alluvial Fan, Natural Drainage near the Yuma Proving Ground and the Arizona-California Border, 1988

41

Erosion in a Dark Field, Washington, 1991

43

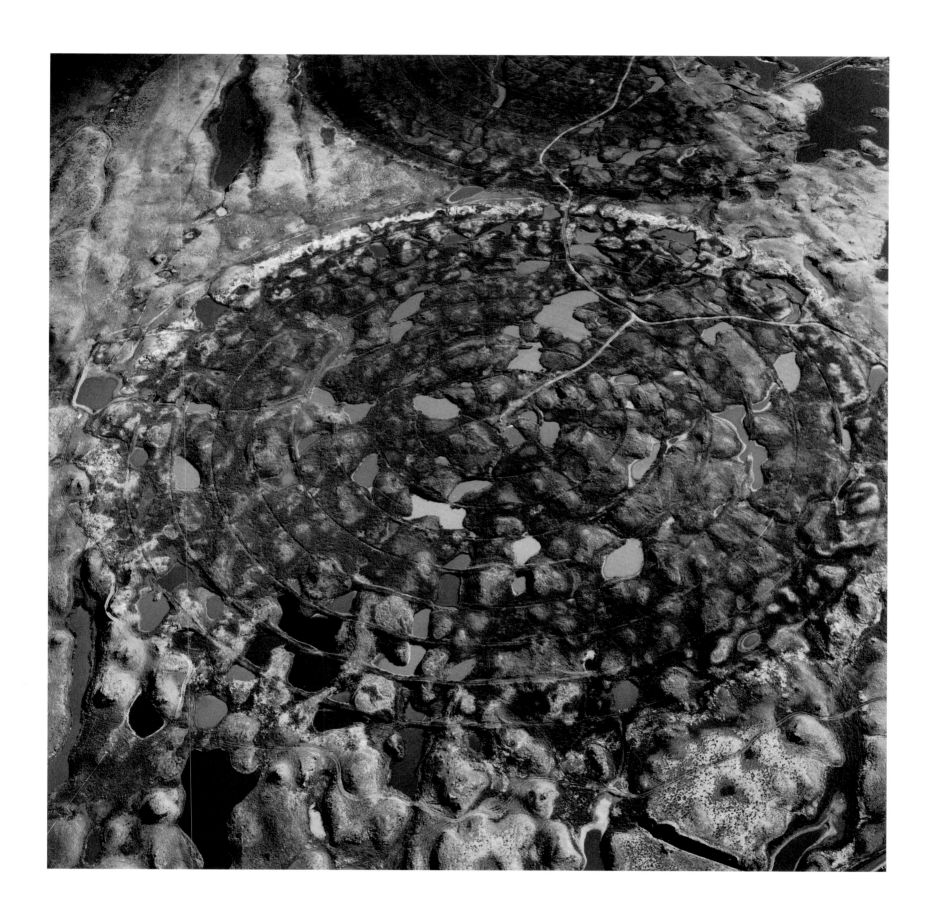

Pivot Agriculture over Glacial Potholes near Moses Lake, Washington, 1991

45

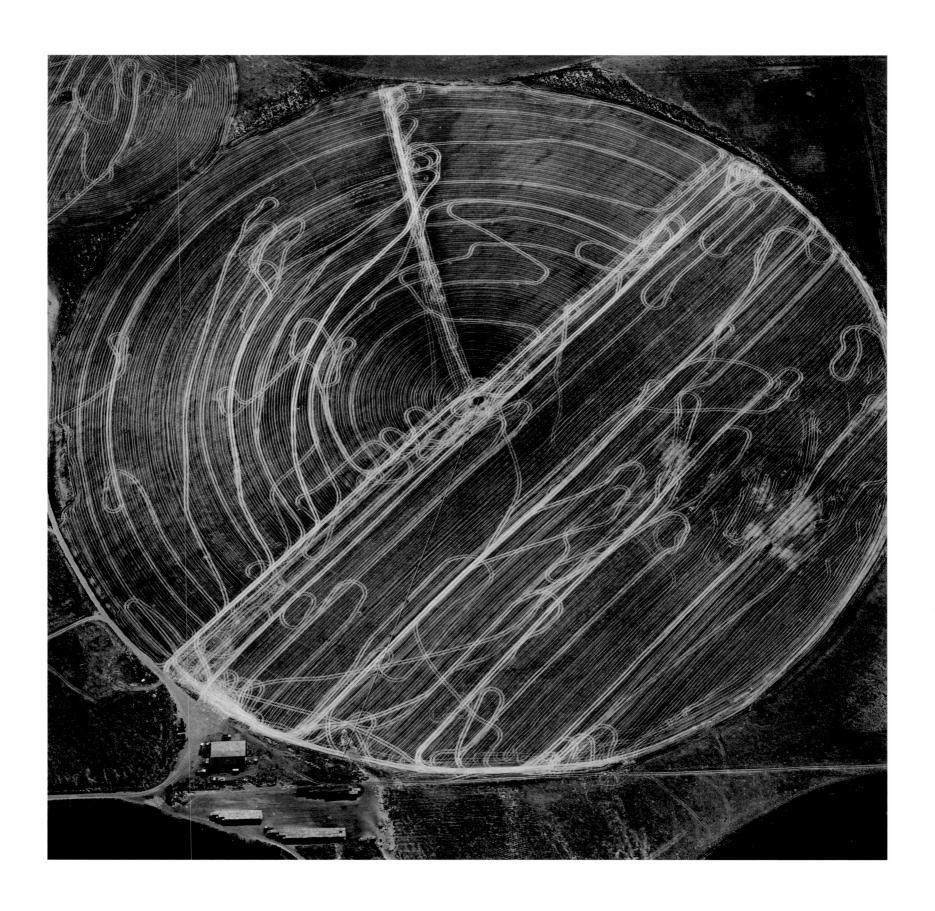

Harvest Traffic over Agricultural Pivot near Hermiston, Oregon, 1991

47

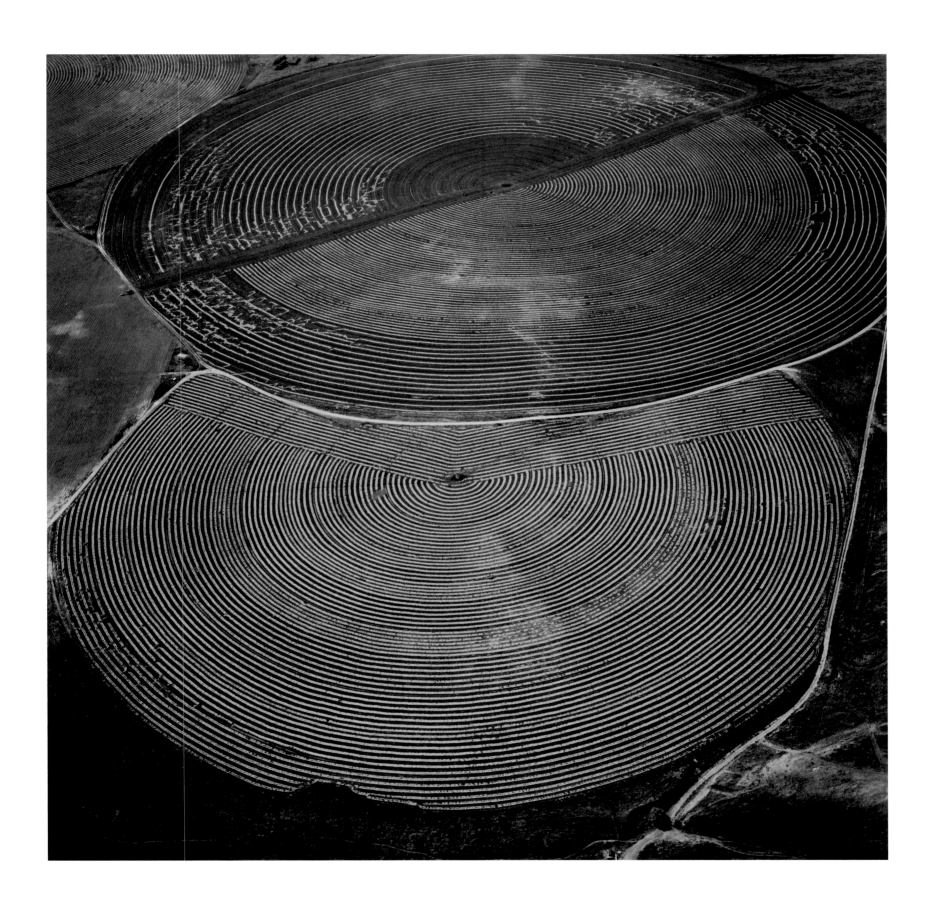

Pivot Agriculture on the Snake River Plain near the Confluence of the Snake and Columbia Rivers, Washington, 1991

49

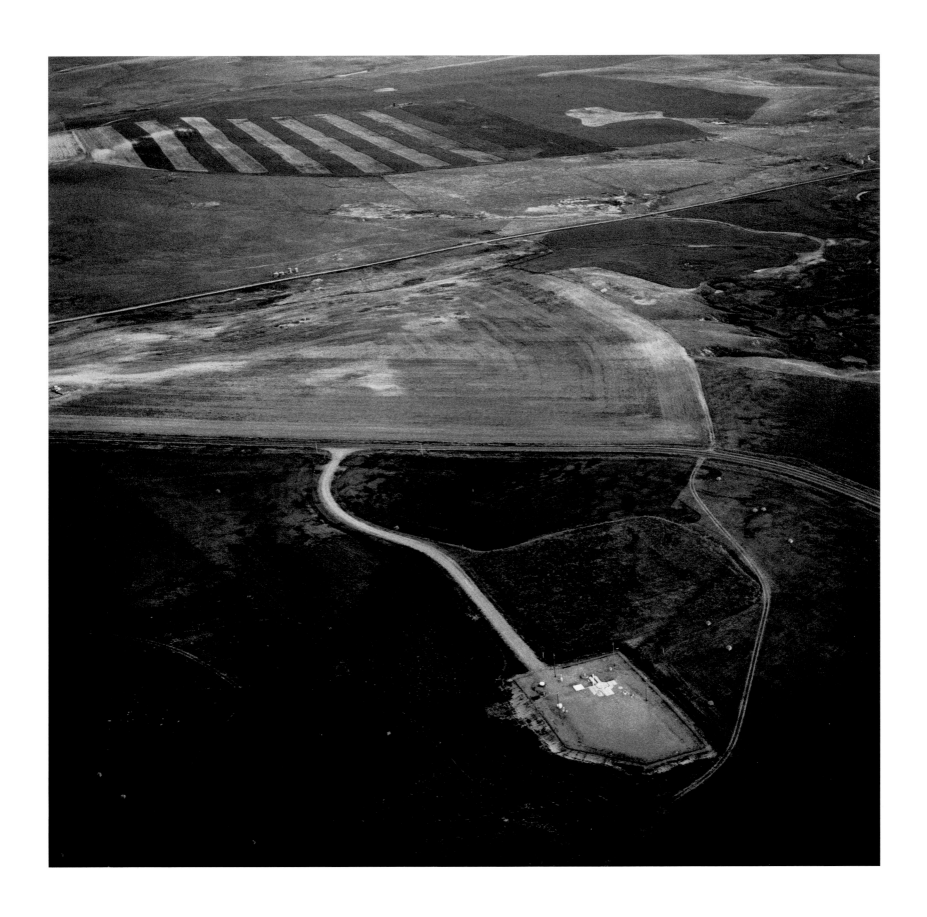

Dry Land Wheat Farming and Minuteman ICBM Missile Silo near Great Falls, Montana, 1987

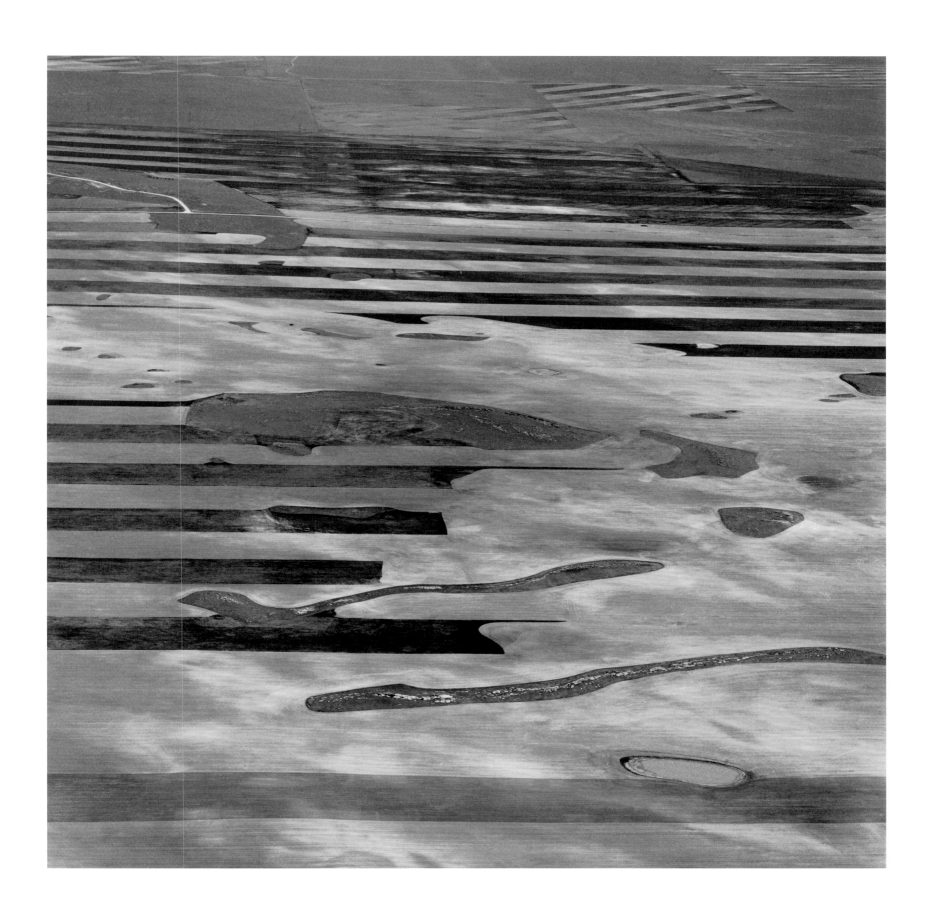

Dry Land Wheat Farming in the Cheyenne ICBM Missile Field, Pawnee National Grassland, Colorado, 1991

51

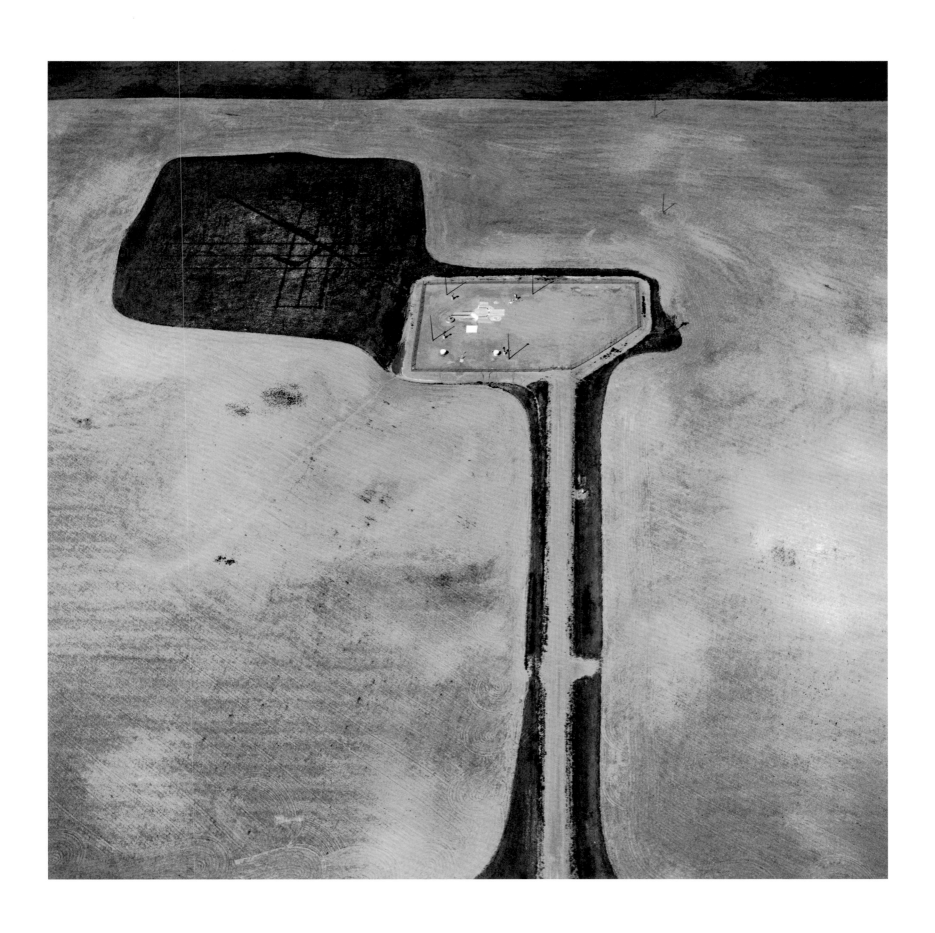

Minuteman Missile Silo near Conrad, Montana, 1987

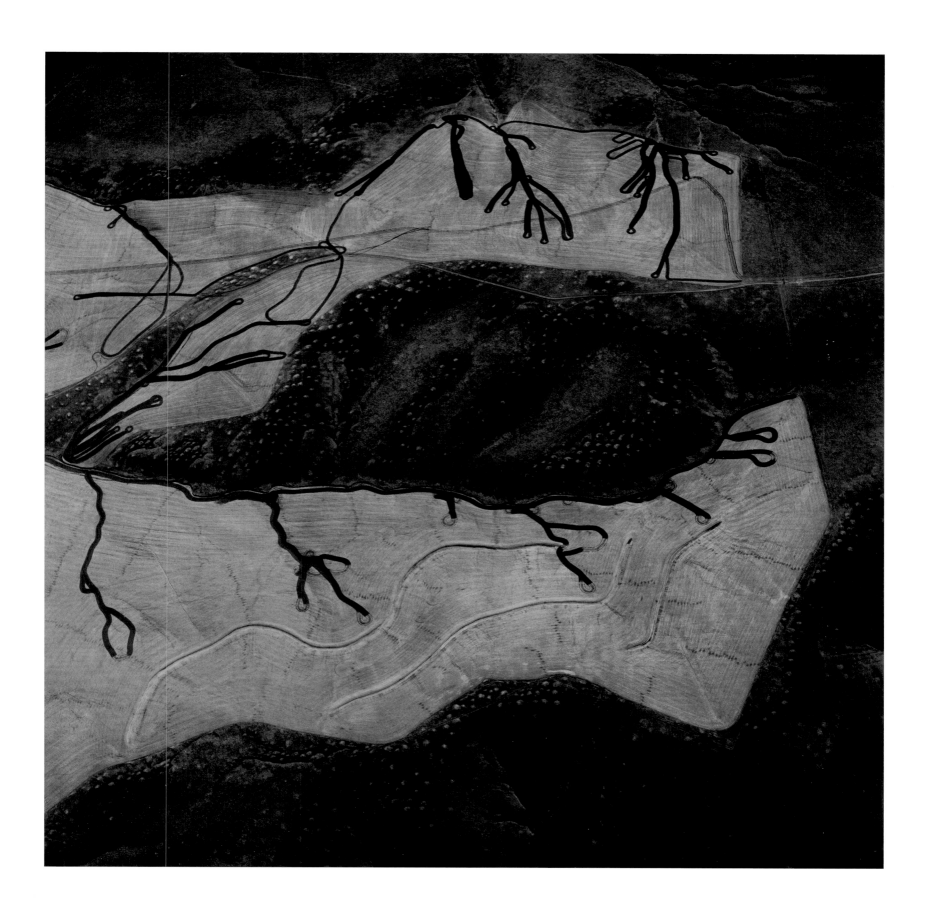

Natural Drainages Outlined by Cultivation, Dry Land Wheat Farming near Hermiston, Oregon, 1991

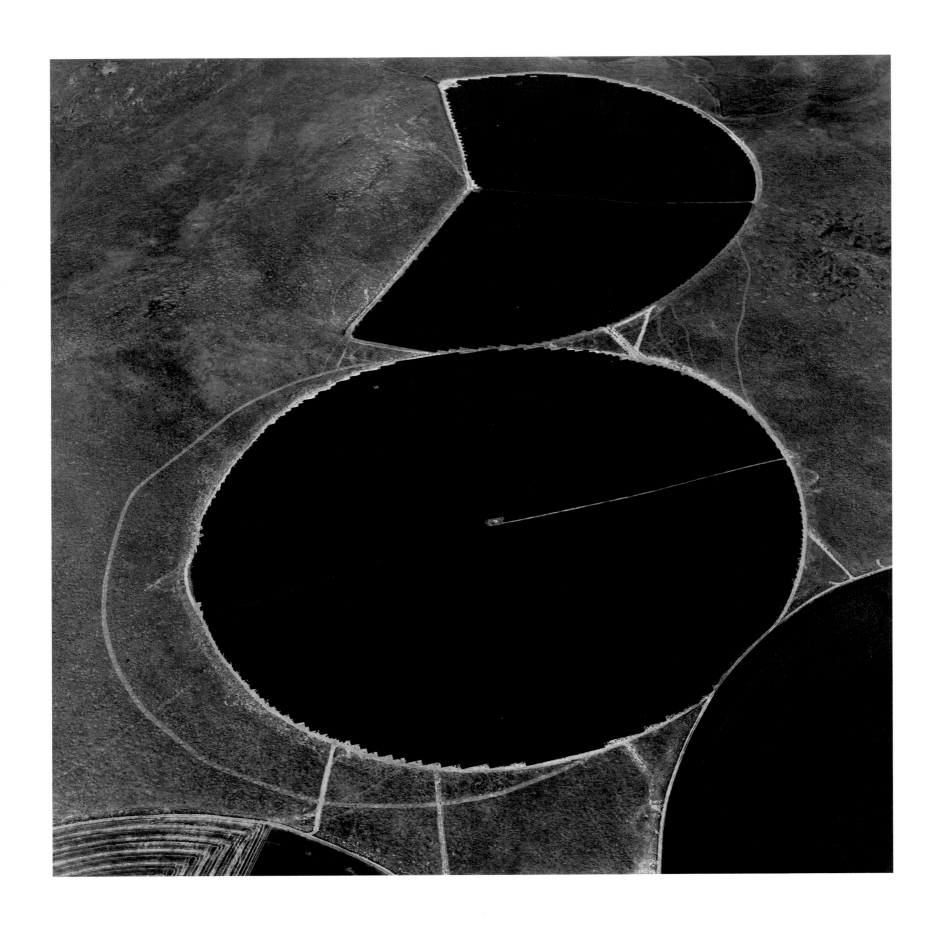

Pivot Agriculture, South of Moses Lake, Washington, 1991

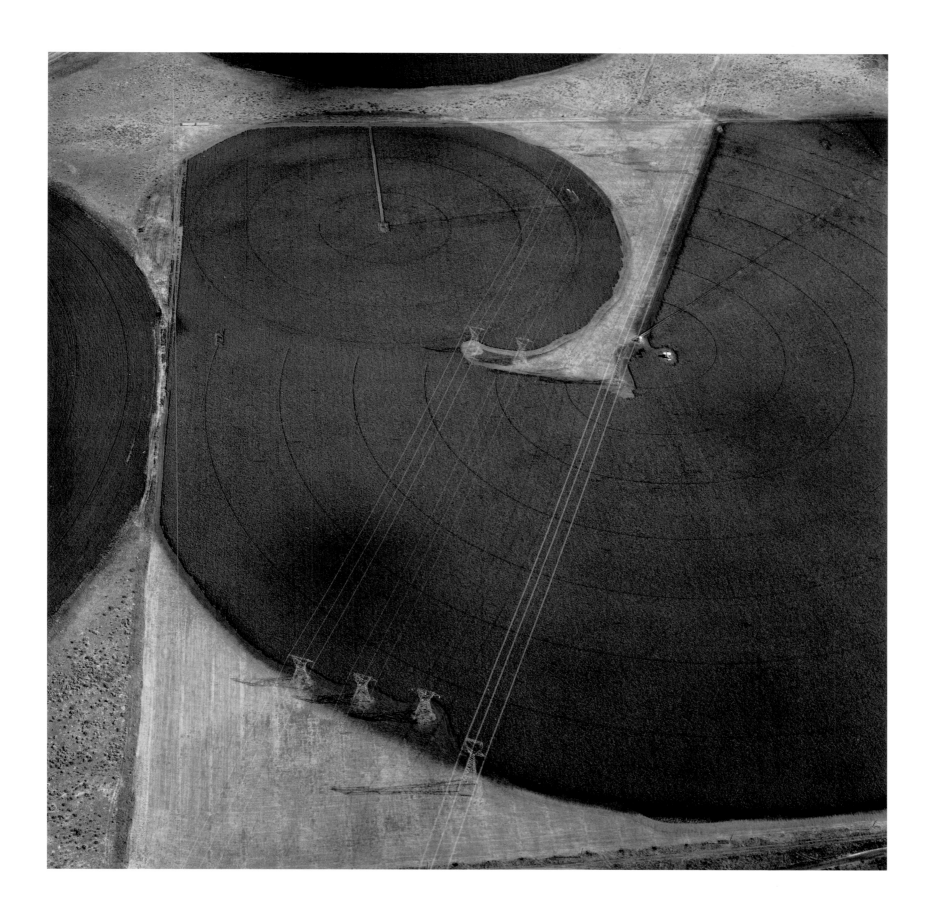

Pivot Agriculture and Power Lines near Moses Lake, Washington, 1991

57

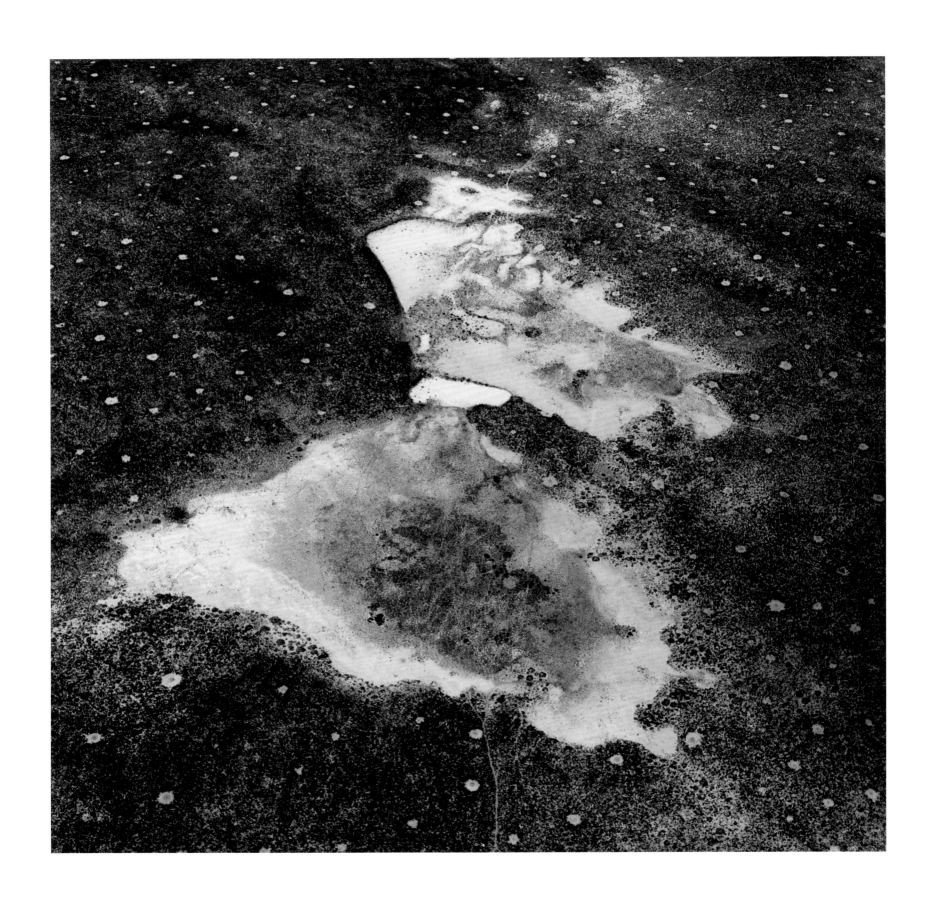

Alkali Wash and Dry Watering Hole near the Very Wide Array, Magdelena, New Mexico, 1988

58

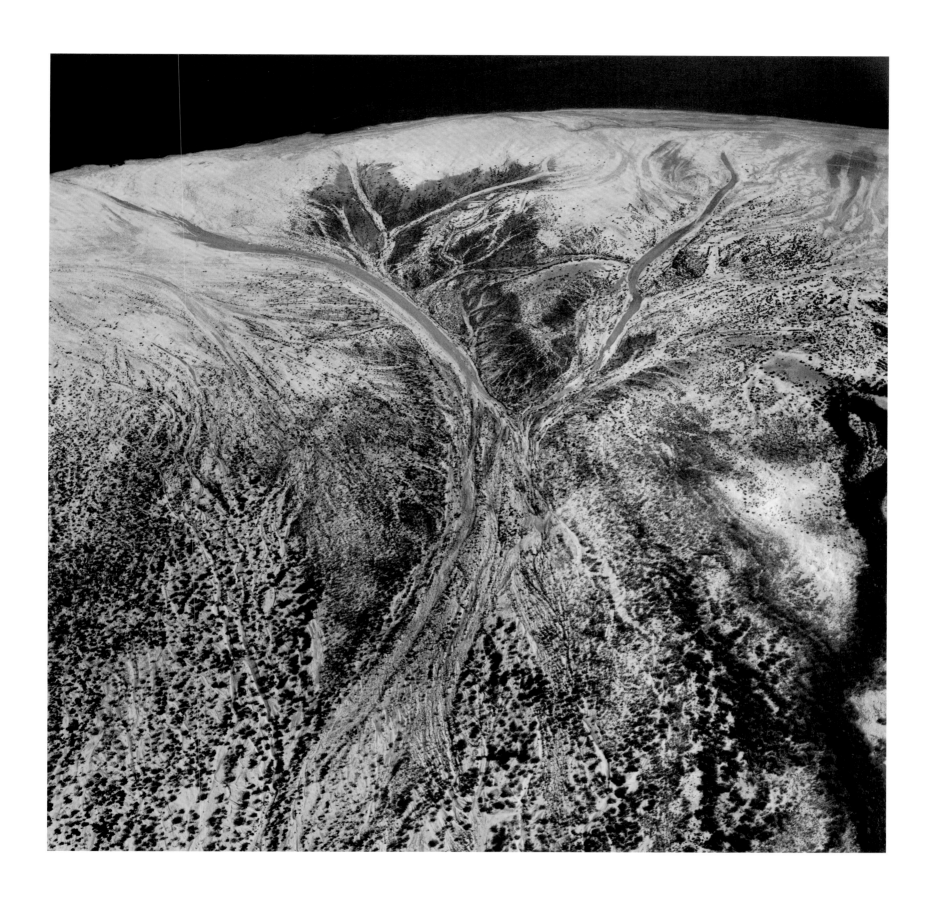

The Edge of the Salton Sea, California, 1990

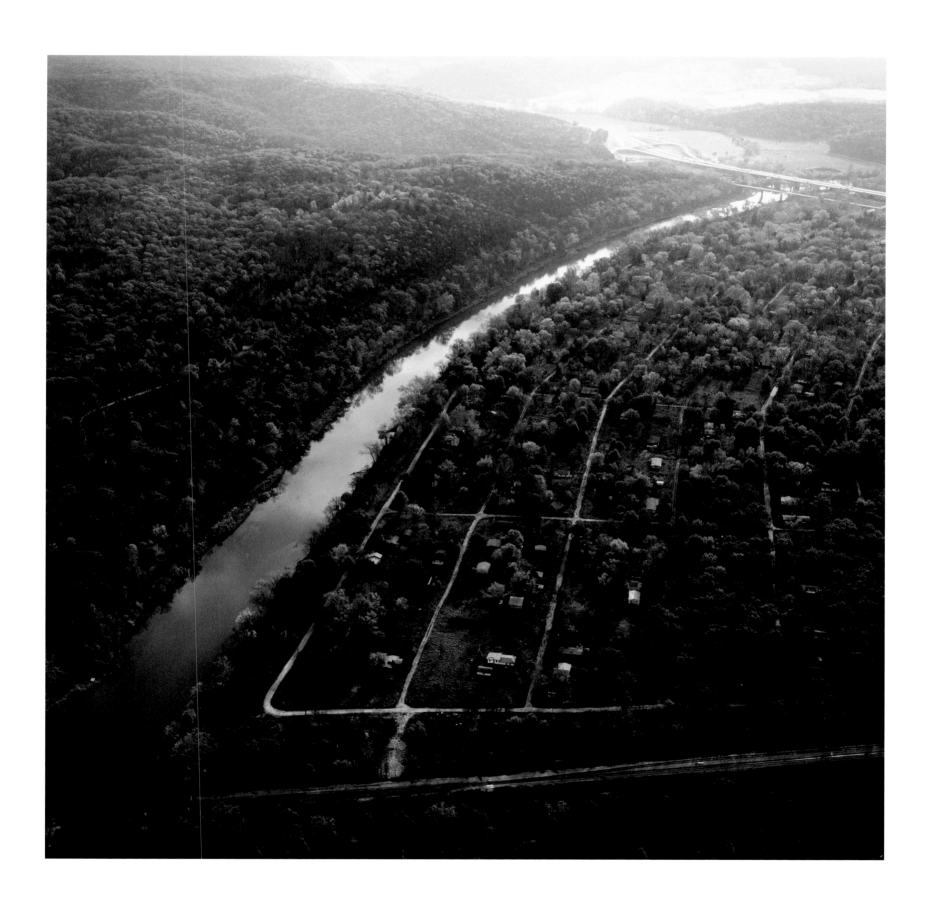

The Abandoned and Condemned Village of Times Beach, Missouri, 1989

CZECH REPUBLIC

1992—1994

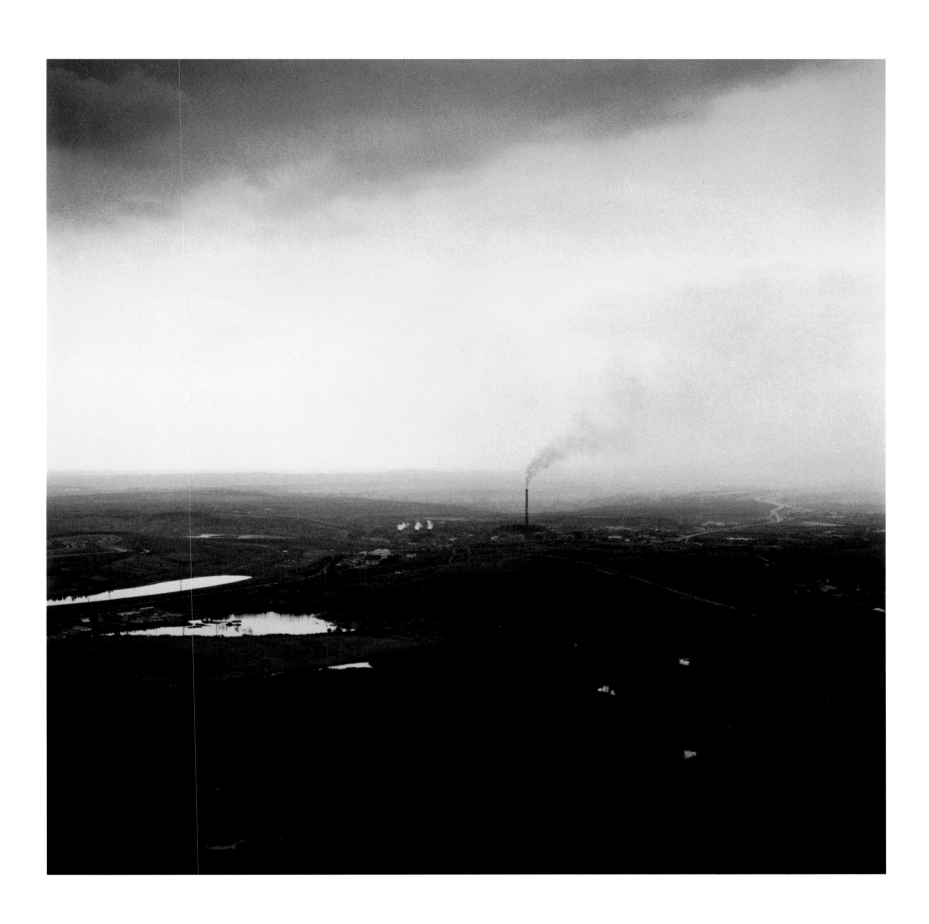

Cooling Towers and Power Station, Bohemia, Czech Republic, 1992

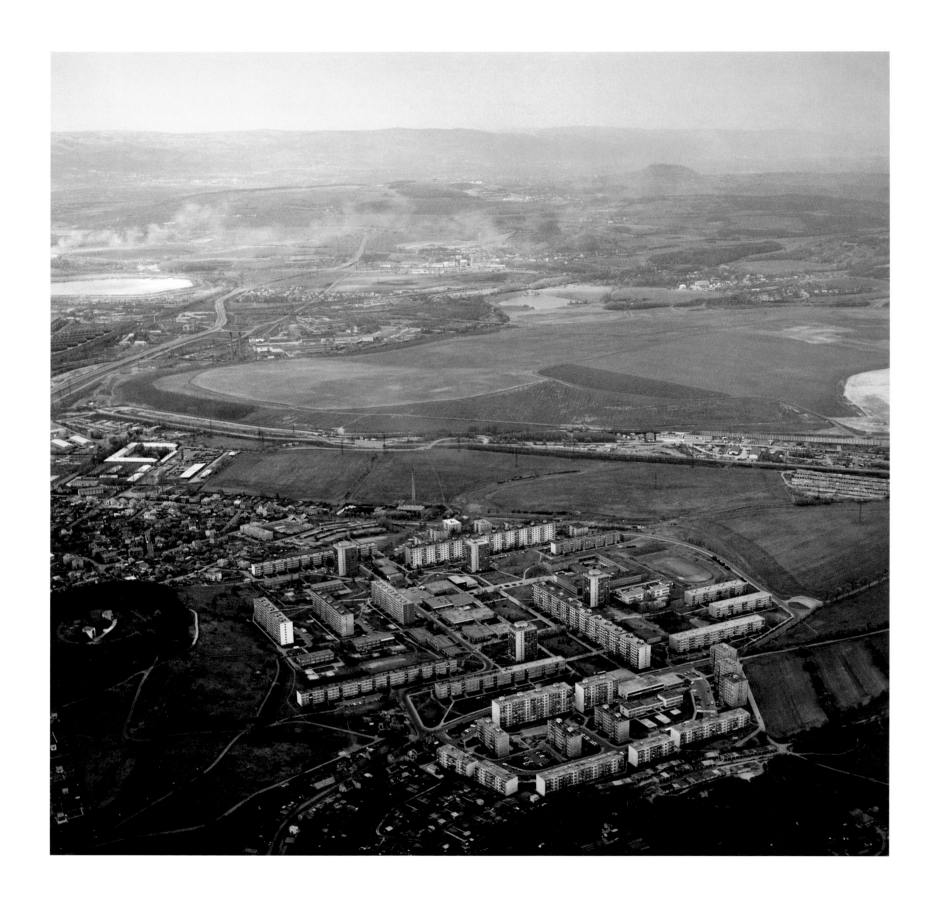

Housing Project, Litvinov, and the Chemopetrol Works, Bohemia, Czech Republic, 1992

64

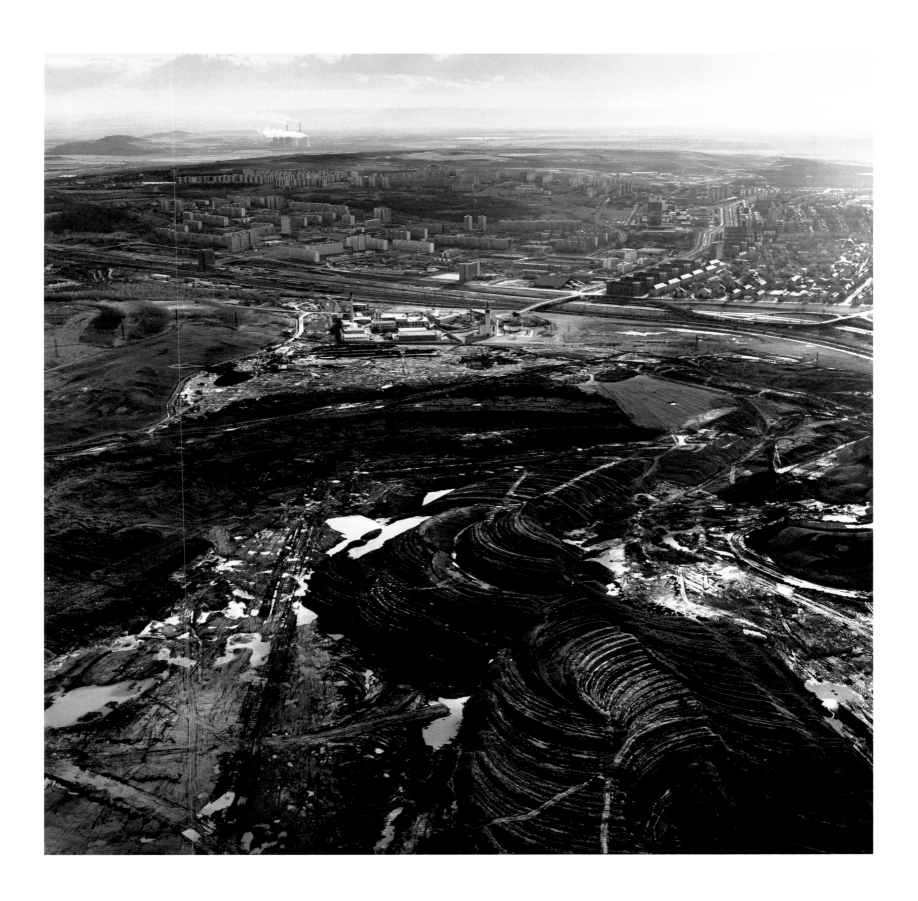

Overburden in the Open Pit, Relocated Cathedral and the Town of Most, Czech Republic, 1994

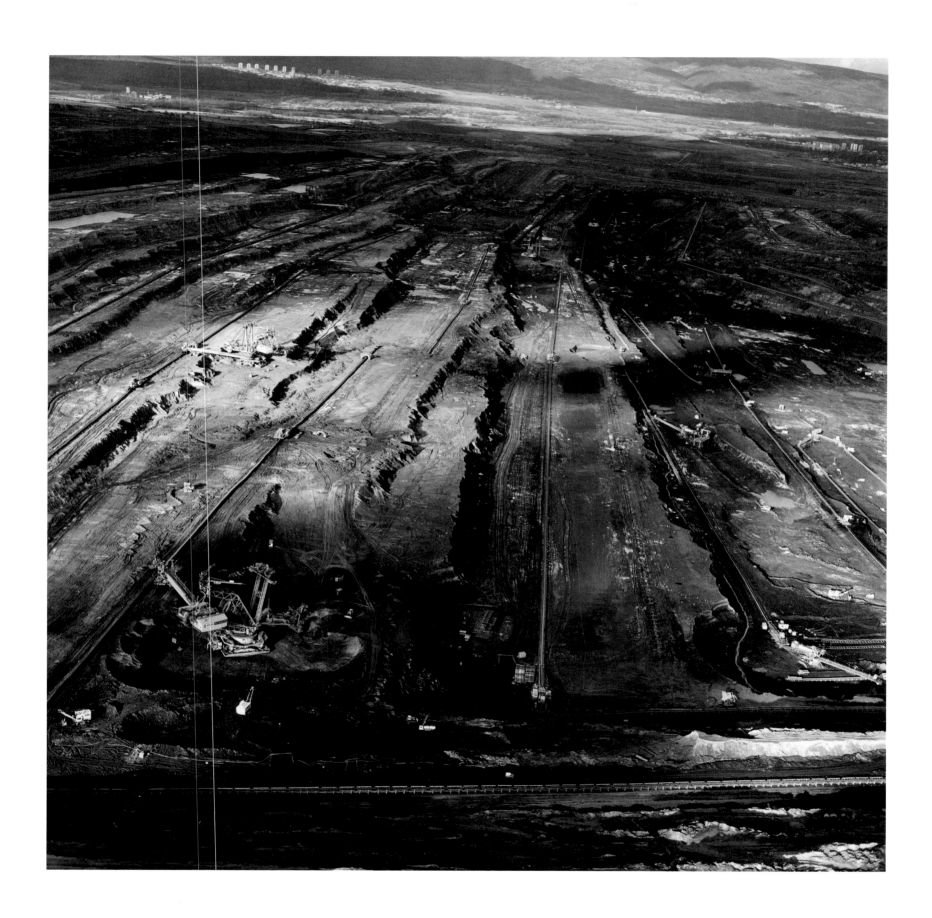

Strip Mine with the Towns of Litvinov, Lom, Osek, and Duchcov in the Distance, Czech Republic, 1994

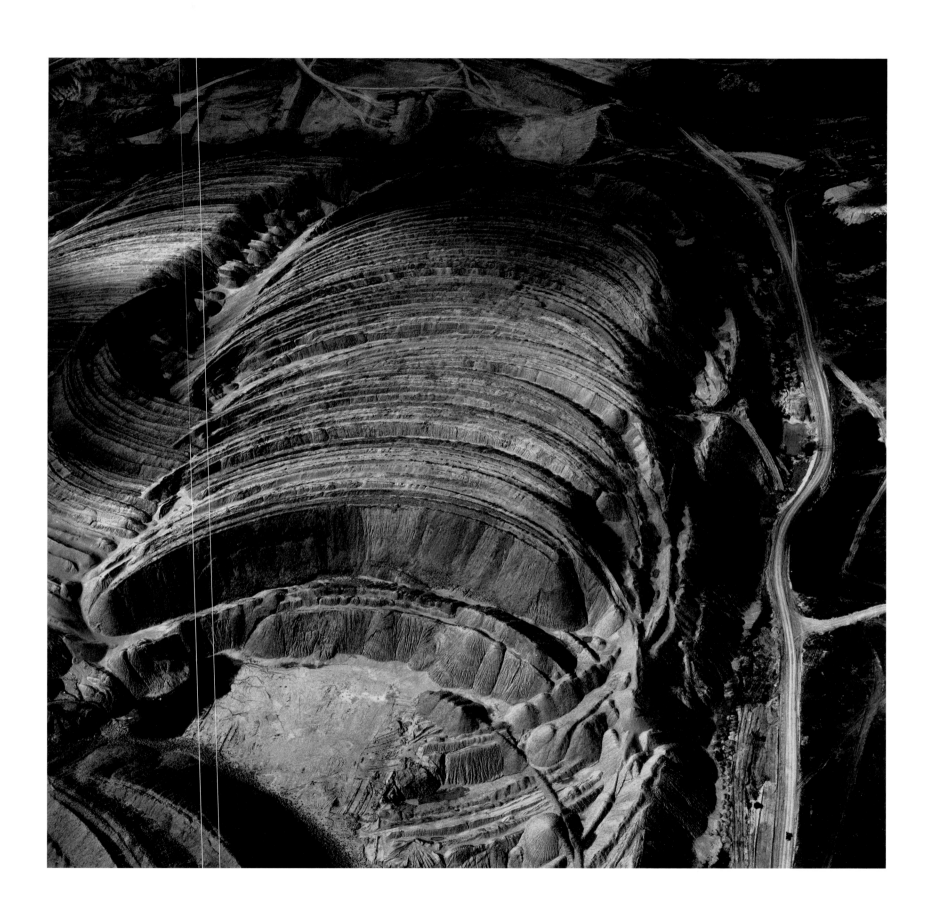

Discarded Overburden near the Town of Most, Czech Republic, 1992

69

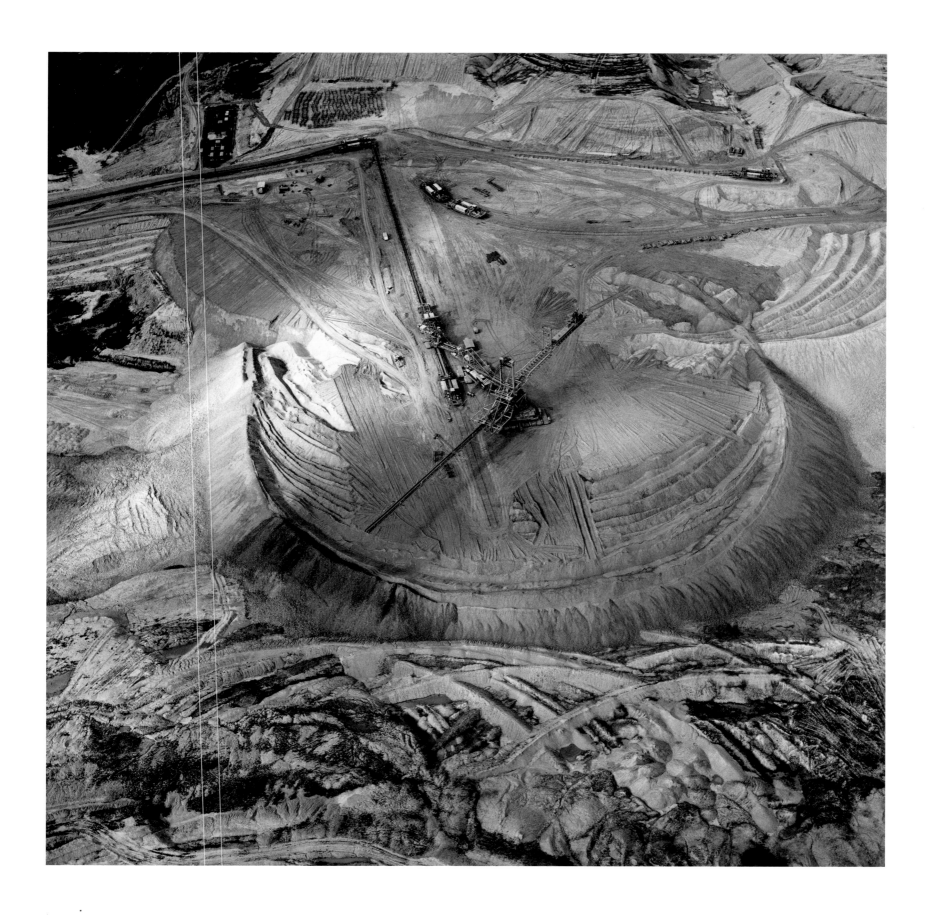

Mechanical Distribution of Overburden, Chemopetrol Strip Mine, Czech Republic, 1992

71

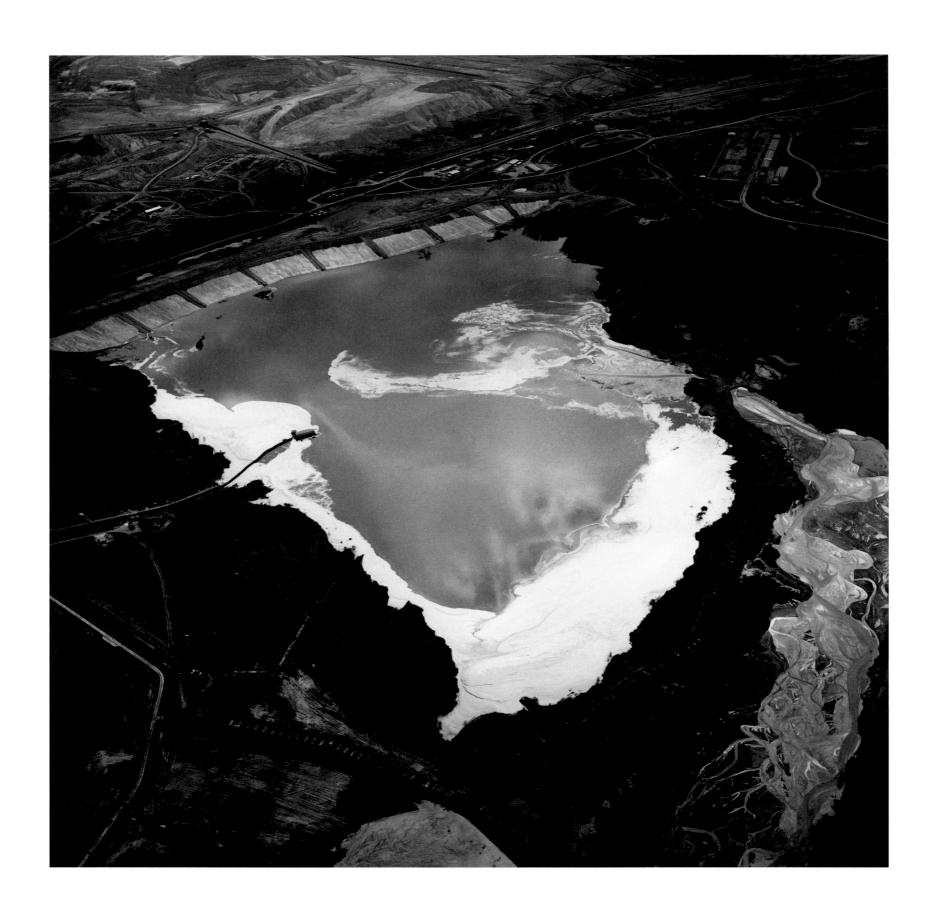

Effluent Holding Pond, Chemopetrol Mines, Bohemia, Czech Republic, 1992

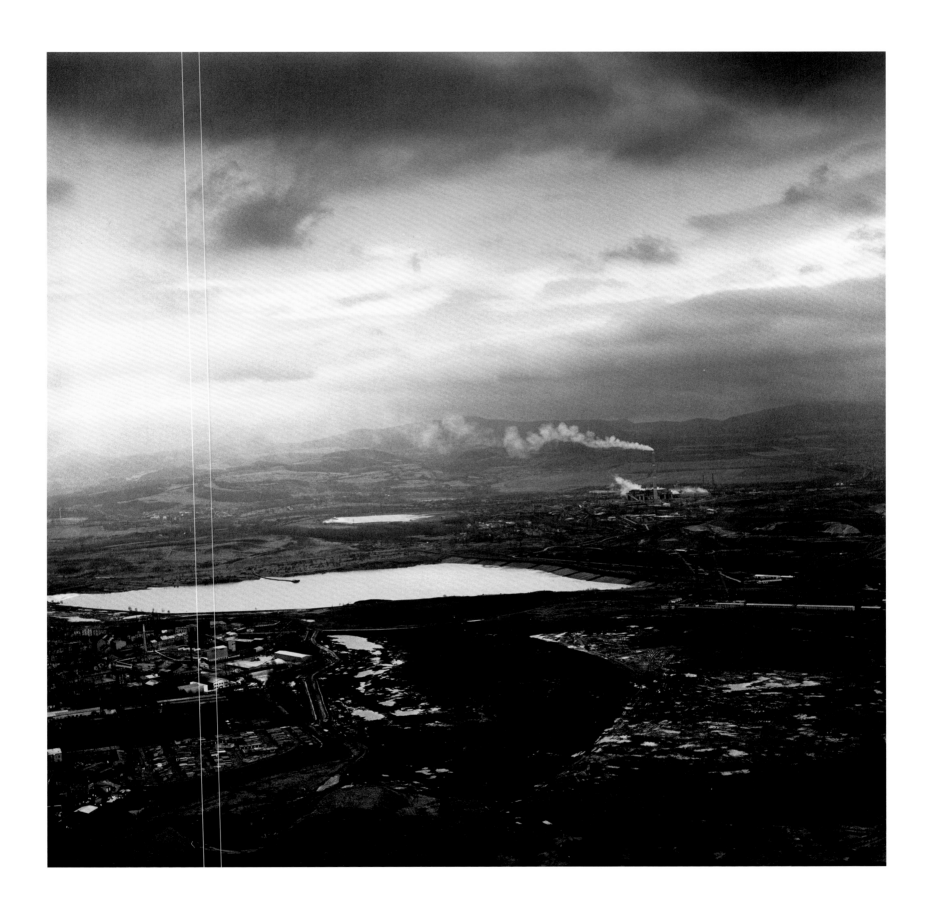

Power Station and the Town of Duchcov, Czech Republic, 1994

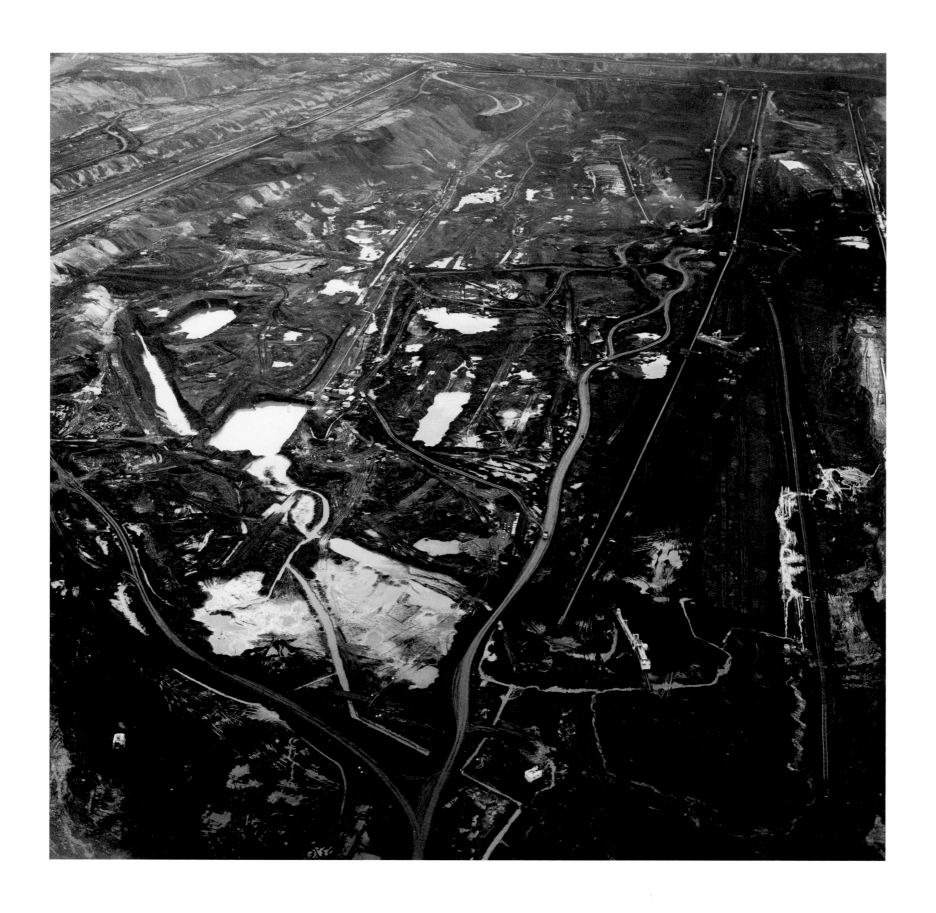

The Working Floor of the Chemopetrol Mines, Bohemia, Czech Republic, 1994

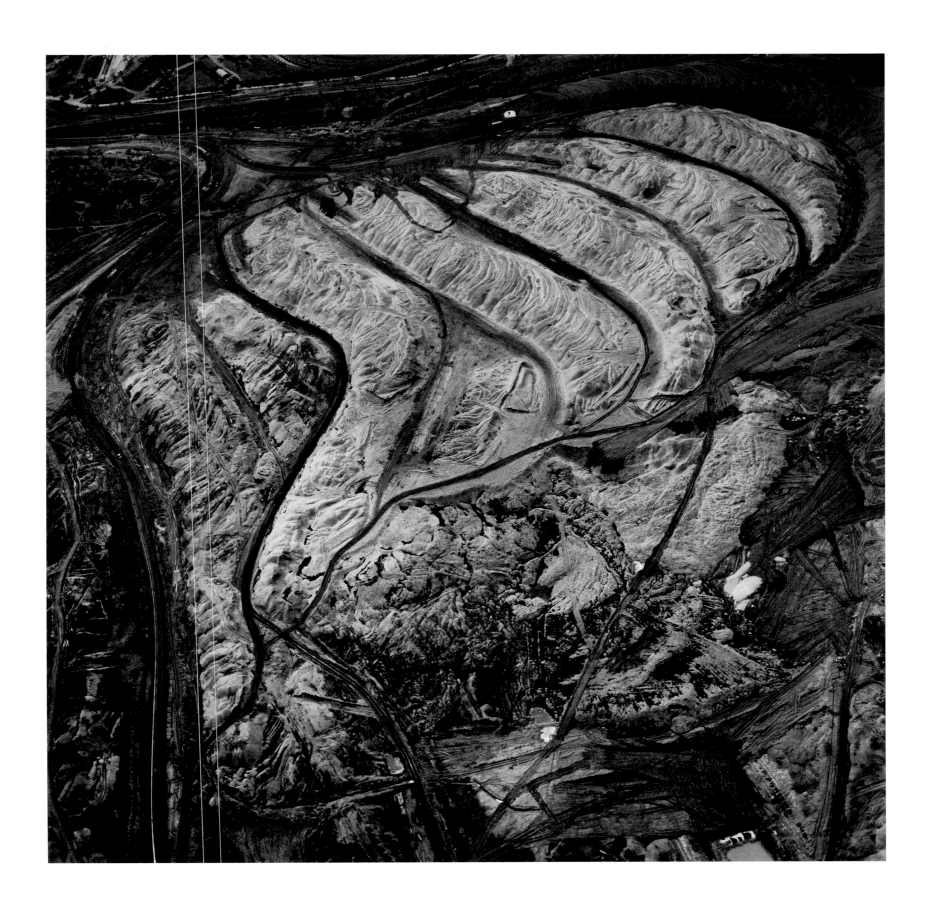

Discarded Overburden, Chemopetrol Mines, Bohemia, Czech Republic, 1992

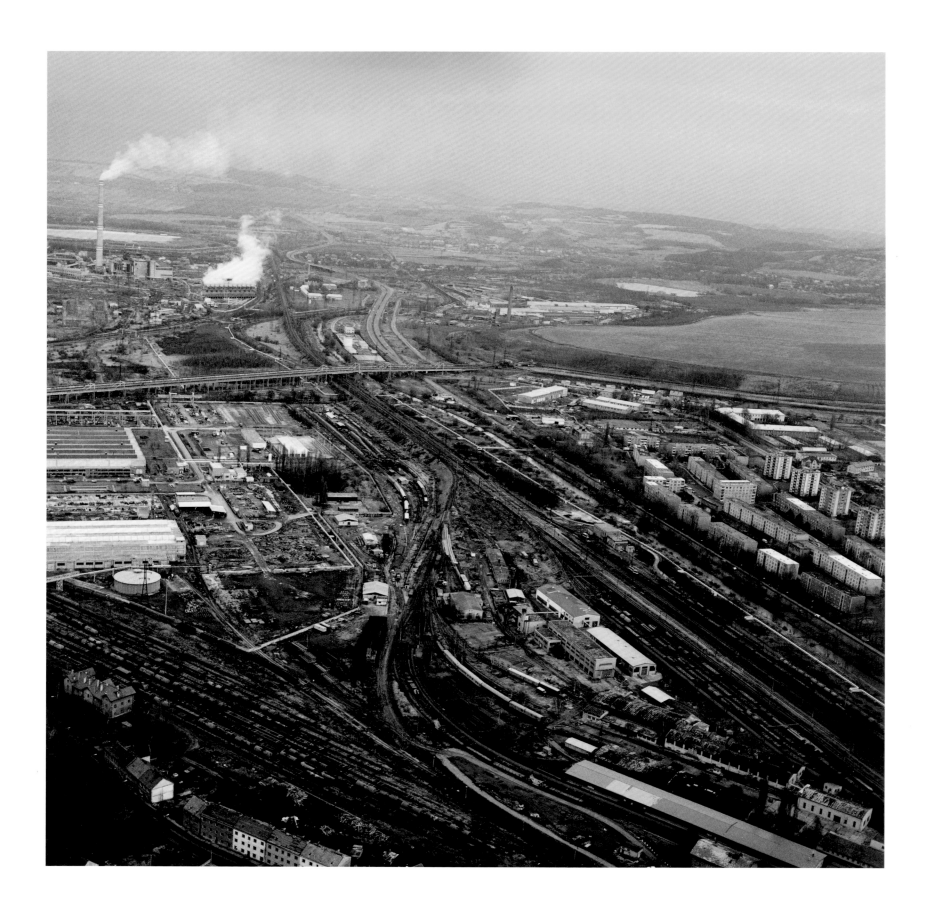

Railyard and Power Station, Bílina, Czech Republic, 1994

76

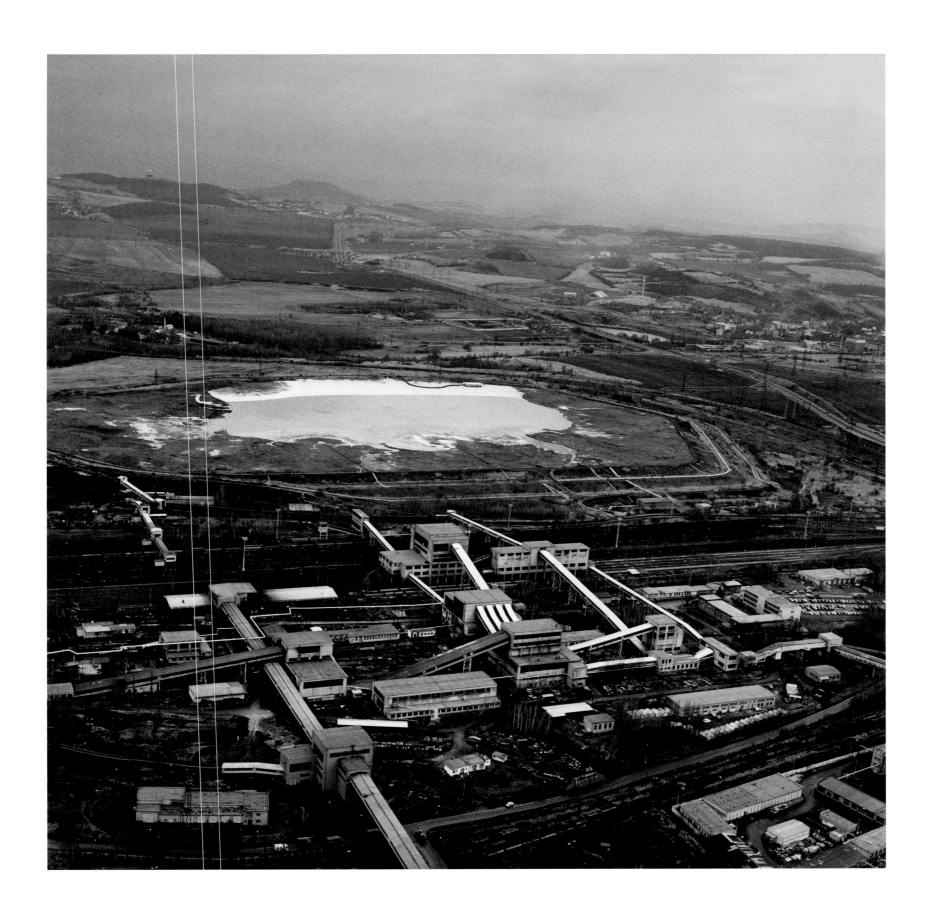

Effluent Holding Pond and Coal Works, Bilina, Czech Republic, 1994

77

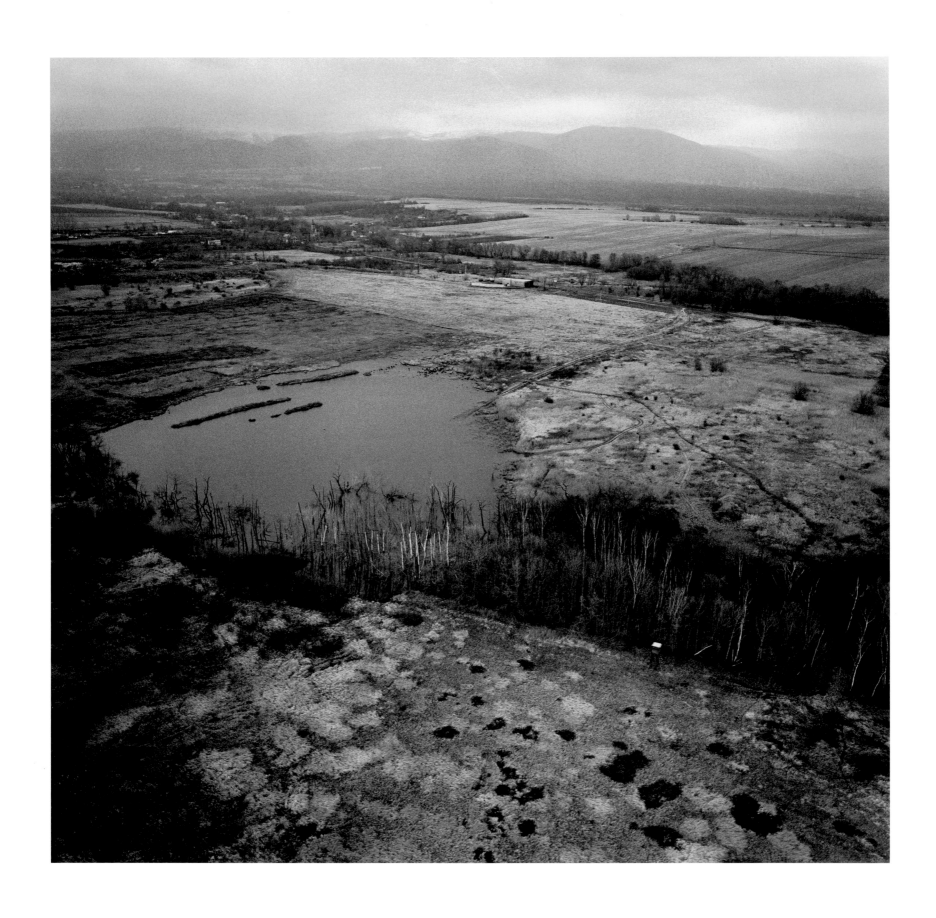

Air Exhaust Shaft and the Razed Village of Libkovce in a Poisoned Landscape, Bohemia, Czech Republic, 1992

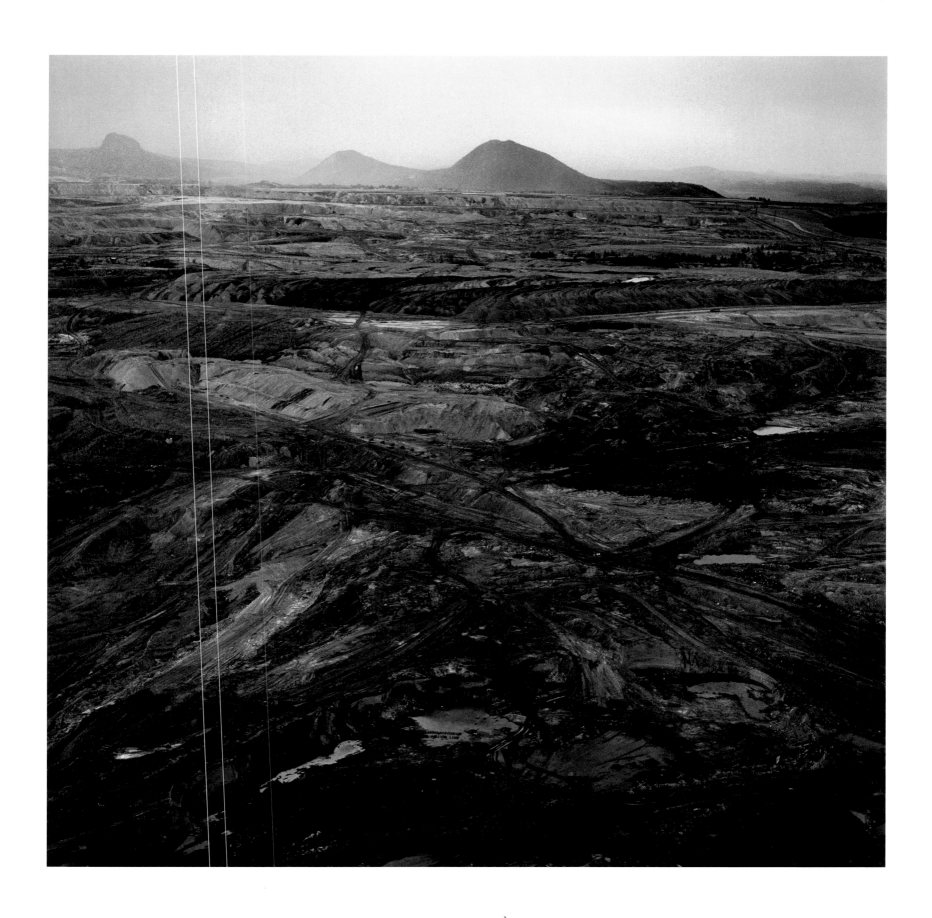

Strip Mine, Bohemia, Czech Republic, 1992

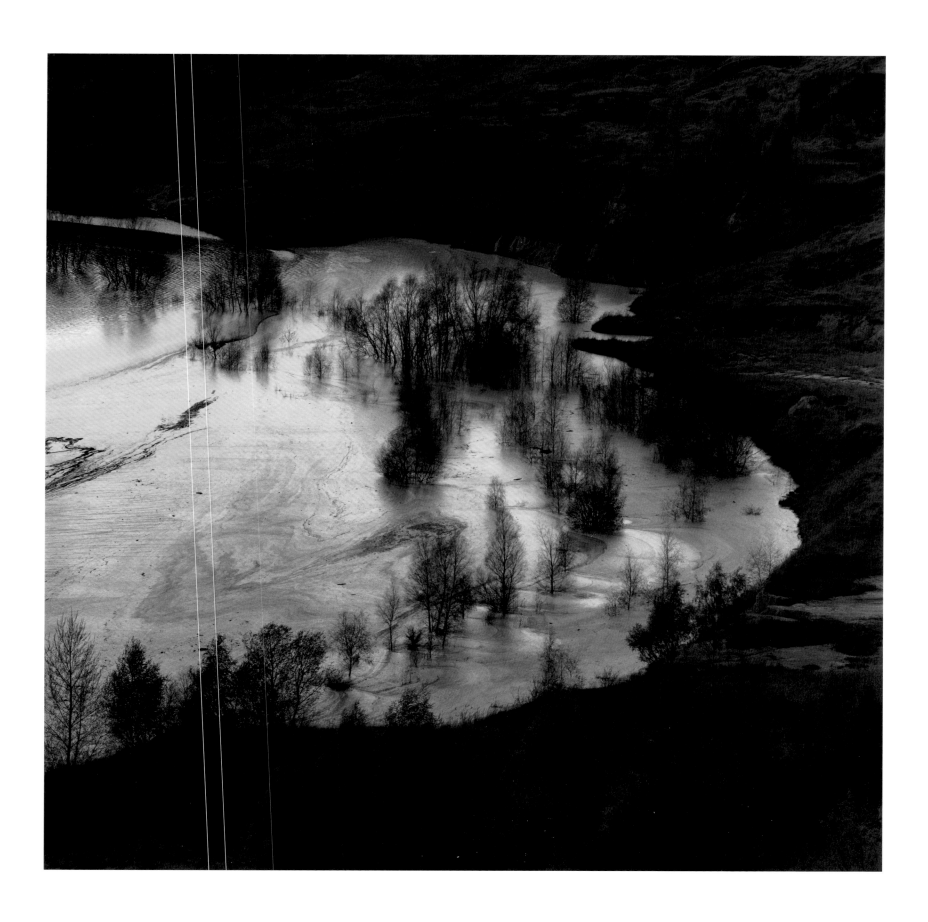

Effluent Holding Pond, Chemopetrol Mines, Bohemia, Czech Republic, 1992

KANSAS

WINTER 1995

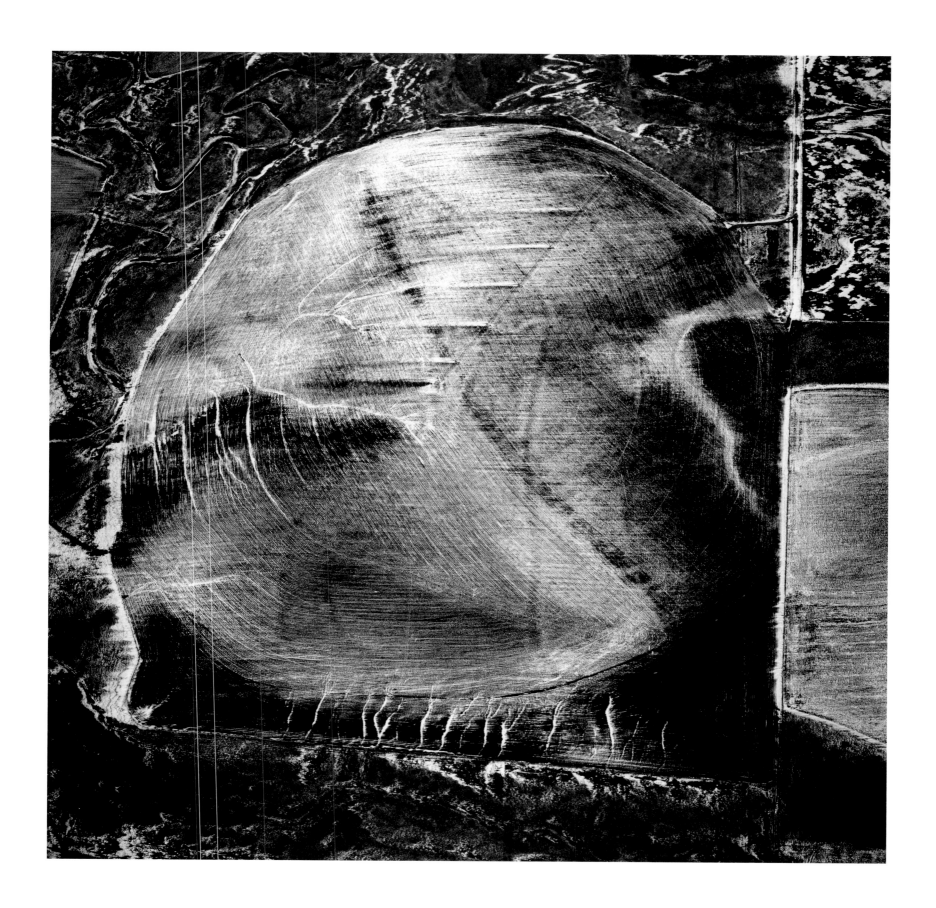

Pivot Agriculture near Garden City, Kansas, 1995

83

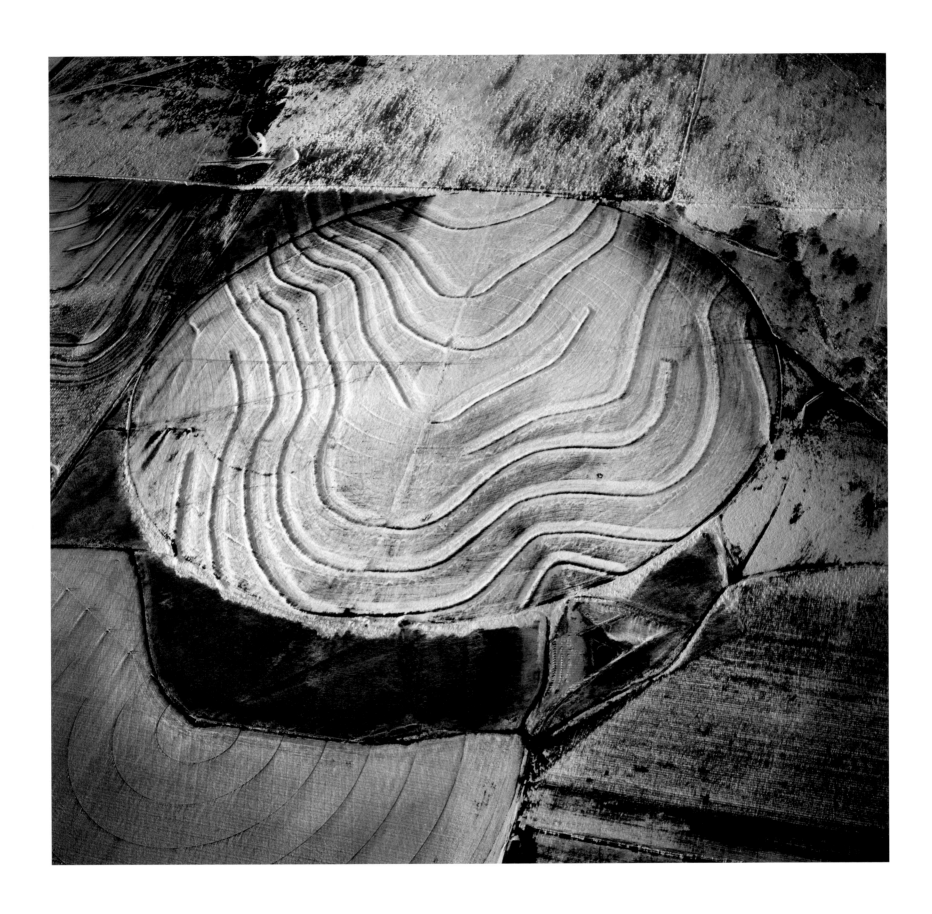

Agricultural Pivot in Winter near Garden City, Kansas, 1995

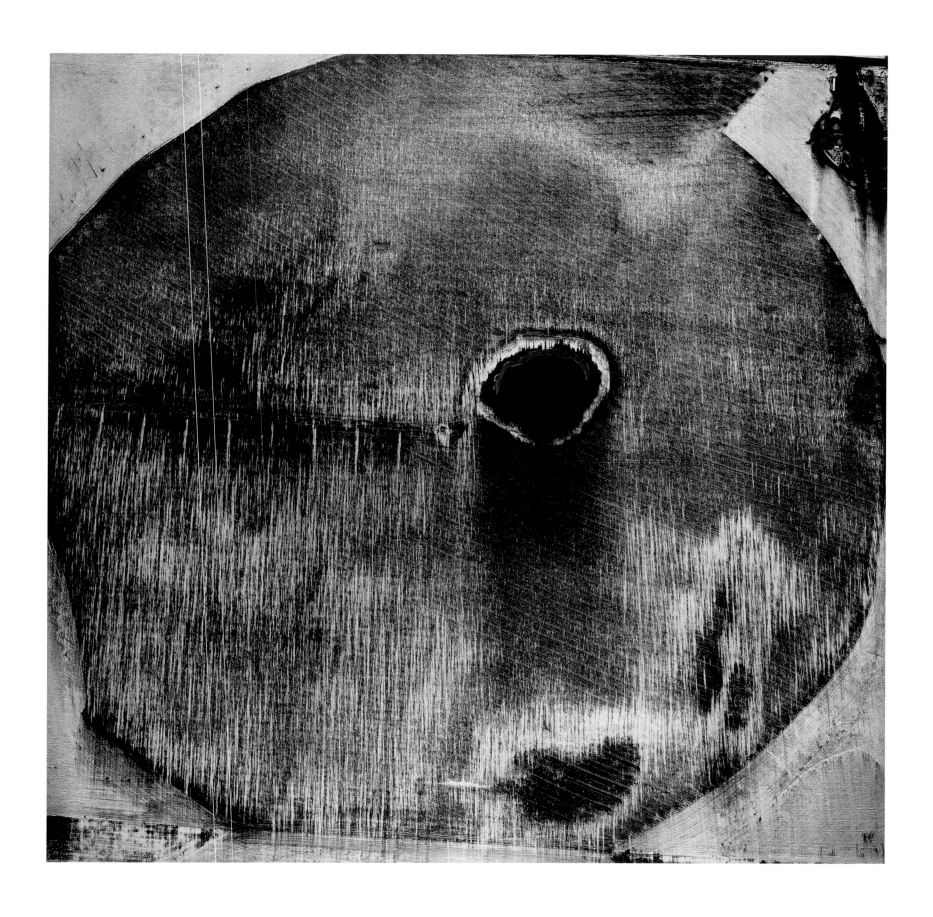

Snow over Pivot Agriculture near Liberal, Kansas, 1995

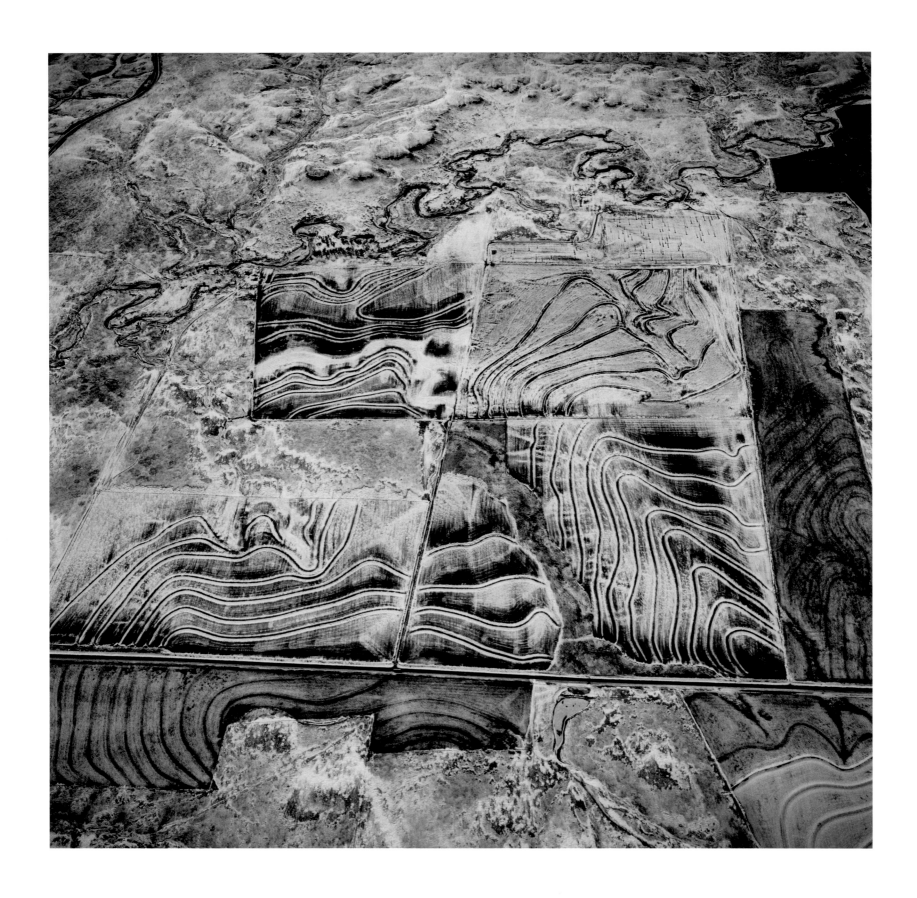

Snow over Dark Soil near Dodge City, Kansas, 1995

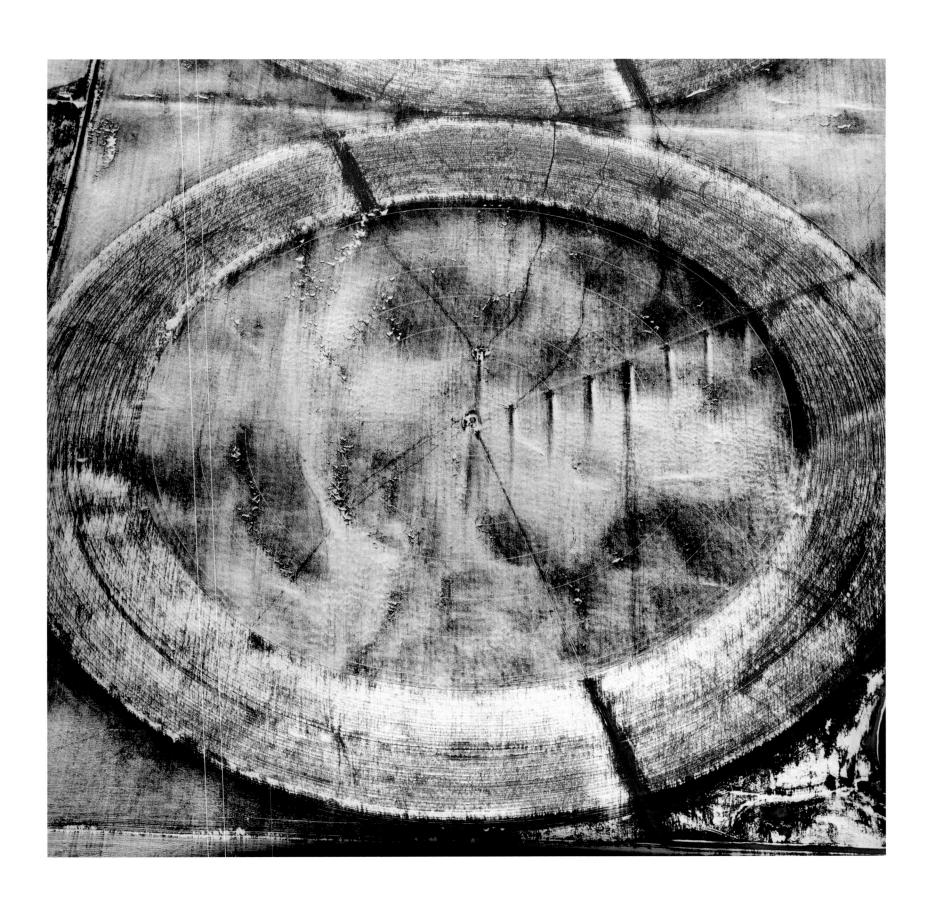

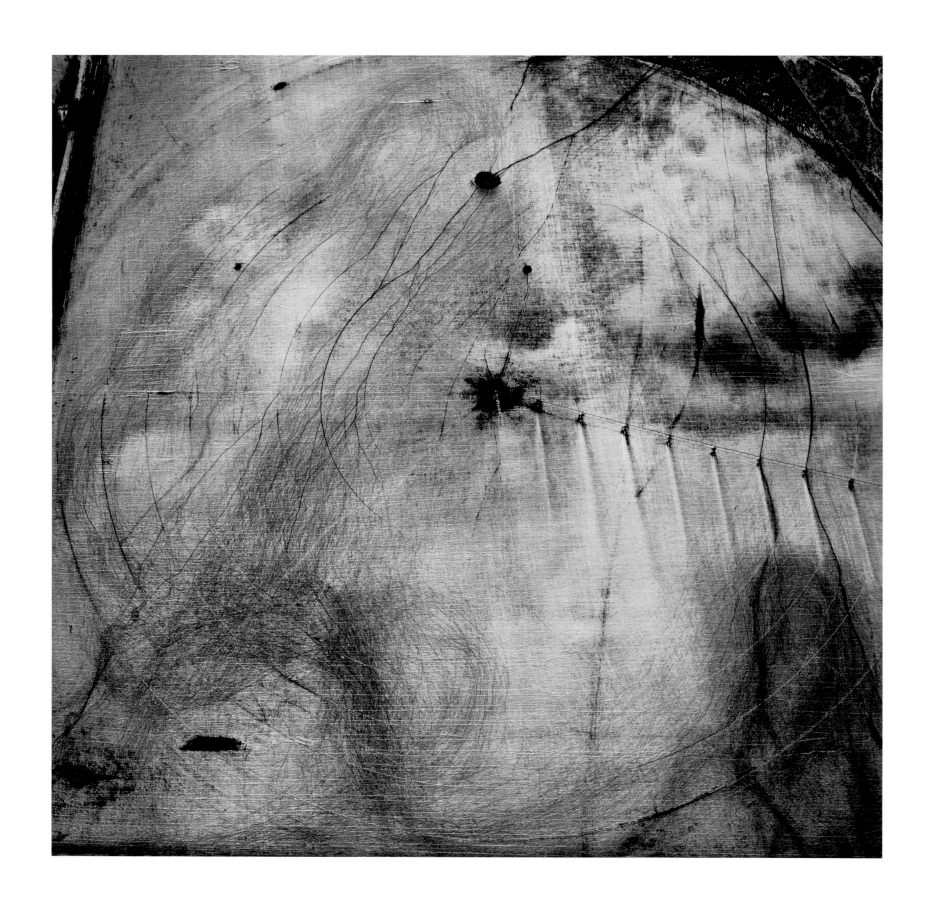

Tracks in Snow over an Agricultural Pivot near Liberal, Kansas, 1995

88

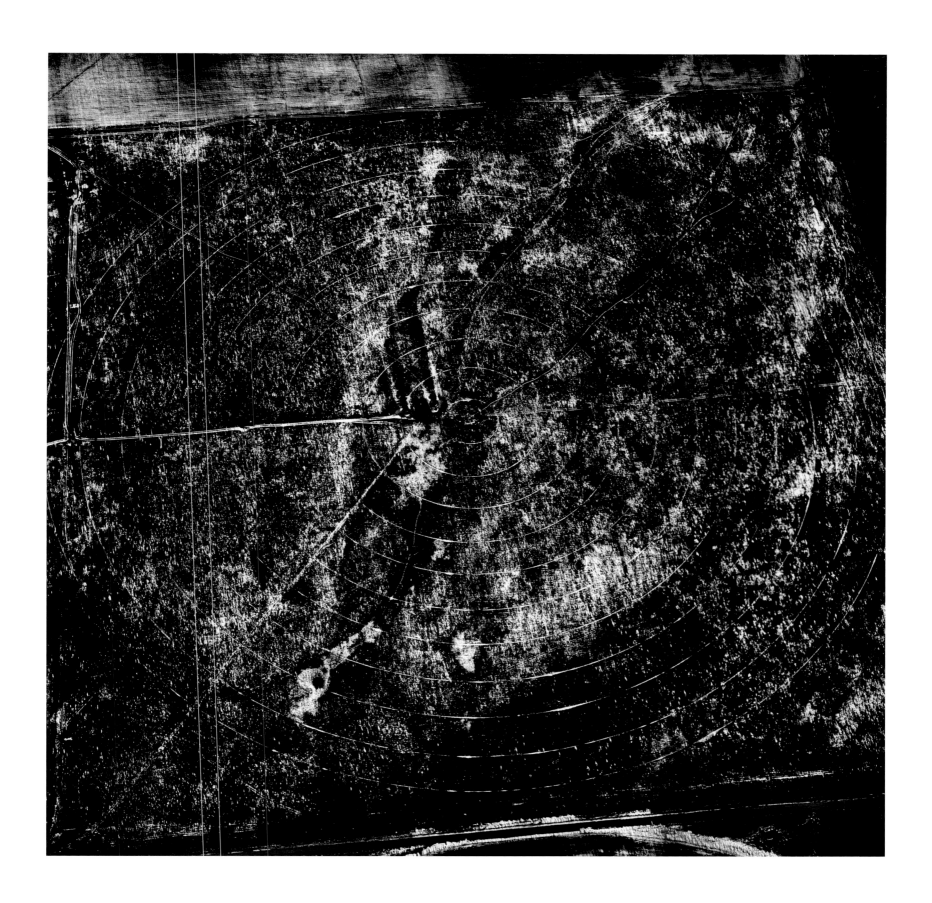

Winter Snow near Liberal, Kansas, 1995

89

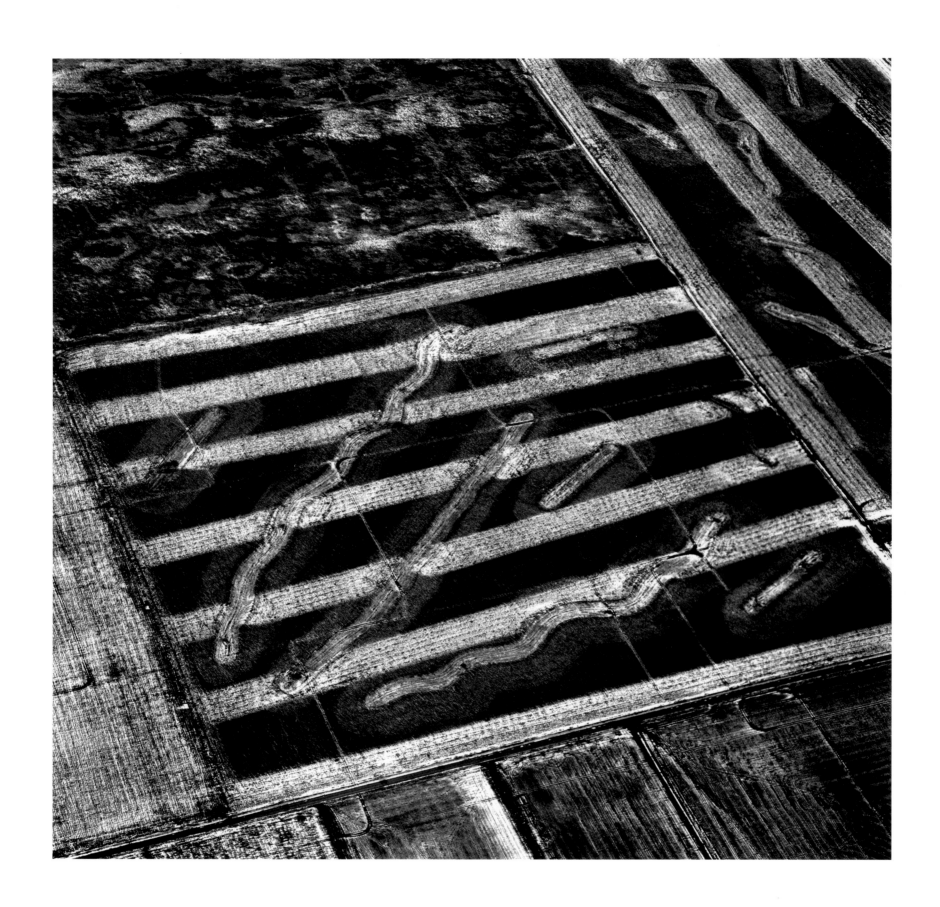

Winter Fields North of Dodge City, Kansas, 1995

90

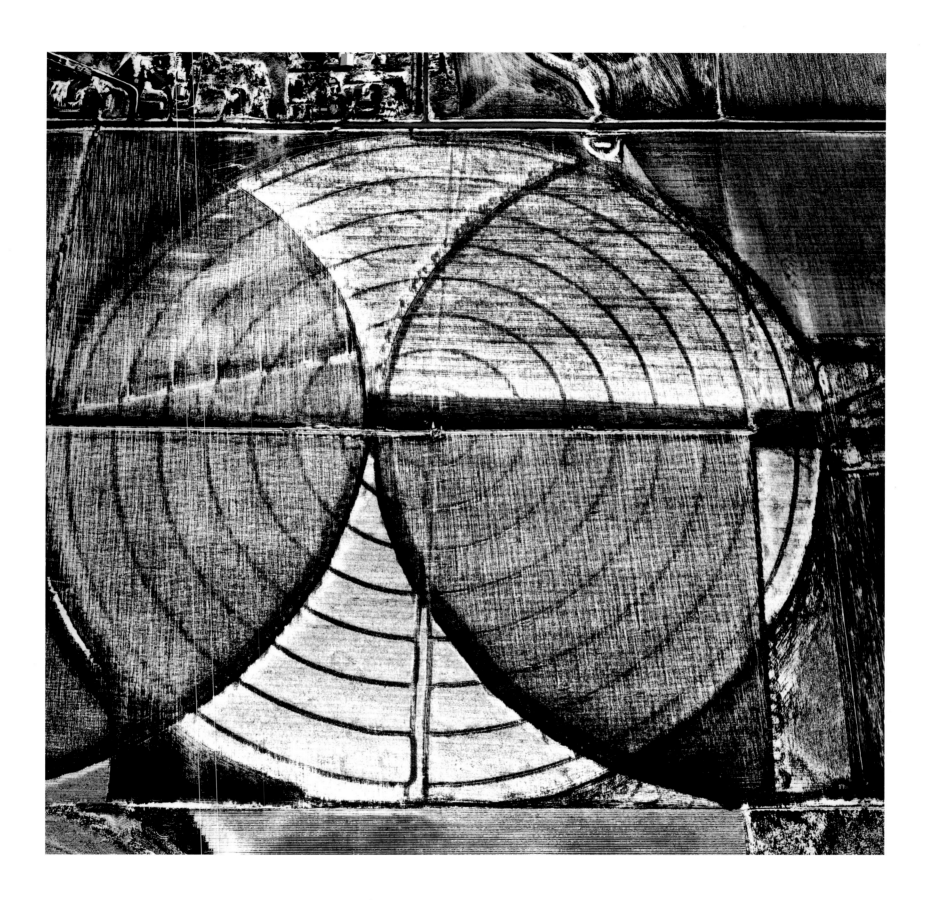

Multiarm Pivot Agriculture near Garden City, Kansas, 1995

91

NEVADA TEST SITE

1996–1997

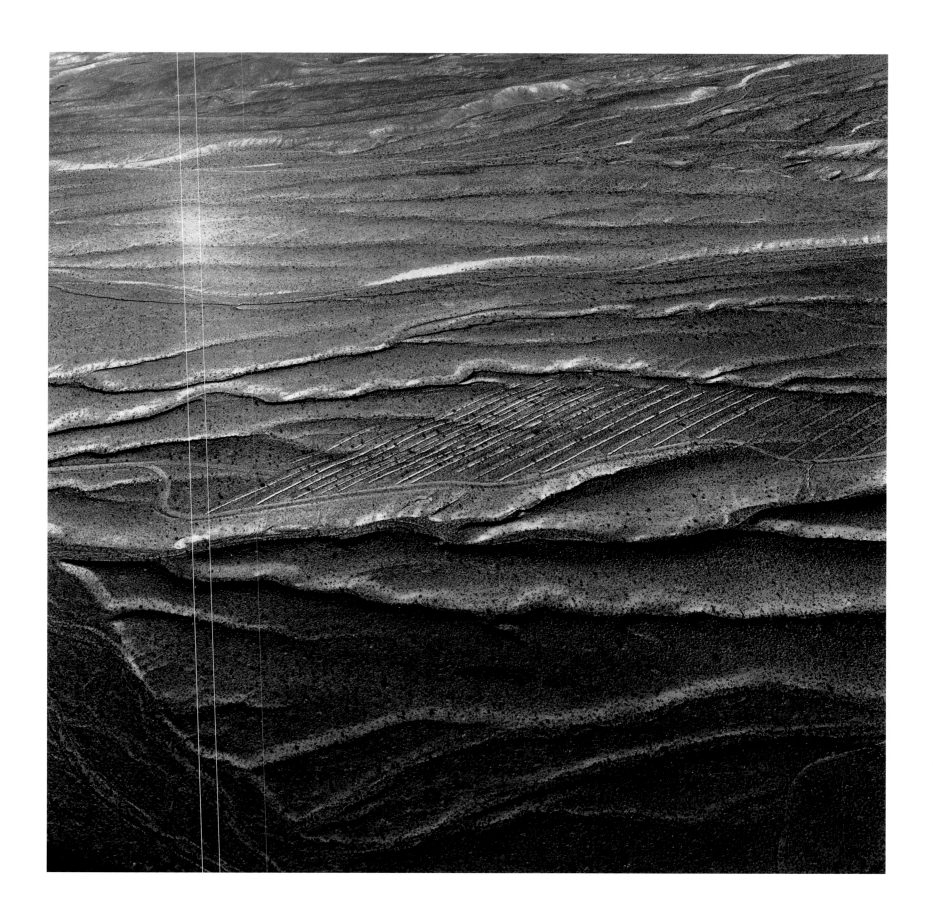

Troop Placement Trenches, Nevada Test Site, 1996

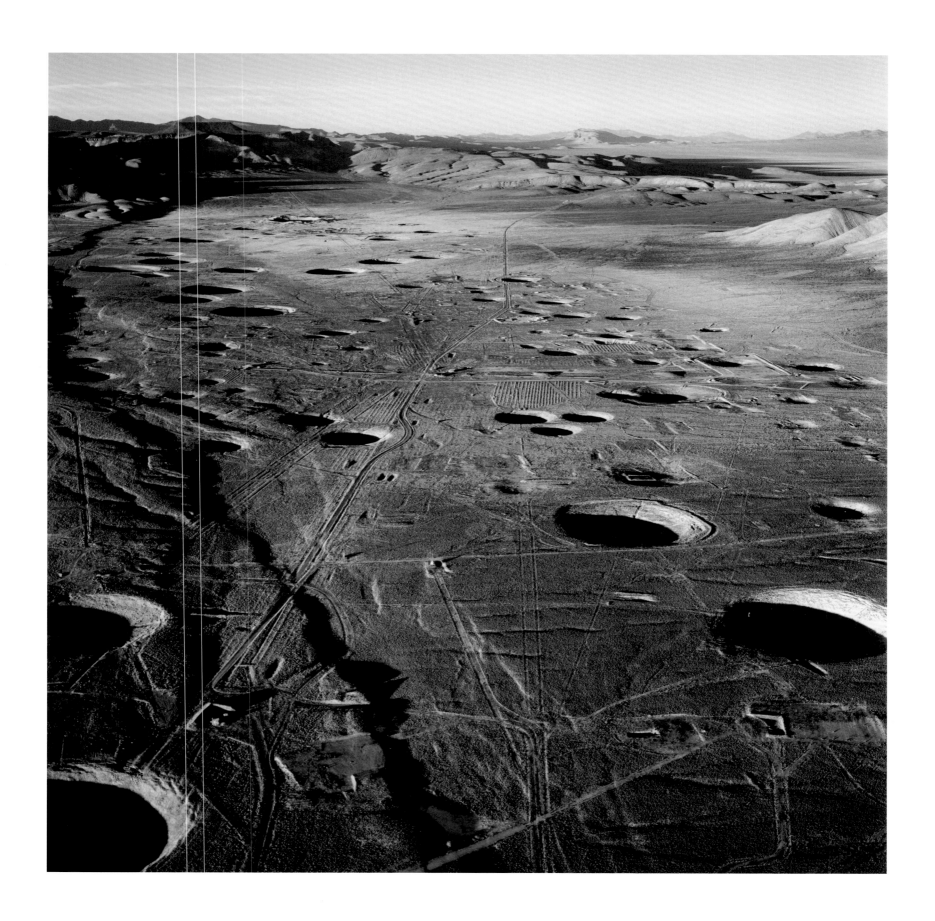

Subsidence Craters, Northern End of Yucca Flat, Nevada Test Site, 1996

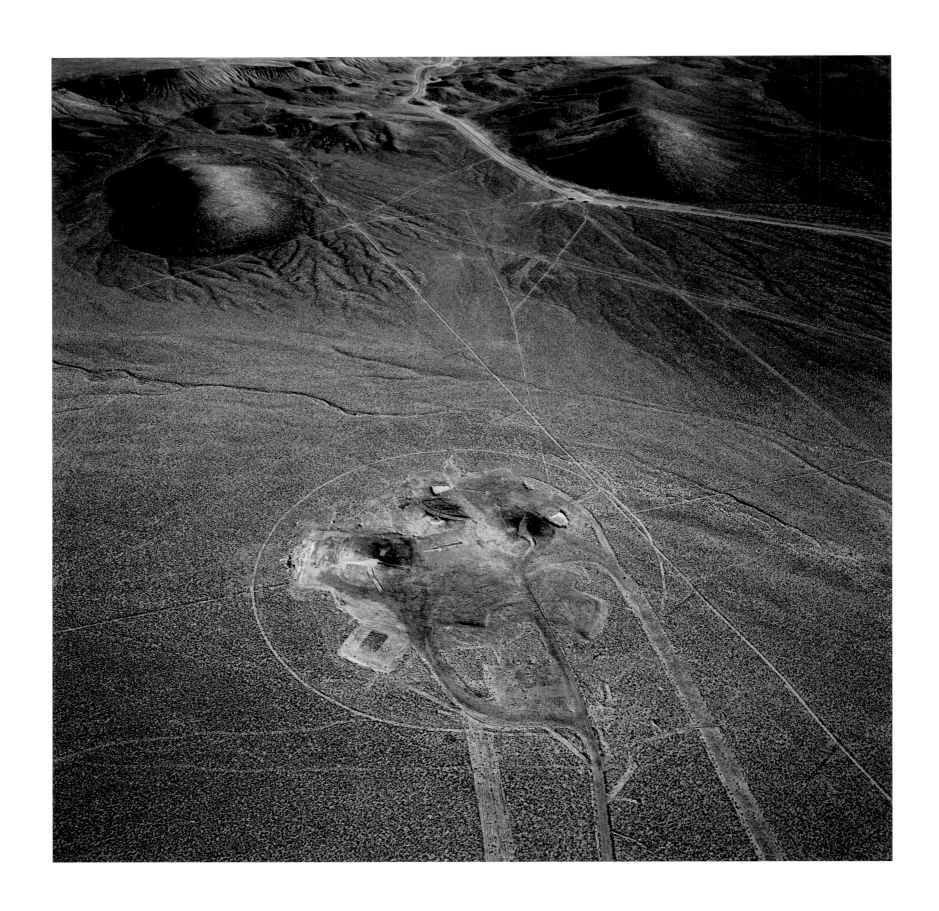

Three Subsidence Craters, Area 10, Nevada Test Site, 1996

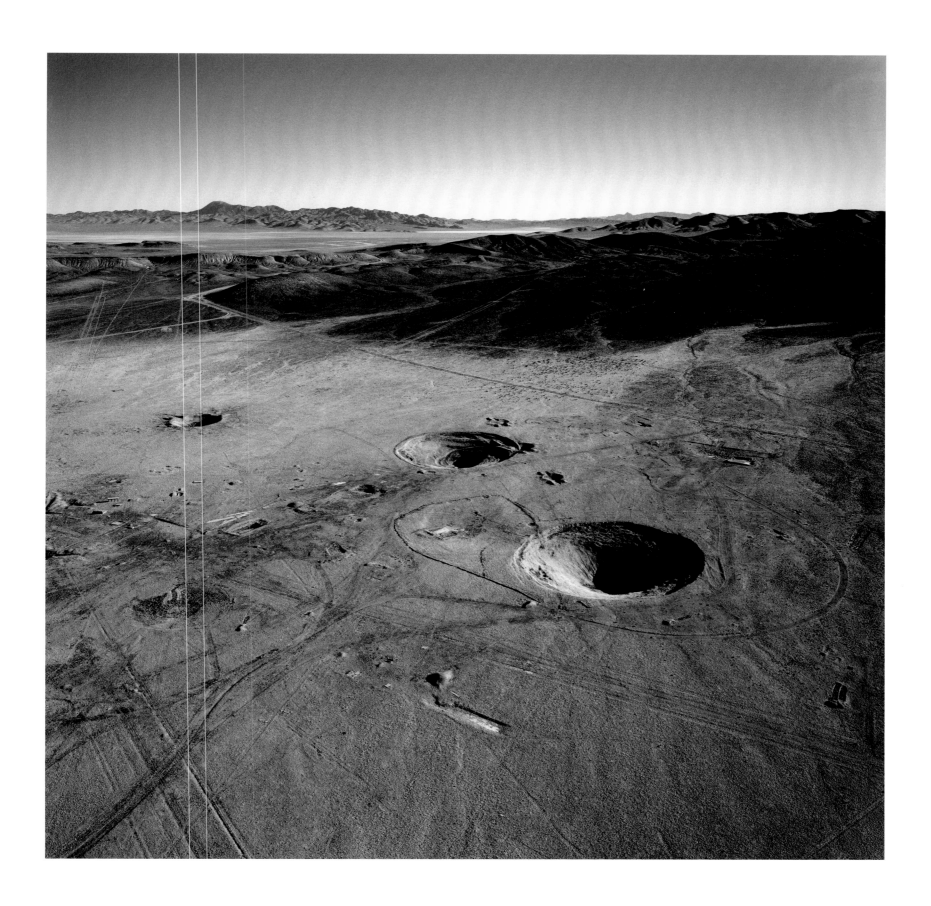

Area 10, Subsidence Craters from May 15, 1970, Underground Nuclear Tests, Nevada Test Site, 1996

97

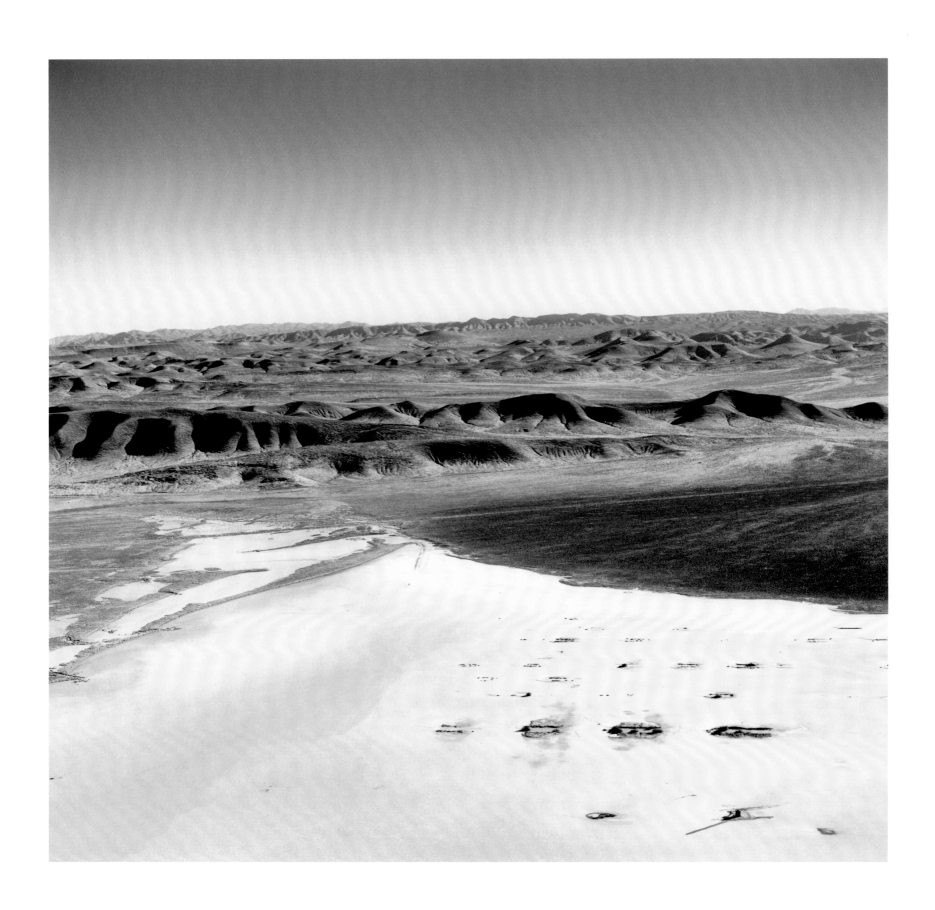

Yucca Lake and Ground Features, Looking East, Nevada Test Site, 1996

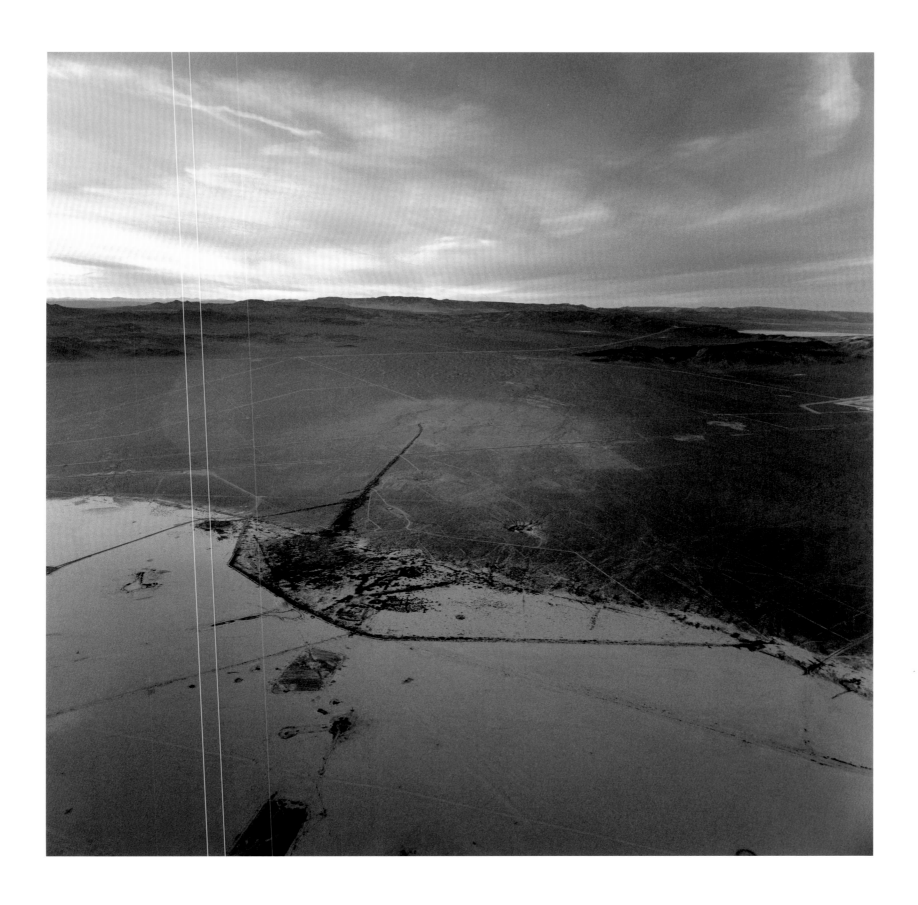

From Frenchman Flat, Looking North, Nevada Test Site, 1997

99

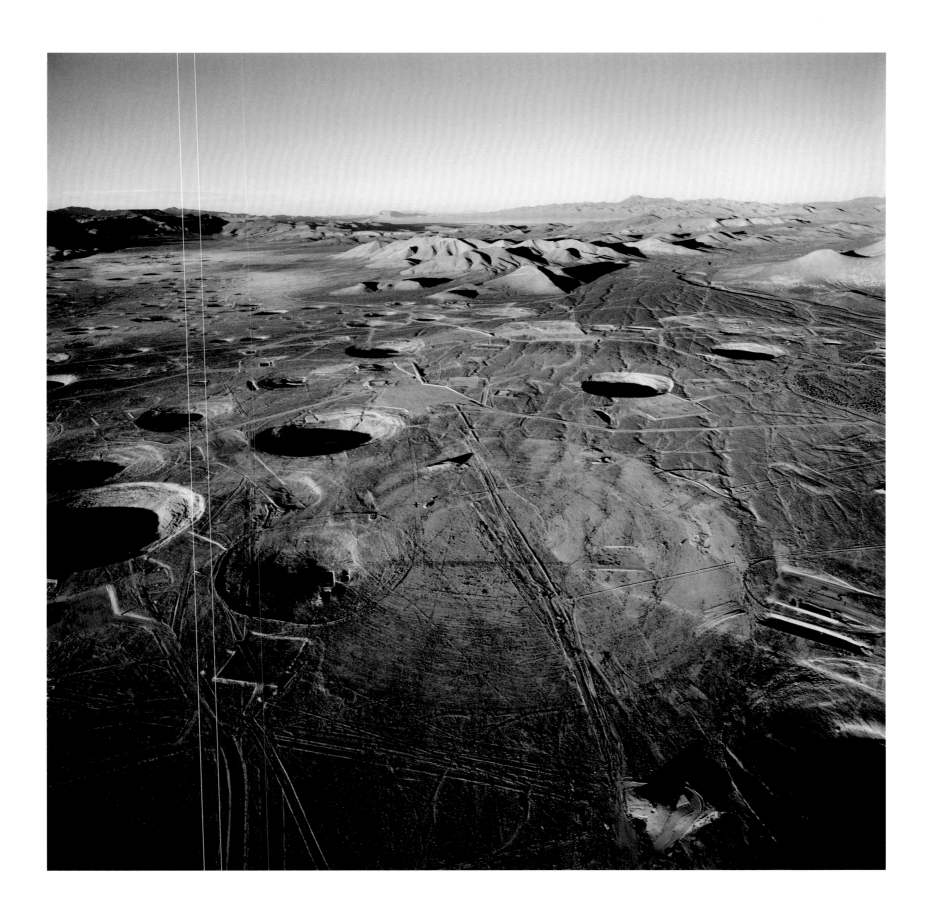

Yucca Flat, Area 9, Looking Northeast, Nevada Test Site, 1996

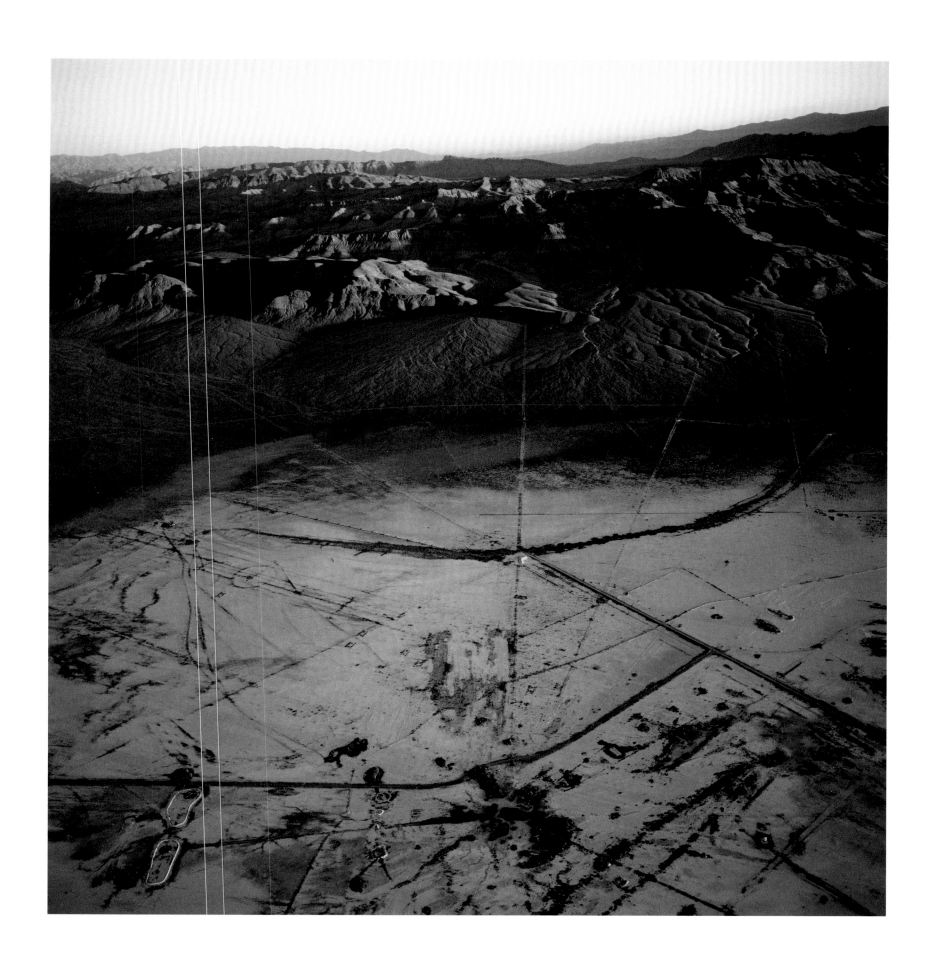

Common Ground Zero on Frenchman Flat, Nevada Test Site, 1996

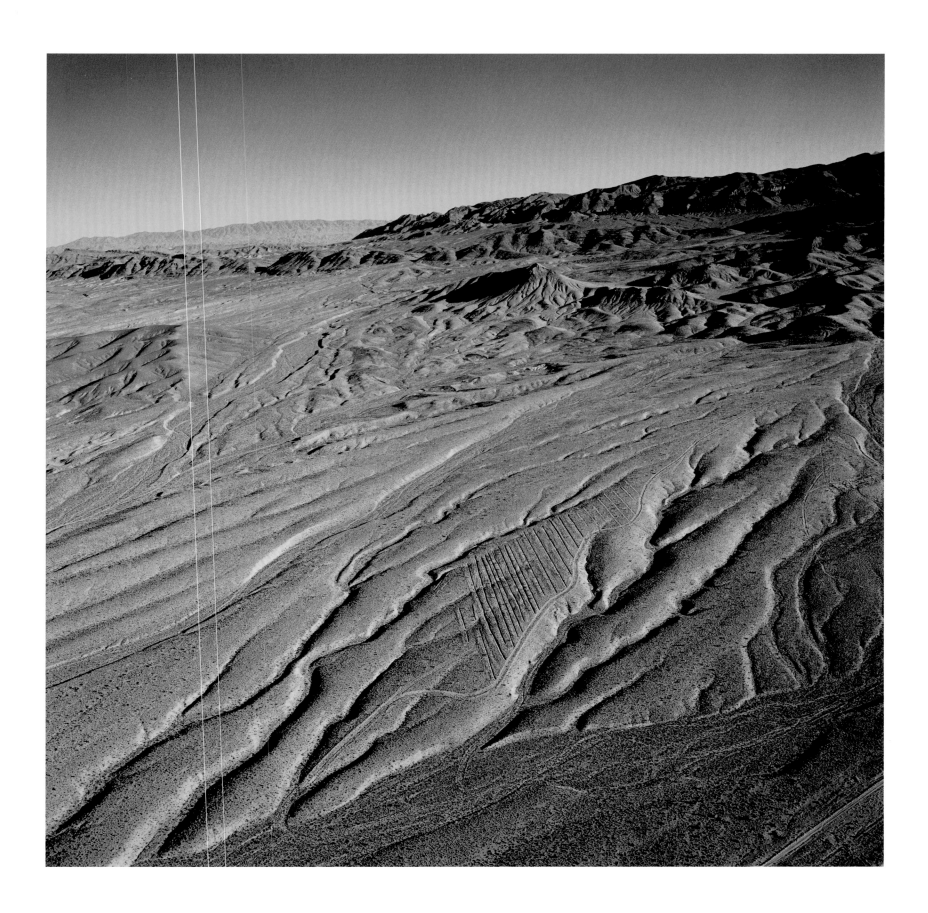

Troop Placement Trenches, Nevada Test Site, 1996

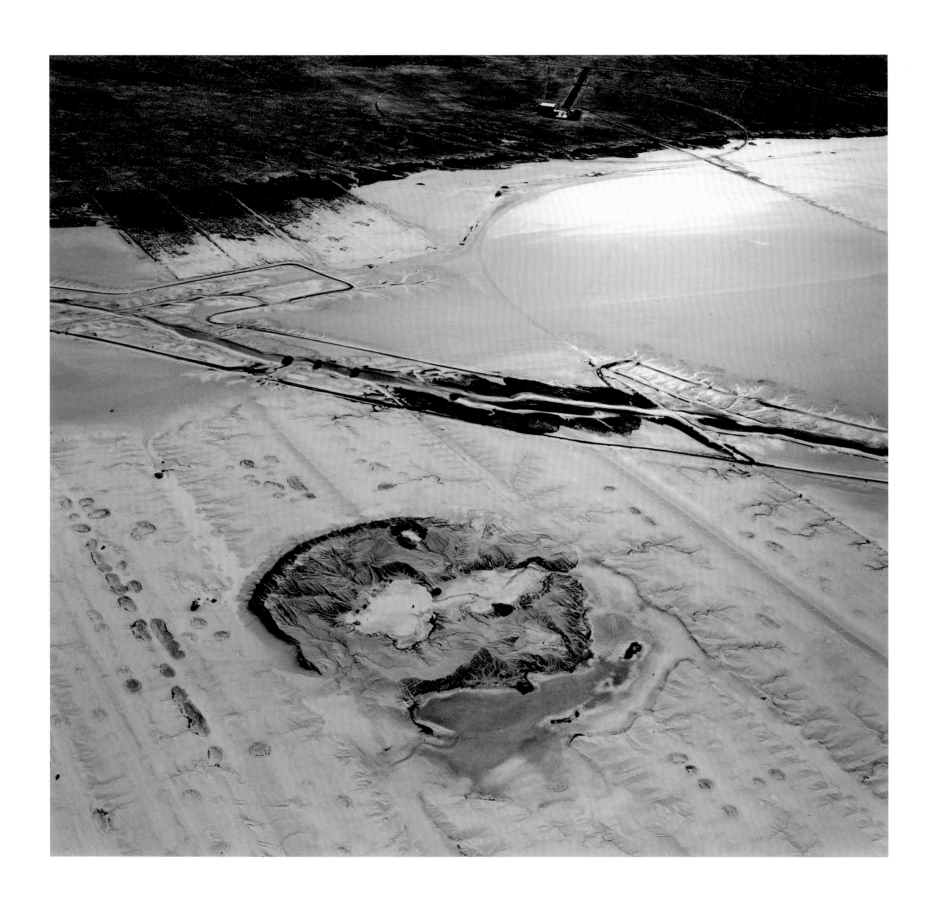

Geological Fault and Other Features, Yucca Lake, Area 11, Nevada Test Site, 1996

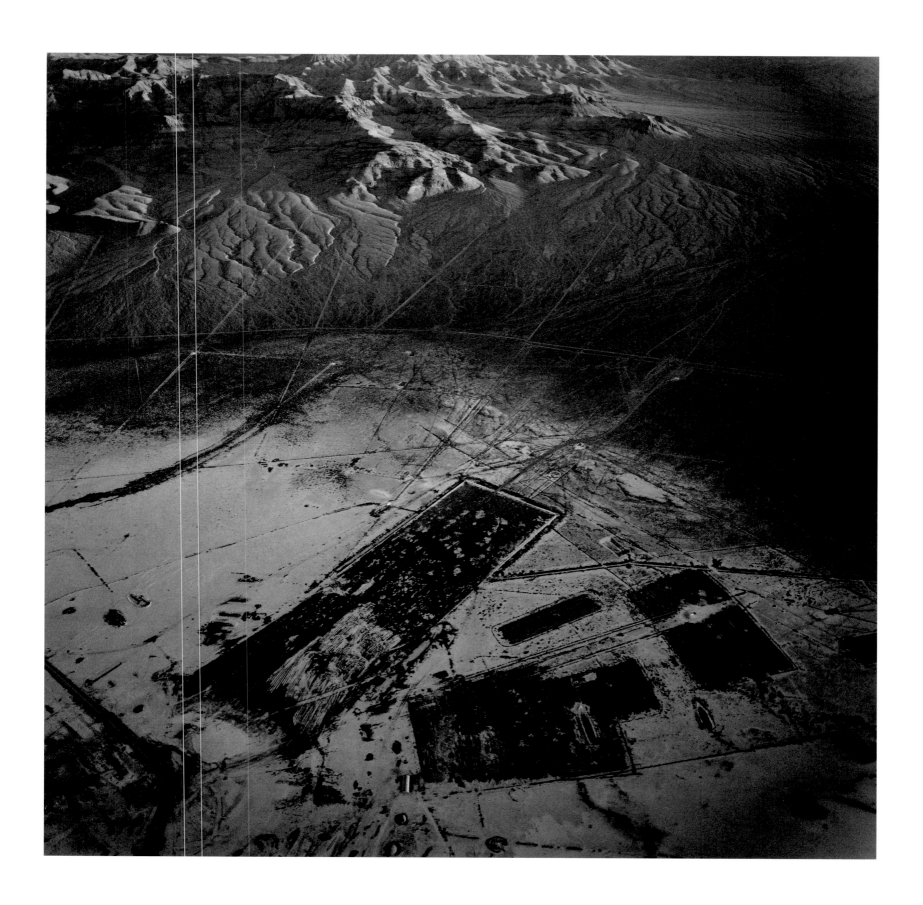

Line of Sight Markings and Areas Cleared of Radioactive Soils, Frenchman Flat, Nevada Test Site, 1996

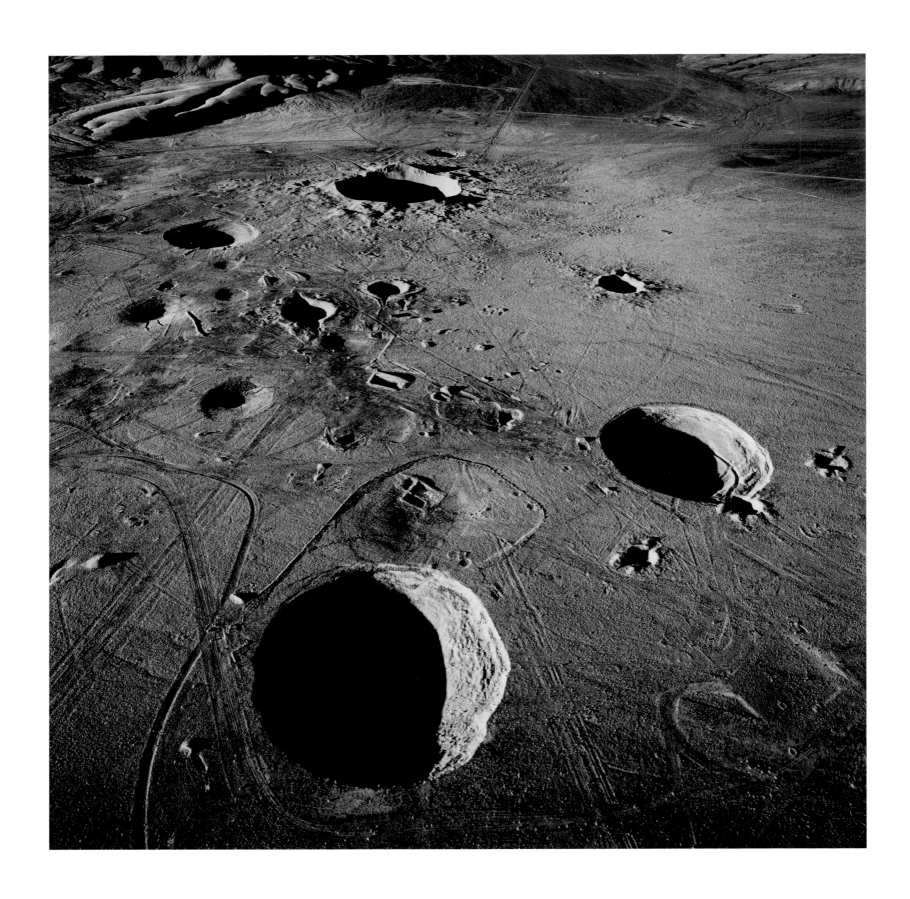

Nuclear Test Craters on Yucca Flat, Area 10, Nevada Test Site, 1996

108

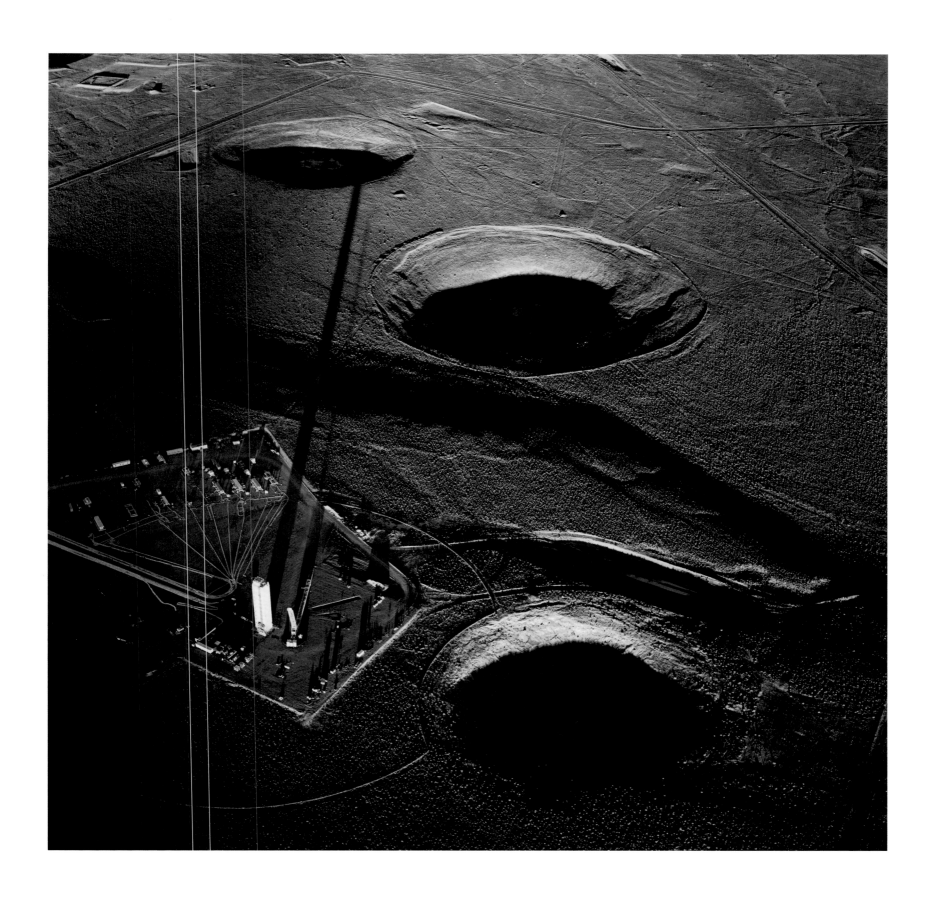

Diagnostic Array for the US/UK Test, Icecap, Suspended 1992, Nevada Test Site, 1996

109

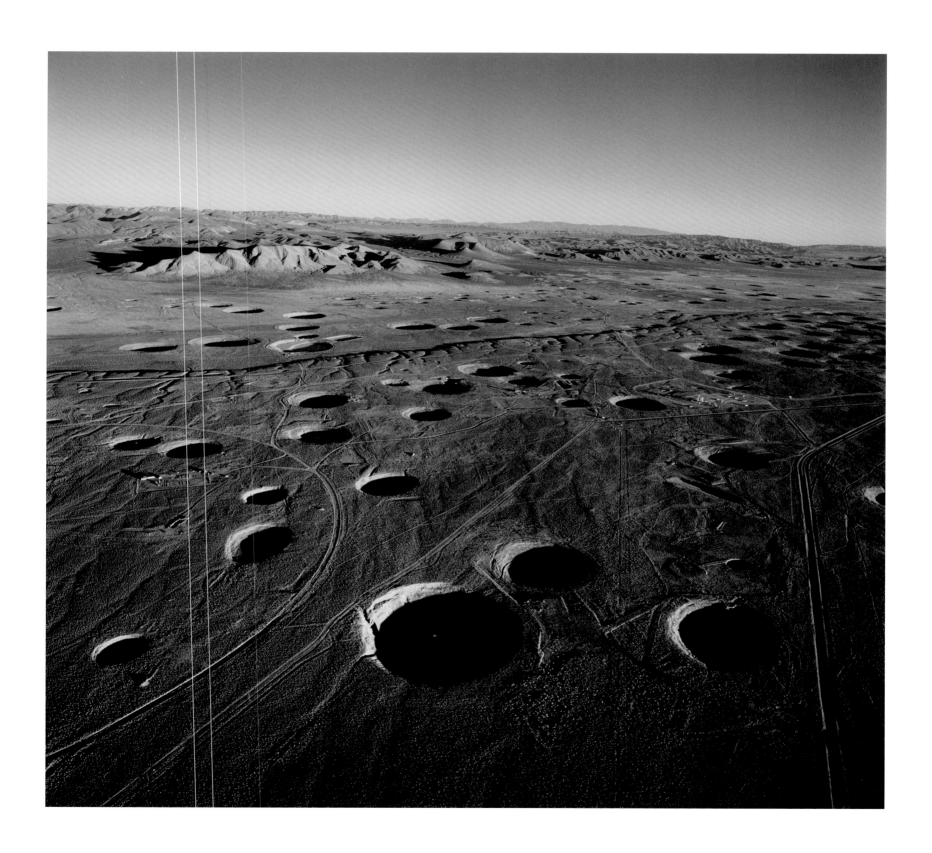

Subsidence Craters, Looking East from Area 8, Nevada Test Site, 1996

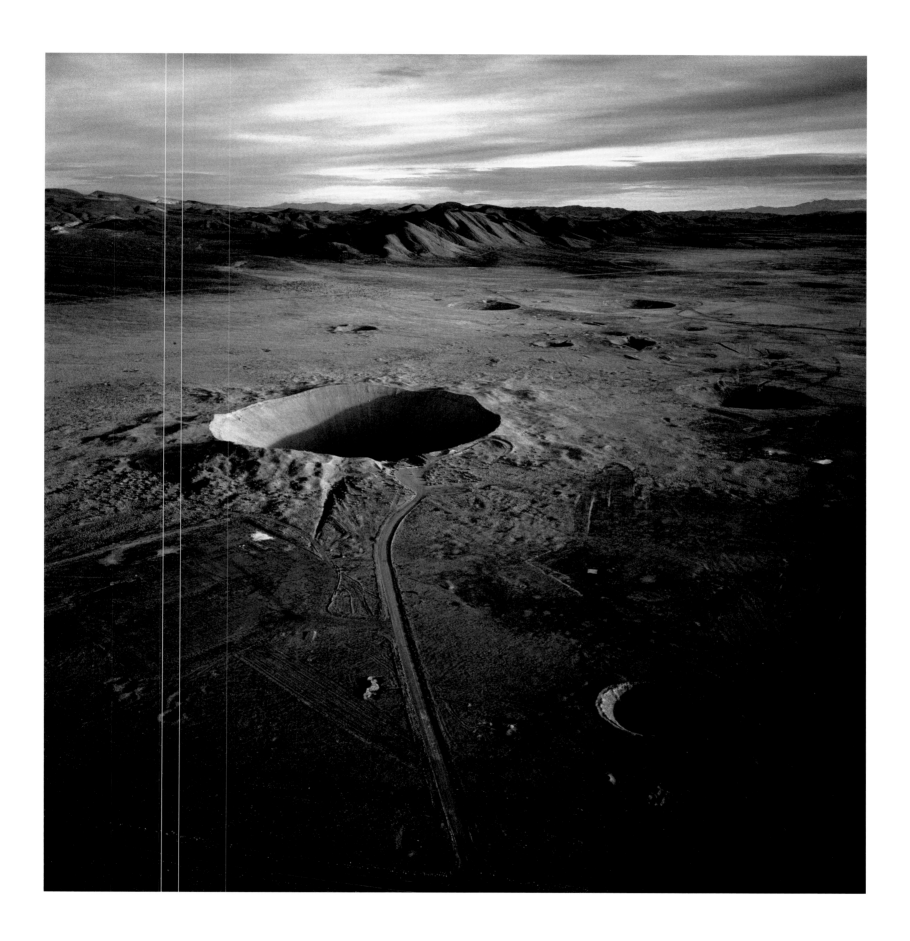

Sedan Crater, Area 10, Northern End of Yucca Flat Looking South, Nevada Test Site, 1996

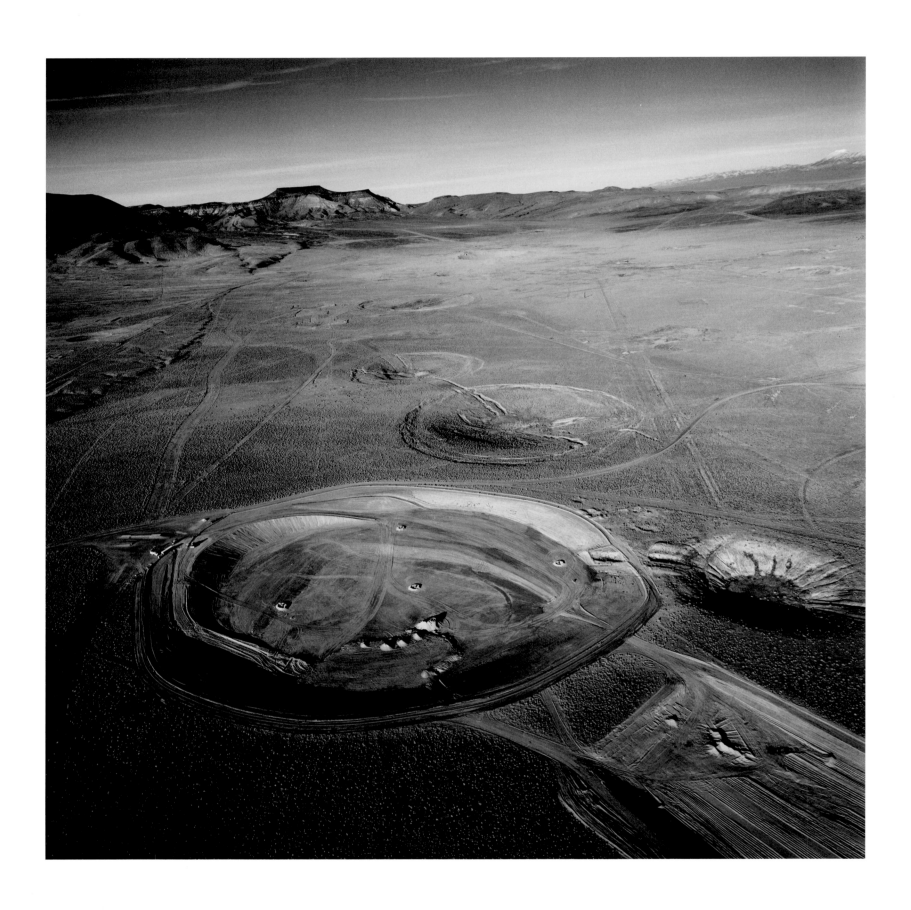

Subsidence Crater Converted for Waste Storage and Burial, Nevada Test Site, 1997

114

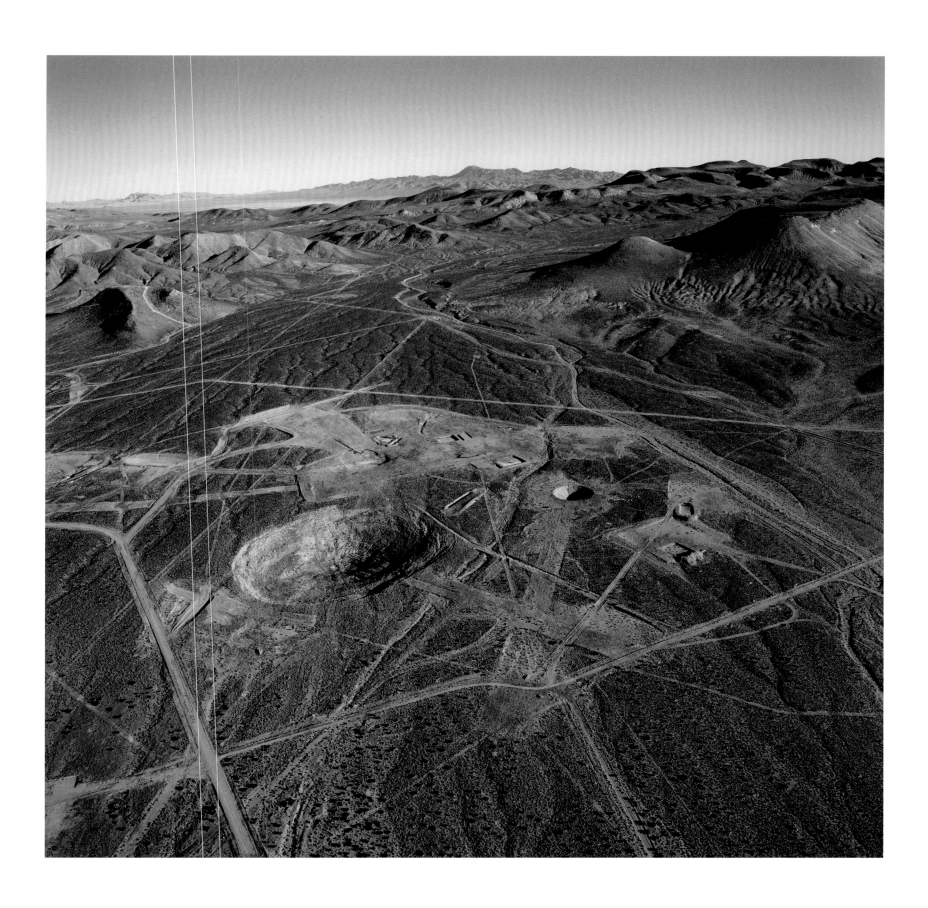

Yucca Flat, on the East Side of Area 7, Nevada Test Site, 1996

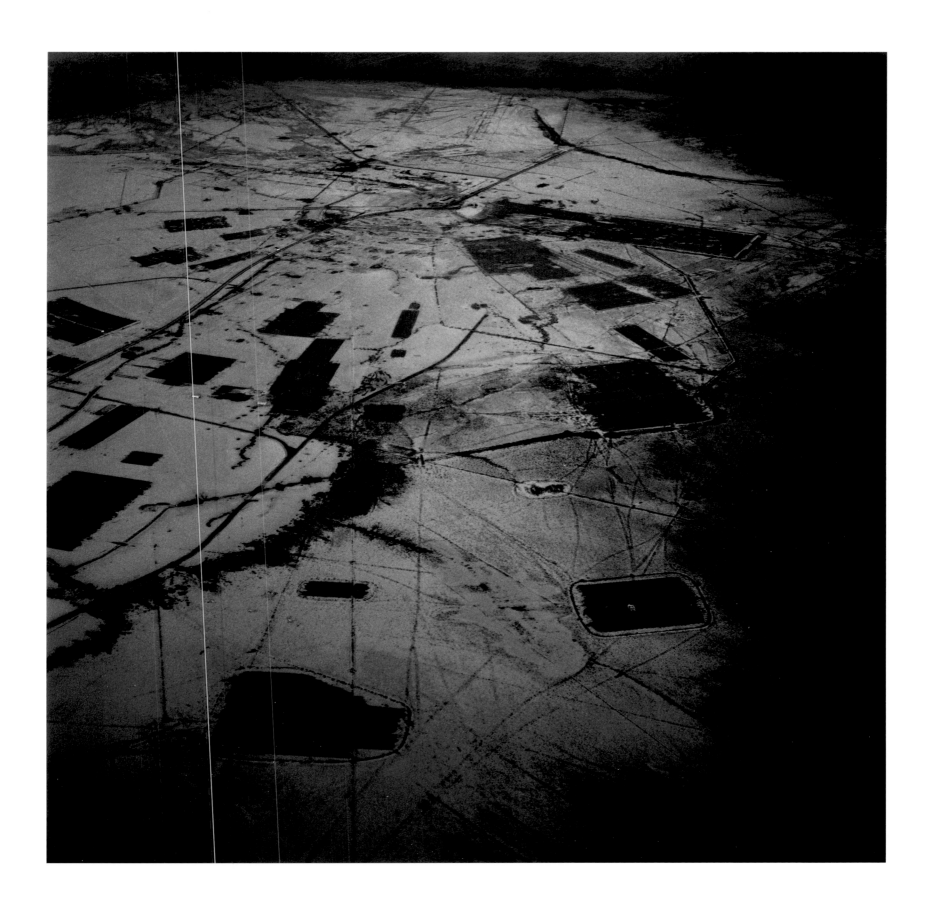

Frenchman Flat, Nevada Test Site, 1996

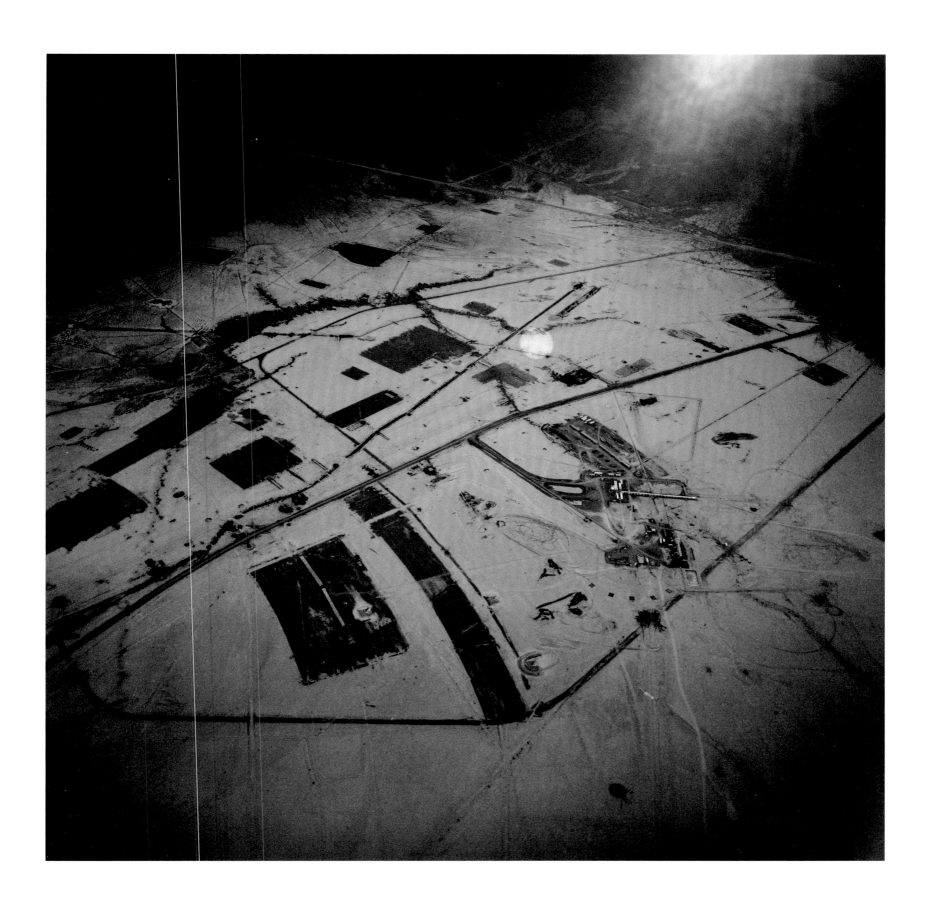

Ground Features, Frenchman Flat, Nevada Test Site, 1997

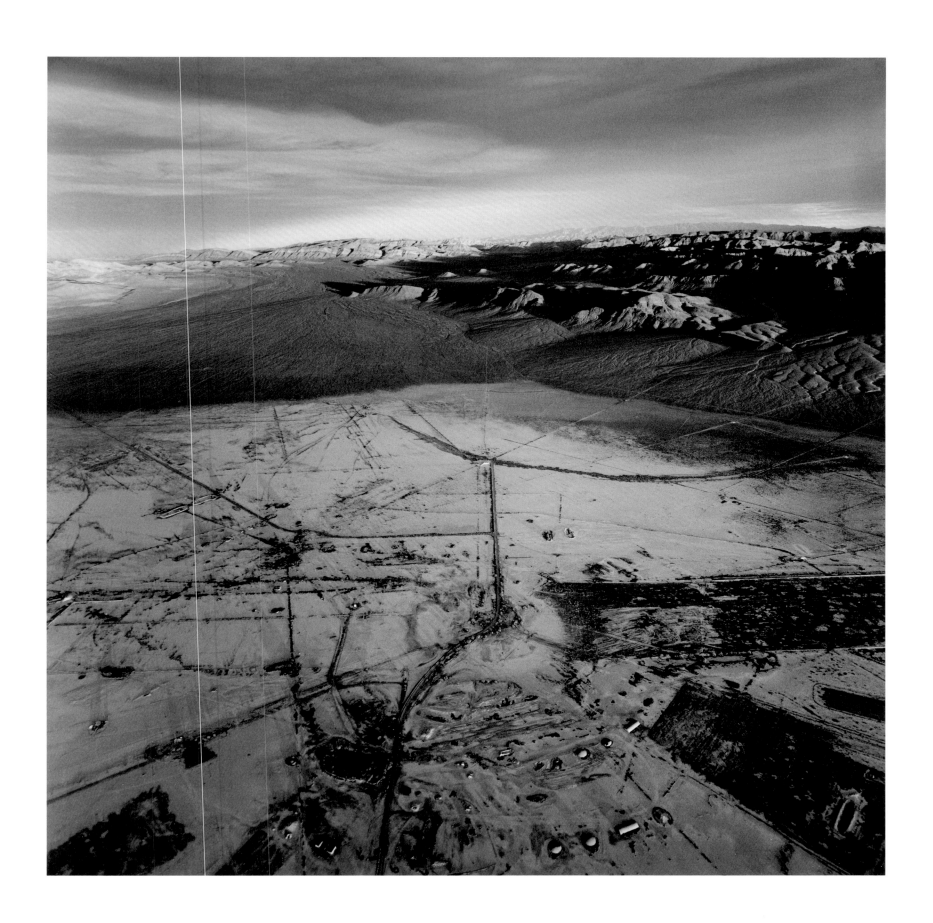

Ground Zero and Lines of Sight for Aboveground Tests, Frenchman Flat, Nevada Test Site, 1997

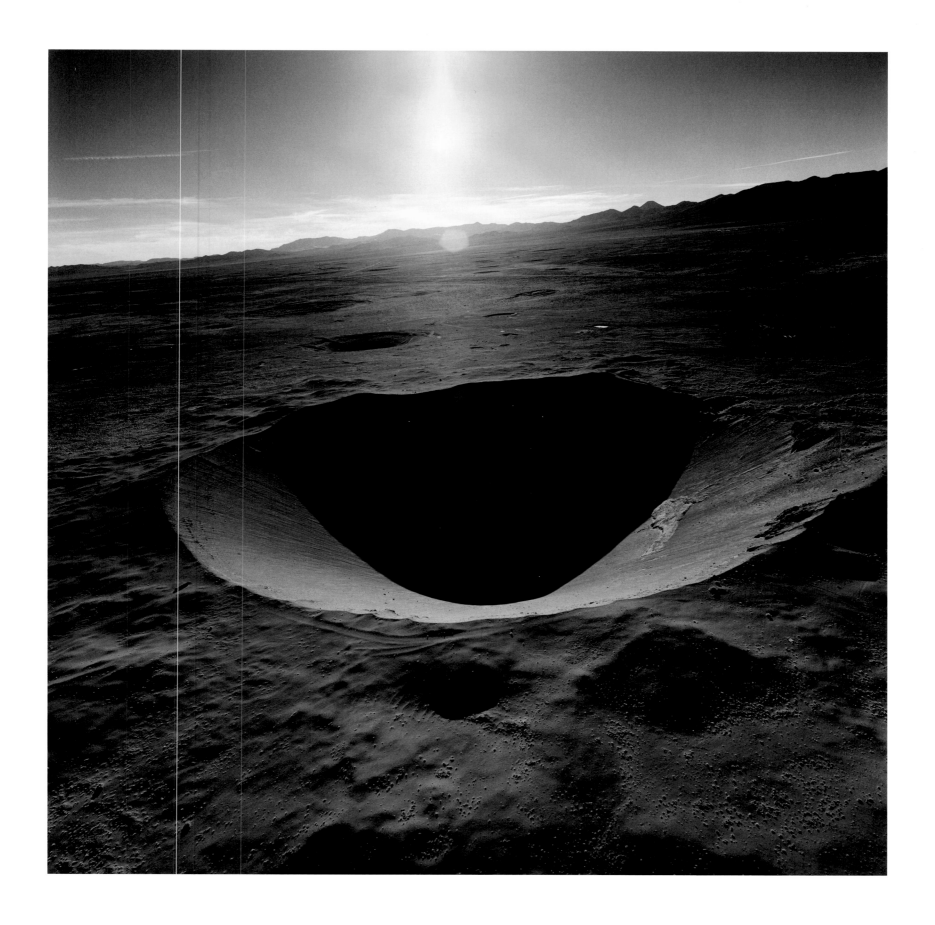

Sedan Crater, Northern End of Yucca Flat, Nevada Test Site, 1996

THE EARTH STARES BACK

TERRY TEMPEST WILLIAMS

It is a windy day in the Great Basin. I wait with Emmet Gowin to board a small plane that will fly us over the West Desert in Utah. I am nervous. He is not. Our pilot, an army veteran, makes last-minute checks and preparations. I put on wrist patches to help with motion sickness should the air become turbulent. Emmet is loading his camera with film.

I think of the conversation we had earlier out on Buffalo Point on Antelope Island where the silver waves of Great Salt Lake were breaking against boulders. Meadowlarks sang in the grasslands, flashes of joy in the desert. We spoke of aesthetics, how it is what we know in our bodies, never our minds, that propels us into the creative trance, how what we know is what we live, gleaned through the integrity of our own experience. He told me the imagination is always realized through love.

What I know about Emmet Gowin is that he loves the land. From his native Virginia to the mountain wildlands of the Wind River Range in Wyoming to the redrock canyons of the American Southwest, he sees the Earth as beloved; that is his word, not mine. *Beloved.* I recall a photograph he gave to Brooke and me, as a gift. It is an image of his wife, Edith, in profile, crouched on a log, her feet perfectly balanced one in front of the other. The interior space of her body is made up of the vines and tendrils of a vegetal world. This is more than merely the double exposure of a photograph. It is the truth of an artist who sees the body of his beloved as one with the Earth. No separation.

In seconds, we are airborne flying over Dugway, home to anthrax production, the testing of bombs, and the storage of conventional munitions. This is the secret territory of the Dugway Proving Grounds. The pilot's screen registers "restricted area." We bank left.

The desert skin reveals shades of sage blue and the chartreuse of foxtails. Barracks and bunkers below appear as white concrete tombs, the abandoned coffins that hold wet eye bombs produced decades ago.

Up ahead, pools of toxic residue glisten in noonday light, reminiscent of the sheen found in abalone shells. It is beautiful. The pilot, a former helicopter gunner in Viet Nam, tells us these are the shines of mining chemicals that polluted this village so badly that the government had to remove the people who lived here.

"That's a ghost town you are looking at now," he says. "Nothing grows around here."

Bomb craters are evident. Emmet delights in the strange juxtaposition of anthills, convex not concave circles created by nature alongside those created by the military. We learn this is the area where bombs were destroyed as part of the SALT II agreement. Soviet witnesses have stood shoulder to shoulder with American armed forces personnel and watched their demise.

"These craters are now good watering holes for wildlife," the pilot tells us. "Deer, jackrabbits, and pronghorn love them."

The plane makes an abrupt turn. My stomach drops and I press the white buttons on my wrist bands, praying

they send a direct message to my stomach. We are now flying sideways, our left wing perpendicular to the ground. Emmet is halfway out of the plane making pictures. I wonder what he is seeing that I am not.

Exposure: Disclosure. Revelation. Uncovering, unmasking, unveiling, baring, laying open; broadcast, report, communication; divulgement, leak, admission, confession, avowal.

Emmet Gowin has made exposures of the Earth, a changed Earth, an Earth we may not recognize because our eyes have been locked on the horizon. We look ahead, always ahead, searching for what is to come, where we will go, rarely turning around to see where we have been or stopping long enough to witness where we stand now. We live at eye level, which is its own conceit, a point of view that supports what we believe to be true—that the Earth is here simply to support us. We survey the land around us and dream of ways it can serve us.

We believe that the transformation of the Earth is our work. We are ants in human form, ground-movers, mound-builders, diggers, and opportunists. We are a species in love with construction, destruction. We drink oil and devour the land. We are never satisfied. The greater we perceive the treasure, be it gold, silver, or uranium, the greater our desire becomes in unleashing our muscle and ingenuity in how to get it, use it, and profit by it. This is the art and economics of desire that employs the tools of excavation and extraction. For millennia, we have manipulated the land to fulfill our needs.

Emmet Gowin captures the handiwork of our species from an aerial point of view. He shows us what the birds see, what the gods know from the vantage point of flight. He is creating art in motion from a plane with his camera in hand. He is a visual philosopher, a lyrical photographer, a poet in motion with his eye focused on Earth.

Each photograph becomes a returned gaze. Emmet stares at the Earth and the Earth stares back. Our footprint upon the land is framed.

Still life.

Look again. Do we view each photograph as a work of art and simply enjoy the pleasure of form and texture as its own aesthetic statement? Earth becomes the artist's canvas. Or do we see this portfolio of images as a haunting documentation of place, how we have altered the land with our industrial and technological might from agriculture to recreation to national security? Art becomes revelation, "the quickened expansion of experience." What has remained hidden is exposed. What is largely unseen, therefore unknown, is revealed. What we thought benign becomes malignant. Our perception of the world shifts. It is clear we have altered the Earth, but has the Earth altered us? How can we begin to contemplate where our rights as human beings end and our responsibilities to the land begin?

Emmet Gowin provides us with the opportunity to witness Earth as both abstraction and homeland. "Home: not where I live or it lives," writes William Faulkner, "but where we live."

Image: likeness, representation, resemblance, simulacrum; effigy, figure, straw man, scarecrow, doll; icon, fetish, graven image, false god; photograph.

One cannot look at the images in *Changing the Earth* without seeing images of the human body: face, neck, breasts, torso, pelvis, thighs, arms and legs, embodied and disembodied, at once. Nor can we speak of Emmet Gowin's photographs without using the vernacular of biology: cells, nucleus, mitochondria, DNA, tissue, nerve, muscle, arteries, veins, and vessels.

And the body of Earth is not without its wounds.

I recognize *Glacial Furrows and Bomb Disposal Craters at the Umatilla Army Depot* as sutures binding flesh. *Weapons Disposal Trenches at the Tooele Army Depot* are brutal cuts and gashes in Earth's skin. A photograph of *Mining Exploration near Carson City, Nevada,* becomes a woman's body repeatedly abused and scarred. The pictures of *Troop Placements and Traffic Patterns in Kuwait* are a virus cultured in a petri dish, and *Snow over Pivot Agriculture near Liberal, Kansas,* is a tumor detected in a mammogram.

After living with these images, holding them, studying them, returning to them as a meditation in elegance and horror, I feel the paradoxical nature of what it means to be human, how we create and destroy, simultaneously. Both inspire and initiate beauty.

And then, one photograph in particular pierces my intellect and releases a memory of dark tenderness; the story of my own family and so many other Utahns as Downwinders is exposed. Evidence: *Subsidence Craters, Looking East from Area 8, Nevada Test Site, 1996.* In an instant, craters become the begging bowls of monks. My mind collapses, my body responds, the full press of what we have done to this beautiful blue planet and its inhabitants crushes my heart.

For beauty is nothing
but the beginning of terror, which we still are just able to endure,
and we are so awed because it serenely disdains
to annihilate us . . .
And so I hold myself back and swallow the call-note
of my dark sobbing. Ah, whom can we ever turn to
in our need?
—RAINER MARIA RILKE

I am driving home from Salt Lake City on Highway 6, from Price to Moab, the very road that registers as a long scar in Emmet's image, *Erosion, Highway Route 6 and Railroad, Looking North from Green River, Utah, 1988.* I see the road now through Gowin eyes. I recognize my denial, my own complicity in the construction of roads. I drive them regularly, how else can I get myself home? But I'm having a particularly hard time with roads in the wilderness. It's an enormous issue before the federal courts and Congress now known as RS 2477. Let me be brief. Revised Statute 2477 is the repealed mining law that once gave counties the right to construct public highways across certain federal lands. We are talking about how people in the American West today define roads as cow paths, wash bottoms, and two-tracks that rural Utah counties are claiming as "highways" in their effort to prevent wilderness designation. If a "road" is found in the wilderness it no longer qualifies as a place of protection. Opponents of wilderness are finding and bulldozing roads on remote federal lands as fast as they can start up their vehicles. This is another, lesser-known toxic residual left from the unconscious mania of mining exploration.

The State of Utah is suing the U.S. Department of the Interior, demanding that Secretary Gale Norton grant rights-of-way to the counties for these ruts in the sand. To show how insane this really is, in 2001, the U.S. Congress gave money to the State of Utah to help sue the U.S. Department of the Interior, in order to prevent the Congress from designating wilderness. Forgive my impatience. Emmet Gowin incites both the artistry and politics of roads.

I'm having even a harder time with the road we are on in the world. We are at war. We are at war on so many different levels. There are many forms of terrorism, environmental degradation is one of them. How can I articulate the way in which these photographs have shattered my hope of any dreams of sustainability?

I feel a depression rise in me like a recurring fever that threatens to render me unconscious, where every sentence spoken or written becomes a stay against darkness. Despair shows us the limits of our own imagination. My instinct is to retreat. Close the door. Sleep. But my blood is flowing like a meandering river that circles back to itself, keeping me alive, reminding me of the importance of circulation. My pulse becomes a mantra: *May I not become numb. May I stay open not closed. May I turn outward not inward. May I remember I am not alone.*

Can art that dares to initiate grief and shake us out of complacency move us toward an active awareness that heals, even inspires, us to take individual and collective steps toward the restitution and restoration of the planet?

I turn to my community of Castle Valley, a remote outpost in the redrock desert of southern Utah. I fear my own bias as a pacifist and lover of wildlands has tainted my perceptions. I am not a balanced person. I cannot be trusted, so fierce is my instinct to protect and preserve. I think of my neighbors. What might they see in these photographs? How would they read Emmet Gowin's visual landscape? And so, I get up and carry these ninety-two images door to door.

My neighbor to the west, Catherine Howells, and I sit down in her living room for a cup of tea. She and her husband moved from California to Castle Valley for solace. She worked for Boeing and Microsoft as a corporate consultant. She is now a community advocate and serves on the local planning council. Every morning, I watch her walk these arid lands with her Australian shepherd, Brenda.

Catherine approaches each photograph slowly, deliberately. She says nothing. When she finally does speak, she says, "What appears to be superficial cuts in the land accumulatively threaten to destroy the health of the planet. It's the repetition in these pictures that gets through to

me." She turns more pages. "He allows us to see the Earth as diseased. It's almost as though the Earth has a fever. Perhaps this is what global warming is trying to tell us."

And then her vocabulary rapidly becomes a catalog of bodily ailments: sores, pox, parasites, blisters, burns, scrapes, gouges, bruises, cuts, and cells gone awry, tumors.

"The overall effect is systemic," she says. "A break in the energy flow of life." She pauses. "This image, *Winter on High Plains, Agricultural Pivot, Kansas, 1995,* looks like a sonogram of a stillborn."

Catherine turns to me three-fourths of the way through the photographs and stops. "You know we have to preserve the integrity of this valley. We can do this, Terry. We may not be able to take on the world, but we can try and protect our own backyard. People being mindful of their own homes, this is our only hope."

My neighbors to the east, Jerry and Marilyn Bidinger, find each photograph as a window into their own imaginations. Jerry is an attorney, former global managing council of Mobil Oil Corporation's legal department. Marilyn is a concert pianist from Manhattan. They find the beauty of Castle Valley and surrounding country reminiscent of the high desert of northern Hejez in Saudi Arabia where they had lived.

"Reality is in our minds, isn't it?" Jerry says as he begins looking at each photograph. "And if reality is in our minds then the laws of nature are what we make them to be."

He is excited by these images. "The abstractions of nature in juxtaposition with the abstraction of human activities are two forces at work."

"This one looks like an amoeba under a microscope. This one looks like a series of sores, ulcerations, cancers." He stops himself. "When I look at these I start creating, don't I?"

Marilyn points out the captions on the back. They begin to read them together. Their tone shifts.

"We never see this perspective," she says. "It's not possible from ground level. Would our actions be different if we could?"

"Look at this one," Jerry says, referring to the image *Golf Course under Construction, Mount Aso, Kyushu, Japan, 1992.* "I had no idea. It is the Earth transformed. And this one right next to it is a stunning abstract painting."

We move through the stack slowly, taking a couple of hours, all along the way engaged in conversation.

"Stop, go back." Jerry turns to Marilyn. "These agricultural pivots with light striking the spray of water—they look like clocks where time ran out."

Marilyn uses words like "hope," "futility," "insanity."

Finally, Jerry says thoughtfully, "The Earth is looking back at us."

Bill and Eleanor Hedden are neighbors to our north. They have lived in Castle Valley for more than twenty-five years. They graduated from Harvard and Radcliffe in the 1960s, then decided to leave the academic scene as a scientist and anthropologist and "go back to the land." Their homestead is a testament to water in the desert, a true oasis. Bill, a former county commissioner, is now working with local ranchers in retiring grazing permits on federal lands in Utah. Eleanor is a cellist and master gardener. They have two daughters.

Over dinner, they read the photographs as biologists.

"This one, *Waterfowl Nesting Site and Wetland Area near Sutters Butte, California, 1993,* looks exactly like the extraction of DNA. And these images of Kuwait look like Brownian movement, the irregular motion of small particles suspended in a liquid or gas. You can see the organelles on the edges."

Eleanor corroborates and expands the cellular metaphor, handing him the image *Aeration Pond, Toxic Water Treatment Facility, Pine Bluff, Arkansas, 1989:* "These look exactly like epithelia cells."

"There's nowhere on the planet we haven't impacted," Bill says, "especially when you think of the weight of the military's footprint."

A silence follows.

"I wonder if the definition of fanaticism is repeating the same acts over and over again and expecting a different result?" he says. "It's not one bomb tested in the desert, it's a thousand tests in the Mojave."

Conversation shifts to the Atlas tailings pile, one of the nation's largest uranium tailings piles, sitting on the banks of the Colorado River, a stone's throw away from Arches National Park.

Spring winds blow with a force so fierce, there are days one cannot even see the pile, the red dust is swirling so violently in town. Moab is not only blanketed with uranium dust, but so is our skin. Eyes and throats are irritated. It is a story we know too well in the Nuclear West.

In 2000, in a bipartisan effort, Congress passed legislation that would authorize the removal of this radioactive tailings pile. In 2001, the Bush administration refused to fund it.

This was the United States' first commercially operated uranium mill built by Charlie Steen's Uranium Reduction Company in 1956 and expanded by Atlas Minerals Corporation beginning in 1961. This facility extracted yellowcake uranium for nuclear bombs and reactors from ores trucked from more than three hundred mines on the Colorado Plateau. Today, the uranium tailings pond has grown to 13 million tons, covering 130 acres with a depth of 110 feet.

From the unlined bottom of the pond, toxic seepage has turned the groundwater into a radioactive broth of heavy metals.

"On any given day," Bill says, "ammonia bubbles up in the Colorado River just a few hundred feet away. The near shorewater is so poisoned with ammonia that any fish unlucky enough to swim there dies immediately."

Today's discharge of contaminated groundwater into the river is estimated at 110,000 gallons per day. In wet years, when the spring flood in the Colorado River exceeds about 45,000 cubic feet per second, the river tops its banks and inundates the base of the tailings pile, leaving it not merely leaking into the river, but standing in the drinking water for 25 million people living downstream in Nevada, Arizona, California, and Mexico.

"The damaged landscapes Emmet Gowin is photographing from an airplane," Bill says, "is where we are living."

"There is nothing abstract about these images," Eleanor adds. "They were caused by the work of man. Now our work must be of a different nature. We must work to recover what we have unconsciously destroyed. Our focus must be on how to heal these places."

Jolene Williams is the mother of six children. Her husband, Richard, works at the Potash plant in town. They are members of the Church of Jesus Christ of Latter-Day Saints who have lived in the valley for ten years. I invite Jolene to take a look at these photographs.

She wastes no time.

"Look at the power and grace of this river," she says, referring to the first photograph, *Old Hanford City Site and the Columbia River, Hanford Nuclear Reservation near Richlands, Washington, 1986*. "This is Heavenly Father's creation. It is so beautiful." She is not interested in the captions. It is the image that holds her attention.

We move through the pile quickly.

"Look at these mountains—sometimes I wonder if He did the sculpting or if He just allowed the wind and water to do that?" She stops and looks straight ahead, "You know these pictures make me realize that there is a bigger world out there. We get so mired in unnecessary details, living in these crackerbox houses, trying to keep them clean when there is a greater thing out there, a greater purpose than our daily worries. It makes me aware of Heavenly Father's work, all the beautiful rivers and mountains and trees He has created, the raw materials we have been given to produce things to live comfortably."

We move to the last section of Emmet's portfolio, the Nevada Test Site. Jolene stares at the bomb craters.

"Unfortunately, we probably aren't done with this," she says.

We talk about China's escalation of nuclear weapons, as well as the tensions between Pakistan and India.

"Have you read the Book of Revelations?"

I tell her not recently.

"Go back and take a look at it, particularly chapter eight where it talks about the burned trees and grasses."

"I wonder—"

"What I ask?"

"Well, I just wonder if all this isn't related, how we have destroyed so much of God's creation and are now reaping the consequences. You know there has been so much cancer in this valley."

I listen across the kitchen table to the names of people I have never known, how so-and-so died of liver cancer and so-and-so down the valley near the Hedden's died of sinus cancer.

"That was very strange. There's a pond down there and the neighbor's horse developed cancerous growths on its face, open wounds around its mouth. And then there were our goats. We began breeding them and some of them were born with these grotesque growths that wrapped around their throats like huge goiters. I think

there were at least eight of them. It broke my heart. They couldn't swallow and so they did not live long. We held them and loved them and watched them die. I think about our water. You know there are those old uranium mines up in the mountains not so far from here. I just wonder— I have my own problems you know, with my thyroid. I'm just so tired, some days I have to will myself out of bed."

The tenderness of this moment with my neighbor brought us into an unexpected intimacy. I thought we had moved to paradise.

Art . . . has always been the revenge of the human spirit upon the shortsighted.
—ARTHUR MILLER

Photograph: picture, image, snap, slide, transparency, frame, exposure, negative, positive; portrait, blowup, shoot.

Emmet Gowin has captured on film the state of our creation and, conversely, the beauty of our losses.

And it is full of revelations.

Is this the beauty born out of terror that Rilke names?

Emmet's last image is *Sedan Crater, Northern End of Yucca Flats, Nevada Test Site, 1996.* This is the burial place of my mother and grandmothers and aunts and uncles, all of my kin who died from cancer as a result of radioactive fallout from the nuclear tests conducted in the Mojave Desert in the 1950s and 1960s. Call it a mass grave for all Downwinders or *hibakusha*, as the Japanese refer to "explosion-affected people."

But there is something else, something larger, just as Jolene Williams suggests. I see the generosity of Earth as being able to absorb our own darkness. I turn the image upside down and see an eye, the Earth's eye staring back at us.

Do we now dare to look ourselves in the eye and begin the necessary work of repentance and restoration?

ABOVE THE FRUITED PLAIN

REFLECTIONS ON THE ORIGINS AND TRAJECTORIES OF EMMET GOWIN'S AERIAL LANDSCAPE PHOTOGRAPHS

JOCK REYNOLDS

The development of this publication and exhibition project, devoted to Emmet Gowin's aerial photography, coincided by sheer chance with the extraordinary events occurring on September 11th of 2001, when airborne terrorist attacks on America set off reverberations felt instantly within the hearts and minds of our citizenry and those of other nations around the world. The seismic shifts wrought in human emotion by these tragic events, and the strategic political, economic, and military responses they are certain to prompt for many years to come, may well cause our species—one that spent much of the twentieth century wreaking havoc on itself—to seriously reappraise its purpose for being in an ever-shrinking interdependent world. None will doubt that we have entered this new century and human era keenly aware that the transport of pleasure, commerce, disease, rescue, terror, and death can be dispatched by air in a matter of seconds, minutes, and hours—on a scale utterly unimaginable to those who lived a mere hundred years ago. As Emmet Gowin so presciently wrote in 1994, as he was in the midst of creating this compelling body of aerial landscape photographs, which bear stark, beautiful, and often chilling witness to the many ways mankind continues to transform this hardy and yet fragile earth, "We tremble at the feelings we experience as our sense of wholeness is reorganized by what we see."[1]

Seeing, thinking, and feeling things "whole" has long been the hallmark of Emmet Gowin's approach to life and art-making, one kindled within an especially close-knit family that lived and worshipped in strong support of its own members and the religious congregations his parents served in rural Virginia. At the time of Emmet's birth in 1941, Gowin's father, Emmet Gowin, Sr., was the strong-willed minister of a Methodist church in Danville, Virginia. He had earlier married Lynden Grace Parker, the daughter of a western Quaker minister, whose family had supported her—even moving twice—in her intensive study of the Bible and the piano. She eventually became not only a loving wife and mother, but also the talented organist serving her husband's congregations.

In past interviews Gowin has recalled his childhood as somewhat confining at times, but generally as a period of happiness and incredible freedom. He has also acknowledged that his character was formed in direct reaction to the complexities he observed in his parents.

My father lived the will of the Lord, as he saw it, and although he understood the Gospels in an intellectual sense, I felt the central meaning was often confused with the specific law. It was terrifying to me because the law could destroy the spirit. I was seven years old and I could see that, so I have no doubt that my fundamental character was already fixed by that time. My father frightened me with his theology, whereas my mother practiced patience and forgiveness. She was the influence in my life.[2]

I cite this particular quote from Gowin, for it seems key to the person I have come to know, a man who constantly strives to balance his own strong will, tenacious spirit, and tendency toward certitude with a commitment to open inquiry, rigorous introspection, and a sustained practice of personal generosity.

The other formidable influence in Gowin's life remains his wife, Edith, the mother of his sons, Elijah and Isaac, the artist's muse, and the subject of many of his photographs. A year his junior, and now his partner for almost forty years, Edith Morris grew up a mere mile from Gowin's childhood home in Danville, Virginia, the daughter of four generations of her family who continuously lived within easy calling of one another in a compound of five family houses. The able adults of the clan all worked for the Dan River Mills, a textile manufacturer that furnished much of the local economy. It was to this home place, the source of the especially close and comfortable relationships that Edith's extended families provided their new son-in-law, that Emmet Gowin returned in 1965 as a young graduate student to create his first mature photographs. There he found in his wife, her family members, and their immediate environs the subjects that finally captivated his being and brought to him a clear sense of creative purpose as he continued the difficult process of becoming an artist. This pivotal experience also came about as Gowin considered how he would reply to a summons he had received from his draft board as the Vietnam War escalated amidst growing discord in American society. Responding to the government's increased call for young servicemen, the young man wrestled with his convictions, drawing on Quaker values long held and taught in his mother's family, and registered himself as a conscientious objector, volunteering to serve as a non-combatant if called to duty. As he later related to Martha

Chahroudi, during a number of 1989 interviews she conducted with Gowin while he was preparing his first mid-career retrospective at the Philadelphia Museum of Art,

I was wandering about in the world looking for an interesting place to be, when I realized that where I was was already interesting. There was something in family life, in the development of young minds, that was my subject: how it feels to be the child asking for the parent's attention, and how it feels to be yourself, for the first time to recognize yourself as a parent rather than the child. My mental state had been that of a child, but I'd been drafted and I could no longer be a child, yet I wanted to look at children to understand this differentiation between what I used to be and what I am now. It was my realization of coming of age.[3]

The image *Nancy, Danville, Virginia, 1965*[4]—which depicts his young niece feigning dreamy sleep while surrounded by eight of her favorite dolls, the family dog also looking on—not only marks the beginning of Gowin's family pictures, but may also in some respects—in point of view and composition—be considered his first aerial image. It was made by the artist hovering directly above his young subject with a 4 x 5" camera, recording the tableau she had arranged for him against a ground carpeted evenly with a rich mix of leaves and vines. This particular point of view contains the young girl, her pet, and her toys wholly within an intimate landscape, one devoid of a traditional horizon line or any other direct reference to the world beyond. In the raking light of late afternoon, only some shadows—seemingly emanating from the photographer's tripod and body—are cast across the lower right quadrant of this startling image, slightly torquing the composition of the scene that has been visually flattened and secured to the earth from Gowin's visual vantage point over his niece.

Gowin made his first family portraits with the encouragement of his great teacher, lifelong mentor, and friend Harry Callahan, who was at the time chairman of the photography program at the Rhode Island School of Art and Design (RISD). Callahan regularly sent all of his young charges out to work independently at the onset of their graduate studies, wanting to see what they could produce unfettered by his and other faculty influences. He even lent Gowin—his new student—the film holders that were used in making these first pictures. Earlier, however, in 1963, before seeking out Callahan in Providence, Gowin had shown some of his prior undergraduate street photography to Robert Frank in New York, as well as images he was then making of civil rights demonstrations occurring in Virginia and worship services he was privy to within black churches in North Carolina. The impulse to record these images had marked another formative moment in Gowin's creative development, the first time he turned his visual attentions directly to matters of social justice and religion, themes that Frank had so richly illuminated in his classic work *The Americans*. It was Frank, in fact, during their session together, who reinforced Gowin's desire to study with Callahan.

During the two years that ensued after meeting with Robert Frank, Gowin married his beloved Edith and then finished his bachelor of fine arts degree from the Richmond Professional Institute (now Virginia Commonwealth University) in spring of 1965. Notified of his acceptance to RISD's graduate program, the couple moved to Providence so that Gowin could begin his studies with Callahan.

Interestingly, Gowin's undergraduate thesis at Richmond Professional Institute had dealt with the pioneering writings and photography of Alfred Stieglitz, whose personal philosophy toward art-making profoundly stirred the young student. As a photographer, gallerist, publisher, and primary spokesman for the modernist creations of many painters and photographers, Stieglitz was arguably the most influential figure in American art during the twentieth century, and had well articulated for himself and others how artistic creativity could function as a highly personal, strongly emotional, and deeply spiritual enterprise—just what Gowin was seeking to imbue in his fledgling work. For his culminating academic submission at RPI, Gowin produced *Concerning "Alfred Stieglitz and America" and Myself*, printing with great care a limited-edition book of his own design that juxtaposed text reprinted from the original *Stieglitz and America* Festschrift of 1934 with a series of Gowin's own contemporary photographs. The young creator could not then have imagined how clearly the abstract visual nature of Stieglitz's fastidiously printed *Equivalents* photographs would many years later come into direct dialogue with the aerial images he would begin making in 1980.

Another key event for Gowin, amidst his youthful development as an artist, was his first encounter with Frederick Sommer, one of the many distinguished photographers whom Harry Callahan regularly invited to RISD to share work and ideas with his students. At the time of Sommer's first foray into Providence in 1967, Gowin had just received his M.F.A. degree and begun teaching at the Dayton Art Institute in Ohio, from whence he drove all night to hear the famously reclusive artist speak and review the work of Callahan's students, including his own. Gowin's encounter with Sommer produced an immediate chemistry between the two men, ensuing in a friendship that would last until Sommer's death at age ninety-three. From Sommer, who was not just a gifted photographer, but also a talented draftsman, collagist, poet, philosopher, avid reader, and keen lover of nature, Gowin was inspired

to dramatically broaden his intellectual horizons and later travel to the American West, where he would repeatedly visit Sommer in Arizona. There his older friend had already distilled the visual essence of the landscape in his chosen home place through photographs such as *Goldmine—Arizona, 1943,*[5] depicting a shockingly beautiful desert display of tailings excavated from a working mine, and *Arizona Landscape, 1945,*[6] an image that offers a pristine hillside of yucca, grease wood, and sage, populated by magnificent specimens of saguaro cacti that tower in the foreground and recede in visual splendor all the way to the top edge of the photograph. Although neither of these seminal Sommer images is an aerial photograph, both of them were shot from elevated vantage points and are devoid of traditional horizon lines. Early on, they gave Gowin a model for viewing the earth's landscape from on high in both blemished and pristine environmental conditions.

Sommer's accepting and confident use of strong natural light, coupled with his willingness also to bleach his photographs—to intensify further their physical presence and clarity—also impressed the young Gowin. He eagerly discussed such techniques with Sommer and thereafter—over many years—has trained himself in the darkroom to become one of the finest producers of hand-toned prints in the world, something this publication makes abundantly clear. Gowin had also learned a deep respect for craft from Harry Callahan, who always championed the inherent value of a finely made photograph and admonished his talented student never to apologize or back off from mastering the craft of printing. In a recent discussion of Callahan's affirming admonition, Gowin recalled for me an incident that occurred when Sommer visited him in Ohio in 1970, early in their friendship. The pair ventured out together to view the collections of the Dayton Art Institute, and after passing a particularly striking Chinese

painting in one of the galleries, Sommer remarked to his young peer, "Don't ever let anyone talk you out of physical splendor."

The value of clear expressive written language also became important to Gowin early in his development, something he came to appreciate more fully through Sommer's rigorously concise and economic use of words. He willingly acknowledges his debt to Sommer's poems such as the following pair, through which the artist spoke volumes about his creative intentions with a clarity as astounding and precise as the photographs he made in the stark western landscape that surrounded him.

Logic begins
where perceptions meet.

Design brings to perceptions
a strategy of configurations
not yet on display

Art serves problems
that display themselves
in the structure
of the perceived.

We do not need models
when pictorial logic
animates a field.

Making and discarding images,
nature returns to fundamentals

There is no design
without raw materials.

Design builds structures
through which function flows.

Complementarity of design
displays itself
in the possibilities
of an ebb and flow
endlessly reconstituting
the world.

The world is a reality,
not because of the way it is,
but because of possibilities
it presents.

Looking tranquility in the eye,
reason finds a place
in the divine.

Because aesthetics is an
equal opportunity concept,
the profane also stands
at the Gates of Paradise.[7]

The willingness to adopt strong models, most notably through the establishment of enduring artistic friendships, but often also through close examinations of other artists'

work that he admires, is another strong component of Gowin's creative being. He readily reveals how such models have continuously served his development whenever asked about his many influences. Whether it be the direct sharing and borrowing he has conducted with respected elder artists like Walker Evans, Frederick Sommer, Robert Frank, Aaron Siskind, Harry Callahan, or the many other photographers, writers, and scientists, Gowin is fastidiously attentive in paying homage to his sources. Again, in one of his interviews with Martha Chahroudi, he stated the tremendous value he found in learning directly from others,

I think I have always developed stage by stage by accepting some model as very interesting. And in the earliest stages I often replicated the model. Eventually, I worked my way through it by simply coming up somewhere alongside of the standard that it represented. And then it is always true that the coincidence of the many things that fit together to make a picture is singular. They occur only once. They never occur for you in quite the same way that they occur for someone else, so that in the tiny differences between them you can reemploy a model or strategy that someone else has used and still produce an original picture. Those things that do have a distinct life of their own strike me as being the things coming to you out of life itself.[8]

I first began to pay closer attention to Gowin's work in the early 1990s, when I was directing the Addison Gallery of American Art at Phillips Academy, Andover.[9] As someone who had grown up in California, I had an abiding personal interest in the western American landscape, and was eager to fortify my alma mater's artistic holdings with fine examples of nineteenth-century and contemporary western landscape photography. To do so, my new colleagues and I began actively to seek out more images produced by William Henry Jackson, Timothy O'Sullivan, Carleton Watkins, Eadweard Muybridge, and other early practitioners of the medium. We also paid attention to many twentieth-century photographers working in the western landscape, such venerated artists as Ansel Adams and also William Garnett, who for many years had produced poetic aerial photographs.[10] Robert Adams, Lewis Baltz, Richard Misrach, Frank Gohlke, Mark Klett, and many other younger photographers also received attention. I was especially intrigued with the ambitious collaborative effort that photographers Mark Klett, Ellen Manchester, JoAnn Verburg, Gordon Bunshaw, Rick Dingus, and Paul Berger had undertaken in creating *Second View: The Rephotographic Survey Project.*[11] This 1984 publication juxtaposed numerous nineteenth-century documentary images recorded by Jackson and O'Sullivan for the U.S. Geological Survey with images the young team of contemporary photographers had created from the very same viewpoints in the western landscapes. These direct visual comparisons sometimes revealed subtle but often dramatic changes that had occurred in particular places within the western landscape during the hundred years that had ensued between the historical and contemporary surveys. The project was impressive in the way it combined diligent historical research and deft fieldwork into environmentally conscious contemporary art practice. The project was another strong model that Gowin and other artists of our generation encountered and respected.

Work such as this interested me not only for its importance within American history and the history of photography; it intrigued me as well because of my particular upbringing, which included regular family backpacking and skiing excursions into California's high Sierras and annual summer vacations spent in the Sierra Club's Tuolumne Meadows campground (then still owned by the Club within Yosemite National Park). There, at an early age, I had seen Ansel Adams operating in the flesh as

a fellow Club member, working throughout the park with his 8 x 10" camera. He promoted photography and conservation tirelessly with a ministerial zeal through the regular workshops and gallery exhibitions he staged in Yosemite Valley, and through the many books the Sierra Club published of his work. His images taken within the park presented the sheer visual and poetic grandeur of its physical features and the wonderful light that fell upon them in all conditions of day, weather, and season. These photographs offered nary a clue, however, of the more troubling human activities occurring in the western landscape beyond the park's boundaries. Instead, they served as rich visual emblems for what had been and still is worth preserving of America's wilderness.

Well representing the feelings of many artists of Gowin's and my generation are words succinctly written to Ansel Adams by Robert Adams in 1979, not long after the younger artist had completed recording, printing, and editing an exhaustive trio of landmark photographic surveys in Colorado.

I was lucky enough to know parts of the West in a better day, and that knowledge is, as you must experience it too, now both an inspiration and a burden; one wonders, at dark times, whether one actually did live in a cleaner world. It is the power of your pictures to confirm that it existed. And to suggest, I think, that it is eternal, no matter what happens to be out in front of us at the moment.[12]

It was Carleton Watkins, however, a century earlier, who had preceded Ansel Adams in producing multiple photographic views of Yosemite, then being "discovered" in an even more unspoiled grandeur. Watkins, who was especially active in Yosemite during the 1860s and even later, had edited and mounted many of his landscape images into compelling presentation albums, documentary surveys that helped John Muir and others prompt the

U.S. Congress to preserve the great tract of California wilderness in perpetuity, and helping found in 1916 what we now know and cherish as our country's National Park Service.[13] William Henry Jackson's numerous early photographs of Wyoming's wilderness similarly helped provide the incentive to establish Yellowstone National Park, displaying another powerful model for how landscape photography could help shape the world.

Carleton Watkins remains of particular interest to many artists working today, not just for his views of pristine western wilderness, but because he also transported his visual attentions and large-format glass plate cameras to other sites in the Sierra wilderness and elsewhere, most notably to lumber and mining operations that revealed another human ambition loose in the wilderness. His focus was the rampant and unchecked harvesting of the region's natural resources, materials readily shipped eastward on the very railroads that William Henry Jackson was also documenting in Colorado and other regions of the Rocky Mountains. It was, in fact, the acquisition for the Addison Gallery of one of Watkins's Yosemite albums and three of his mammoth prints of the *Malakoff Diggings, North Bloomfield Gravel Mines, Nevada County, c. 1871*,[14] which almost clinically document the hard facts of large-scale hydraulic mining and the massive erosion it was causing at the time, that prompted me thereafter to regard more carefully the aerial landscape photographs that Emmet Gowin was making in the American West. Seen side by side, photographs by these two artists resonated richly with one another. It struck me that Watkins had long ago composed his images with a strong conceptual and well-considered physical point of view, taking into careful account both the scale of his subjects and how they might be perceived from multiple perspectives. In some cases, the multiple images he made of the same

subject were taken from vastly different vantage points, an example being five of the photographs Watkins recorded of Yosemite Falls, *Yosemite Falls, 2630 ft., c. 1865–66; Yosemite Falls (From the Upper House), 2477 ft., 1861; Lower Yosemite Fall, c. 1865–66; Yosemite Falls (River View), 2477 ft., 1861;* and *Yosemite Falls from Sentinel Dome, c. 1865–66.*[15] Each of these photographs is a masterful image in its own right, with its central watery subject boldly and somewhat asymmetrically framed within compositions comprising other vivid details in the natural landscape—the rocks, domes, skylines, trees, and vegetation that Watkins chose time and again to include in his strikingly modern compositions when documenting Yosemite Falls and the essential facts of their surroundings. It's also worth noting that to take even five such photographs in Yosemite during the 1860s represented an enormous commitment of time and energy. Watkins had to use pack animals and his own strong back to carry his cumbersome camera equipment to the staging area of each of his wilderness pictures. He then had to prepare and develop his glass plate negatives in river waters and a tented darkroom before eventually printing them back in his San Francisco studio. One of these images, *Yosemite Falls from Sentinel Dome, c. 1865–66,* is about as close to being an aerial photograph as one could make before the invention of the airplane enabled image makers to take to the skies regularly with their cameras. Mountaintops, after all, had long afforded humans the closest thing there was to a true bird's-eye view of the world, and it can be surmised that Watkins sought out particularly lofty perspectives for a number of his Yosemite photographs in order to record a fuller sense of the grandly expansive Sierra landscape and its complex topography. Doing so allowed the primary subjects of his other photographs, those portraying Yosemite Valley's majestic granite domes, cascading rivers and waterfalls,

stately Douglas firs, Ponderosa pines, Giant Sequoias, and other flora to be seen in a fuller context of glaciated splendor. Watkins's meticulously sequenced Yosemite albums thus offer a gratifying "wholeness," a completeness of viewing and visual comprehension that Gowin and many others have found notable. Watkins's work thus provided another fine model to consider, powerful in visual conception and aesthetic quality, as well as social and political function.

When I first began looking more carefully at Gowin's emerging body of aerial photographs, I erroneously thought they represented a tremendous formal and emotional rupture in his work. This misconception was quickly remedied when I looked again at some of his early family photographs, such as his hovering first view of *Nancy, Danville, Virginia, 1965,* and then other family images that foreshadow the work presented in this book. It seems clear now, for example, that Gowin's *Edith and Elijah, Newtown, Pennsylvania, 1974,* and *Edith, Newtown, Pennsylvania, 1974,*[16] diverge in interesting ways from many other photographs the artist was making at the time, a good number of which seemed to be strongly indebted to the surreal human tableaus that Ralph Eugene Meatyard had been producing in the American South, or to the portraits that Harry Callahan had been making for a long time of his wife, Eleanor, and daughter, Barbara. Both of these photographs were made with a cast-off 8 x 10" camera Gowin had been given, to which he fastened a 90mm Angulon lens, one meant to be matched with a 4 x 5" camera. Mismatched as it was, this equipment produced undersized circular negatives on sheets of 8 x 10" film, negatives that Gowin initially cropped before one day realizing that the circular form of his negatives was providing him with a framing device that was visually and symbolically powerful. He especially came to understand this in the 1974

photographic portraits that record his primary family members—first son and pregnant wife—posed within tightly cropped landscapes all their own. In *Edith and Elijah, Newtown, Pennsylvania, 1974*, Gowin positioned his camera high above a streambed, upon whose shallow flow and darkened stones recline the milky nude figures of Edith and Elijah. Young Elijah is looking up in the photograph and makes direct eye contact with his father and the camera, while Edith stares intently into the stream, gently touching its hard rocks and smooth waters, her pregnant belly forming the visual center of the picture. This poetic image, set forth in its circular format, presents a literal and figurative surround of intimacy and creation, a tender portrait of human vulnerability seen within a natural landscape and a world all their own.

Edith, Newtown, Pennsylvania, 1974, is a singular portrait of the artist's wife at the same stage in her pregnancy, which in point of view directly mirrors the image just cited. In this photograph, Gowin's camera is positioned well down a hillside tangled with dense forest undergrowth from Edith, raking upward to record her full-standing figure, which is posed resolutely before a stout evergreen tree that supplies further visual power to the direct gaze Edith rains down on her viewer. Her dramatic presence is enhanced by her pregnant condition, and her body is elongated and somewhat abstracted by its foreshortening in the camera's lens. Gowin here records a second display of human fecundity, joined together this time in a circular world of verdant foliage. The image presents an essential symbolic representation of animal and vegetable life existing together in harmony.

Interestingly, both of the photographs just described were taken within two years of three other images I sense as being crucial to Gowin's genre. The first, *Avebury Stone and Rennie Booher, England and Danville, Virginia, 1972*,[17] arose

from a double exposure Gowin made by chance. His first exposure on the film recorded an ancient monument his family had visited on their first trip to the British Isles that year, coupled accidentally with a portrait Gowin made of Edith's grandmother, lying in peaceful repose within a fabric-draped coffin displayed in the sitting room of her home (she had expired shortly after the Gowins returned to the United States, and Emmet inadvertently added a single sheet of exposed film from his European trip to his film holders when reloading them for a final devotional portrait session with the beloved matriarch). This unintended creation, close in visual structure, surreal appearance, and metaphoric reading to a portrait Frederick Sommer had made of *Max Ernst 1946 from two sandwiched negatives*,[18] and a poetic series of double-exposed portraits Harry Callahan created of his wife, *Eleanor, Aix-en-Provence, France, 1958*,[19] must have astounded Gowin when he developed it in his darkroom. In all of these photographic portraits by Sommer, Callahan, and Gowin, the presence of a single human subject is centrally framed in the image and superimposed as an elusive and ephemeral presence, one either hovering or passing from human form into a visual union with geologic and/or botanic vistas that form the grounded pictorial environments that extend across the entirety of each of these images. Gowin's portrait in particular provokes deep feelings of pathos and humility, successfully bringing to the fore the artist's empathy with human mortality and its relationship to more enduring symbols of time and material continuity.

With the matriarchs and patriarchs of the Booher family dying off in 1972 and 1973, Gowin seemed to sense that the insulated rural environs of his and Edith's families would cease to contain their lives in quite the same way. Not only had their trip to England and Ireland

broadened the pair's personal horizons, long-held family buildings and properties in Virginia were now falling into different states of repair and use as their owners departed the world or moved away. Gowin would no longer be able to base his identity as an artist in an unchanging family. Responding to this situation and the powerful feelings it summoned in him, Gowin made two startling images of his and Edith's family home places, *Buckingham County, Virginia, 1973*,[20] and *View of Rennie Booher's House, Danville, Virginia, 1973*.[21] Both of these landscape photographs continue Gowin's use of circular negatives, with each image bordered by a broad expanse of black that extends the fully printed negative to the very edges of traditional rectilinear black-and-white photographic paper, adding a further elegiac feeling to Gowin's chosen subject matter. The first picture of the pair has once again been taken from a high vantage point, offering a view of three rooftops of outbuildings extant on Gowin's grandfather's former property, recorded as though a bird or crop duster were swooping across the scene, viewing it quickly and intensely. The image also produces a visual ambiguity that is hard to explain, for the particular way Gowin composed and exposed his photograph suggests both a coming and a going. The circular lenticular format suggests a question as to what would happen if the framing aperture suddenly opened up more or closed in even more tightly on its subject, or perhaps zoomed in or out on the scene, revealing more of what we know with the certitude a camera can show us of the world. The resulting landscape has a truly enigmatic quality, functioning as both a recognizable place in a particular time and a scene that has also been oddly abstracted and imbued with a fleeting feeling of disorientation, one familiar to me from flight in small planes.

The *View of Rennie Booher's House, Danville, Virginia, 1973*, which Gowin often pairs with the image just mentioned,

was shot from within a tree house that his nieces and nephews had built on the Booher family property. For children growing up and modeling aspects of adult life, a tree house functions as their private and magical realm, sometimes offering its juvenile residents the highest vantage point from which to view their immediate world—as close to an aerial perspective as some youngsters get on their own. This photograph was taken on a cold winter day by Gowin, focusing his camera's lens on a rich pattern of branches up in the host tree, and then onward to the distance of Edith's grandmother's home and its surrounding outbuildings. Within the compendium of Gowin's other family photographs, the image reads as a symbolic and emotional leave-taking, one that acknowledges the inevitability of change within generations of all families and visually suggests that the abundant trees and vegetation on the family property will continue to envelop and embrace the buildings in view. In its own quiet way, this image also hints at the more elevated physical perspectives the artist would seek out in the future.

What other clues were there throughout the 1970s that Gowin's work would propel itself forward to a confluence of forms and techniques that would synthesize the richest traditions of nineteenth-century American western landscape photography with the vigorous modernist ideas of the twentieth century to produce his current body of aerial photography?

In many ways it was broader domestic and international travel, with the sampling it offered Gowin of other cultures and places, that began to expand the artist's view of the world more fully beyond his immediate family and its living environs. Excursions made to Arizona, Italy, England, Ireland, France, Greece, Germany, Yugoslavia, Peru, and elsewhere provided Gowin and his young family the opportunity literally to see and feel the world more

clearly. This travel also afforded Gowin, who often verbalizes the importance of going to see something, the chance to record visually how other families and cultures lived and treated their particular places on the earth—gardens, fields, architecture, and more.

During this same decade Gowin began teaching at Princeton and became a more voracious reader, well guided by recommended book lists he received and cherished from Frederick Sommer, fortified with suggestions also received regularly from other colleagues and friends. Through Sommer's encouragement, Gowin was especially prompted to pursue an exploration of the work and ideas of physicists, which excited him enormously and launched a strong self-education in the sciences that continues to this day. He also delved regularly into the writings of historians, philosophers, painters, and poets. This focused effort of cross-disciplinary intellectual inquiry stretched the mind of the maturing artist and brought him a fuller understanding of many ideas, events, and facts. Accruing new knowledge also propelled a new sense of urgency into Gowin's art as he came to understand, see, and continually "picture" his place in the world and universe more completely with his camera. A rich decade of such growth left him more connected to the wholeness of his life than ever before, prepared to more richly synthesize his emotional, visual, and intellectual knowledge in a continuation of more complex portraits of Edith and a new creative enterprise, one that evolved from the chance eruption of Mount St. Helens in 1980.

Many people don't know that during the late 1970s and early 1980s the National Endowment for the Arts and a number of enlightened state and civic agencies actively funded a broad range of photographic surveys undertaken by some of our country's finest photographers, many of them emerging talents in the field. *Second View: The*

Rephotographic Survey Project, cited earlier in this essay, was such an endeavor, enjoying awards of three NEA grants in support of its artists' fieldwork and publication, which was matched with patronage from other institutional and individual sponsors. In 1980, the year Gowin was awarded a fellowship to exercise freely a photographic enterprise of his own choosing within the state of Washington, the Seattle Arts Commission was one of America's most adventuresome supporters of public art. Richard Andrews, an artist who would later go on to direct the Visual Arts Program of the NEA and then later return to Seattle as the director of the University of Washington's Henry Art Gallery, was at the time coordinating Seattle's public art programs. He was intensely interested in commissioning new work from a broad array of regionally and nationally known painters, sculptors, and photographers, and it was within this program that Gowin received one of five fellowships awarded to photographers early in 1980.[22] Having discharged his teaching obligations for the academic year that spring, he moved his family to Washington in June, hoping to document the rich landscape of the state and the aftermath of Mount St. Helens's massive eruption throughout the summer. Only a month earlier, this natural display of force had completely devastated and redefined the natural landscape within a ten-mile radius of the volcano and sent a giant plume of ash upwards into the earth's atmosphere. The volume of this fine airborne particulate was so great that it affected weather patterns for quite some time before settling to the ground hundreds and thousands of miles away, covering some regional communities and land in blankets of gray ash that were several inches deep (not unlike the thick cascade of dust and ash that recently settled on lower Manhattan in the aftermath of the World Trade Center's fiery demise). Astonishing to all who

beheld it, the sheer power of Mount St. Helens's natural explosion was estimated to equal some 27,000 Hiroshima-type nuclear bombs in magnitude, a fact Gowin describes reading about in *Scientific American*[23] well after he had begun personally to survey the transformed landscape.

The mammoth eruption had prompted government officials to post a broad security perimeter around the mountain, one meant to protect the public from danger as lava flows and then land, mud, and water slides continued to rearrange the topography of the area surrounding the active volcano. Gowin thus felt he had to take to the air in order to see and record images of this vastly transformed landscape. He did so with a new hand-held camera and the help of a local pilot, whose plane he chartered after finally receiving permission from National Forest Service officials to pursue his creative work within the restricted zone.[24] Most of Gowin's first aerial photographs were composed as horizonless views of the disorienting devastation he was seeing below him, pictures such as *Spirit Lake, Mount St. Helens, Washington, 1980.*[25] It was shot straight down on the large mountainside lake, revealing a long slope of lava and ash that had flowed right into one edge of its waters, upon which buoy thousands upon thousands of trees, mature stands of timber that were blown off every slope as though they were mere blades of grass. They coalesce and float together in Gowin's photograph as richly textured abstract forms that fully animated his composed aerial view of natural destruction below.

Making such pictures suddenly placed Gowin in an utterly new physical position from which to consider scale in his landscape photographs. Bouncing about in a light plane he had to grapple with his new equipment and quickly make decisions about what he saw and wanted to record. Most importantly, he had to begin measuring for

himself what the sheer and terrifying visual beauty of devastation meant to him, both intellectually and emotionally, for it was present in every image he was making. This new and demanding regimen further stimulated the artist's efforts at self-education, which included reading more about science—physics, geology, botany, conservation, and more—and consulting with those knowledgeable in other fields who could help him grasp and understand fully some of the startling visual information he was gathering from on high. Gowin took full advantage of the technologies and ideas of his time to broaden his perceptual and pictorial abilities in the Mount St. Helens photographs. Again, words by Frederick Sommer well describe the nature of the visual and intellectual discoveries Gowin was making.

> The world of art and the world of science
> are interested in evidence and verification.
>
> Art and science deal with evidence by way of position
> in a harmonious flow of linkages.
>
> The new physics speaks of things we cannot see,
> but there must be order to what we call abstract.
> It is wrong to think there is no structure.
>
> We are interested in facts.
> Facts are not dead objects,
> facts are interrelationships of interrelationships
> endlessly carried down to their consequences.
>
> I do not see any fundamental difference
> between art and science.
> They are both serving our feelings;
> they are both interested in respect for reality
> and they are heavily weighed
> on the side of sense perception.
>
> Aesthetics is the only Greek word for sense perception.
>
> Aesthetics celebrates art as the poetic logic of form.
> Technology is only a special condition of general aesthetics.[26]

After Gowin later satisfied the requirements of his survey fellowship by turning in a requisite number of Mount St. Helens photographs to the Seattle Arts Commission, he continued to return to the area, working both on the ground and in the air, eager to see how the devastated area of the earth would begin to heal itself as new soil, nutrients, seeds, and water brought flora and then fauna back to life in the mountainous region affected by the eruption.

Describing this important time in his life, Gowin has eloquently recalled another pivotal experience he was later to have on one of his return trips to the Pacific Northwest.

In 1986, returning, I thought for the last time, to Mount St. Helens, I took a side trip to Yakima, Washington, and a flight that changed my whole perception of the age in which I live. In less than two hours flying over the Hanford Reservation, a pattern of relationships and a dark history of places and events emerged. Still visible after forty years were the pathways, burial mounds, and waste disposal trenches, as well as skeletal remains of a city once used by over thirty thousand people who built the first reactors and enriched the first uranium. Etched and carved into the body of the desert landscape below was a whole history of unconscious traces. The making of the atomic bomb had cost a great deal in knowledge, money, time, and hardship. It had also cost the total destruction and poisoning of a landscape and placed a great river, the Columbia, at grave risk. What I saw, imagined, and now know, was that a landscape had been created that could never be saved. I began in the next year to search for the other signs of our "nuclear age": missile silos, production sites, waste treatment and disposal sites—in short, the realities that I had unconsciously forgotten.[27]

Old Hanford City Site and the Columbia River, Hanford Nuclear Reservation near Richland, Washington, 1986 (page 2), was the first aerial photograph Gowin recorded that day, an image that was to call forth what has now been sixteen years of additional work created from an airborne perspective, through which the artist has traversed the American West, other regions of this country, and sites around the world where strong visible interventions by humans are evident on the earth. This first image, were you not to look at it carefully and also take note of its deadpan descriptive title, might read simply as a beautiful landscape photograph. But equipped with its title, and even a vague knowledge of history and atomic radiation, a lay viewer can share in the clear danger and terror that Gowin felt when encountering this now almost forgotten American place of enormous consequence. A closer viewing of the city's street grid reveals that all of the buildings within it have disappeared for no apparent reason. The remnants of this abandonment also sidle up to a great river, which winds toward a faraway horizon. Gowin has chemically hand-toned its surface in his photograph to bring forth a strange metallic tint, one whose particular hue produces a distinct sensation of toxicity and alarm. He crafted the print this way after learning more about the nuclear reservation, where "over 500,000 gallons of high-level liquid radioactive waste have leaked from corroding underground storage tanks, and an additional 210 billion gallons of lower-level waste were poured into gravel-lined beds that filtered directly into the soil."[28] A friend of mine once described this photograph of Old Hanford City as "immorally beautiful," a phrase I still consider when viewing the strongly pleasing qualities of visual design and hand-toned surface that service the wallop of genuine fear and trepidation present in the image. It powerfully illuminates the risks of poisoning our earth, as does a second image Gowin took over the same area a year later, *Abandoned Air Strip, Old Hanford City Site, Hanford Nuclear Reservation near Richland, Washington, 1986* (page 5). In this photograph Gowin frames another downward view upon the great expanse of the ghostly

military facility, but focuses this time on its disused airstrip. The landing area is seen in the photograph as a simple single cross of two runways upon the ground. The bold cruciform, incised on a landscape with no horizon in view, reminds me of the cuts one was taught in Boy Scouts to "be prepared" to make on human skin in case of a rattlesnake bite (so that venom could be sucked from the wound to save its victim). In this instance, Gowin reveals a specific place on the earth's body that has been left cut, poisoned, and scarred for the ages.

As Gowin offers compelling visual evidence throughout this book that our species is both willingly and often unconsciously denigrating the very earth we all love and need to return to fuller health, I have learned that he is anything but a simple-minded scolder. It would be a real mistake to view this man as someone just wagging an accusing finger—or in this case an airborne camera—at the rest of us from on high. Having worked closely with Gowin during the past six months to help him edit a mere ninety-two of his many aerial photographs into the most thoughtful and visually poetic sequence possible, I've gained additional respect for the complexities of his knowledge, values, feelings, and intentions. It is clear from talking with Gowin that he has come to understand his own place and time in the universe more fully through observing the earth from great distances of elevated physical perspective. And although he does see international corporations and bureaucracies and national governments of all kinds as promulgating much of the most alarming change visibly apparent on the earth, he is well aware that such functioning human entities are merely larger representations or misrepresentations of individual lives such as his own. Being able to grasp physically concepts of scale and fact in dramatic visual fashion through the air has also enabled Gowin to understand that he, too, has been

and is fully complicit in the often reckless and/or ignorant conduct our species has been displaying on the planet. We have spoken, for example, when considering an image such as *Aeration Pond, Toxic Water Treatment Facility, Pine Bluff, Arkansas, 1989* (page 35), of how for many years all photographers simply dumped their darkroom chemicals and metal toners down sewage drains (the two of us certainly did so), not seriously considering the accruing effects of water and land pollution until scientific studies and rising conservation consciousness began directing human attentions more fully to such important matters in recent decades. Gowin is also aware of the sheer material extravagance and privilege he enjoys in arranging the chartered flights that enable his lofty images to exist. He contemplates, too, the ironies of using highly engineered and gyroscopically stabilized cameras and lenses to record his searing aerial views of the heavily secured Nevada Test Site.[29] Such equipment, after all, and other relevant examples of advanced technology have been relentlessly commissioned, refined, and advanced since World War II by our U.S. armed forces and NASA. They have been employed in myriad forms and missions to do such things as guide rockets, surveillance satellites, and humans into space and to the moon, and Minuteman missiles to their targets. Patiently seeking and gaining permissions to enter portions of our national airspace normally restricted to secret military use, Gowin has seen for himself and learned more about what we tested in our now radiated deserts, and then housed in hardened silos. To what extent, his pictures seem to ask, as those made by an individual citizen, do any of us really know about how much of our bristling nuclear weaponry was auditioned on our own land and then came to share a shadowy home within landscapes where our own food is grown and stored in silos of a different kind?[30]

Dry Land Wheat Farming in the Cheyenne ICBM Missile Field, Pawnee National Grassland, Colorado, 1991 (page 51), and two related images taken in Montana that immediately precede and follow this photograph in the book present and name this strange reality. Elsewhere in our land, as represented in other photographs throughout this book, Gowin has seen and recorded how we are growing grain by near industrial means, coaxing it into robust production on naturally arid land through the extensive use of pivot irrigation techniques. Intrigued initially by the sheer graphic beauty of this practice as seen from the air, Gowin has also learned of a darker side, how such farming techniques are rapidly decreasing the deep underground aquifers of the West, where the true economic and environmental costs of water and land use are yet to be understood fully amidst formidable political debate.

So, all this said, when Gowin records an image such as *Off Road Traffic Pattern along the Northwest Shore of the Great Salt Lake, Utah, 1988* (page 12), presents his viewers with military battle sites in *Iraqi Traffic Patterns and Troop Placements, Bubiyan, Kuwait, 1995* (pages 30–31), and then provides an image from a flyover of *Harvest Traffic over Agricultural Pivot near Hermiston, Oregon, 1991*, one should consider how he is consciously setting forth a broad spectrum of human behavior—recreational, military, and agricultural activities—for consideration. All of these activities are in some way exerting "patterns" of transformative consequence upon the earth's surface, and sometimes on its aquifers below.

In looking beyond the American West, where this creative endeavor began, to our country as a whole and to other nations abroad, Gowin has also become a thoughtful participant in raising what we now rather generically dub "global consciousness." The aerial photographs he recorded in the early 1990s, of vast chemopetrol mines

and power plants still operating in Bohemia of the Czech Republic, reveal an utterly rapacious practice of coal extraction that has blighted a whole region of a country and its people. The enterprise there originated during the Cold War as a way to produce and ship cheap electrical power to what was then the Soviet Union. The full force of this heavy industry continues unregulated to this day, and it seems utterly shocking in both its scale and its brutality as revealed in the powerful series of images that Gowin made in Bohemia from on high (pages 63–81).

These images lead me to wonder what Gowin might someday choose to picture of the Developing World, much of which is now looking hard at the fully industrialized northern hemisphere, wanting in many instances to transform its natural resources into commensurate wealth and material abundance for its people and nations. Gowin, not as a politician or economist, but as an artist/citizen, thinks of such issues often as he goes about making his photographs, insistently both seeking beauty and bearing witness to hard truths through his art making. Gowin has certainly found, as expressed within his statement at the very beginning of this book, a place for his "heart to stand in the landscape," and he offers his audience the same. At sixty years of age, he now seems to understand fully something else that Harry Callahan, his great teacher and friend, once had to say, "My value lies in the fact that I am a man for whom the visible world exists."[31]

While looking again last week through the entire sequence of photographs being prepared for this publication, I thought back to how Emmet Gowin as a young undergraduate student had been strongly influenced by Alfred Stieglitz's photographs and writings to model a life that became dedicated to seeing. This reflection prompted me to look again at some of the formative outdoor images that Stieglitz made in extreme weather and

light conditions in New York at the very end of the nine-
teenth and the beginning of the twentieth centuries as
well as his later *Equivalents* photographs.[32] I surveyed images
such as *Winter, Fifth Avenue, 1893*,[33] in which a heavily bun-
dled wagon master is driving his team of horses and their
heavy cartage directly into a blizzard and up the deeply
snow-furrowed avenue. Stieglitz takes him straight on in
his struggling physical journey with other living beasts,
and yet a mere nine years later crafted his famed image
The Hand of Man, 1902.[34] Here Man's hand is no longer
holding leather reins, but has been symbolically trans-
formed into a powerful steam locomotive, the mechanical
dynamo that was then dominating much of American
technological and economic investment. This new "Hand
of Man" seems capable of reaching almost anywhere and
everywhere on its interwoven fingerlike system of steel
tracks that comprise the glistening lyrical foreground of
Stieglitz's renowned picture. And in fact it did, helping
to complete the western expansion of people and goods
throughout our country and others in decades when the
car, truck, and airplane were mere ideas or fledglings. The
great pioneer of American modernism pictured a mere
hint of what was to come rushing forth technologically
during the remainder of his life and ours before directing
his camera skyward in the 1920s. In that realm Stieglitz
composed, recorded, and printed the first of his *Equivalents*,
images soon to be considered groundbreaking abstractions
in his chosen medium. As much as these images shared a
strong visual affinity with abstracted landscapes then and
earlier painted by Arthur Dove, Georgia O'Keeffe, and
other artists in Stieglitz's circle, his cloud photographs
had a character all their own. These images soon shed
traditional landscape horizon lines and became billowing
moon-illuminated patterns of water condensing and dis-
persing throughout the earth's atmosphere, blown ever

worldwide through a form of transport as old as the earth
itself.[35] Stieglitz reveled in this natural beauty and visual
dialogue with the heavens above his Lake George property,
describing how it prodded him to be "always evolving—
always going more deeply into life—into photography."[36]
Mostly, he reveled in the profound emotional and spiritual
feelings his *Equivalents* produced in him. At the time he
almost defiantly set about making these photographs, he
wrote that "clouds were there for everyone—no tax on
them yet—free."[37]

He also wrote,

*My mother was dying. Our estate was going to pieces. The old horse
of 37 was being kept alive by the 70-year-old coachman. I, full of the
feeling of to-day: all about me disintegration—slow but sure: dying
chestnut trees—all the chestnuts in this country have been dying for
years: the pines doomed too—diseased: I, poor, but at work: the world
in a great mess: the human being a queer animal—not as dignified as
our giant chestnut tree on the hill.*[38]

I liken the deep spiritual feelings Alfred Stieglitz
discovered in himself as he sought to merge what he saw
and felt of humankind through his camera—his place
in nature, in love and friendship, in the city, and in the
heavens—to similar patterns of emotional, intellectual,
and creative explorations that Emmet Gowin has been
pursuing vigorously throughout his life as an artist. As I
hope I have illuminated in some measure, his moving body
of aerial photography reveals much about the nature of
our earth and our lives that we want and need to know—
things about both that are truly beautiful, truly terrifying,
and always humbling. His images in this volume are a gen-
uine gift to us all—an offering made not only through
Gowin's strong spirit and abilities, but also on the shoul-
ders of many other artists who have helped photography
become such a powerfully expressive visual medium.

1. This sentence fragment is excerpted from an artist's statement that Emmet Gowin wrote in April of 1994, one presented in its entirety in the frontispiece of this book.

2. This statement by Gowin was taken from a number of interviews that Martha Chahroudi, associate curator of photographs at the Philadelphia Museum of Art, conducted with the artist in 1989, in preparation for his mid-career retrospective at the PMA. The exhibition was accompanied by a profusely illustrated catalogue, *Emmet Gowin, Photographs* (Philadelphia Museum of Art, 1990), 7, in which Ms. Chahroudi's essay and interviews with the artist remain the published standard for gaining an informed understanding of Gowin's personal history and artistic development. The author is indebted to Ms. Chahroudi for her fine scholarly work and has referenced many of the artist's photographs described in this essay to plate pages in her PMA catalogue. This was done after deciding that Gowin's aerial landscape photographs should reside forcefully on their own within this book, visually uncluttered by other images that traditionally illustrate catalogue essays. Apologies are offered for the extra work this suggests to especially diligent readers.

3. Martha Chahroudi, *Emmet Gowin: Photographs*, 10.

4. Ibid., 24.

5. *Venus, Jupiter & Mars: The Photographs of Frederick Sommer*, ed. John Weiss (Wilmington: Delaware Art Museum, 1980), title page illustration.

6. Ibid., 5.

7. Dianne Perry Vanderlin, *Frederick Sommer: The Mistress of This World Has No Name* (Denver: Denver Museum of Art, 1987), 12 & 14.

8. Chahroudi, *Emmet Gowin: Photographs*, 10.

9. There, a strong photography program and collection had been launched in 1933 by Charles Sawyer, the Addison's first director, with a display entitled *Modern Pictorial Photography*, followed by successive monographic showings of Margaret Bourke White's and Walker Evans's photographs, and thereafter a hosting of Beaumont Newhall's *Photography: 1839–1937*, which toured to Andover from MoMA, and was augmented with selected works from the Addison's fledgling collection. This pioneering commitment to photography had beckoned later directors, curators, and faculty members to nurture what became an ambitious photographic enterprise at the secondary school, one that well represents the continuing accomplishments of American artists and serves as a rich teaching resource for the Academy's students. For a fuller account of the history of the Addison Gallery's photography program, please consult essays appearing in Avis Berman, Susan Faxon, Jock Reynolds, *Addison Gallery of American Art: 65 Years* (Andover, Mass.: Addison Gallery of American Art, Phillips Academy, 1986). It is also worth noting here that Beaumont Newhall, the artist/curator who founded the MoMA's department of photographs and was so involved in advancing photography in countless other ways during his lifetime in collaboration with his wife Nancy and many other colleagues, authored a fine book on aerial photography, *Airborne Camera: The World from the Air and Outer Space* (New York: Hastings House, in collaboration with the George Eastman House, 1969). Its frontispiece contains the following quote by Antoine De Saint-Exupéry, "The airplane has unveiled for us the true face of the earth. . . . We set our course for distant destinations. And then, only, from the height of our rectilinear trajectories, do we discover the essential foundation, the fundamental of rock and sand and salt in which here and there and from time to time life like a little moss in the crevice of ruins has risked precarious existence."

10. A rich compendium of this artist's work from the air was recently published in Martha A. Sandweiss, *William Garnett: Aerial Photogaphs* (Berkeley: University of California Press, 1994).

11. Published as Mark Klett, Ellen Manchester, JoAnn Verburg, Gordon Bunshaw, Rick Dingus, Paul Berger, *Second View: The Rephotographic Survey Project* (Albuquerque: University of New Mexico Press, 1984), this ambitious project has now been extended into a new time frame and title, *Third View*, a survey that photographers Mark Klett and Byron Wolfe are continuing in the same western locations as those previously photographed. They are actively adding new photographs, video clips, oral histories, and digitally interactive multimedia programs to the project's growing archive of information on the American West. To gain a fuller knowledge of the pioneering photograph work that William Henry Jackson conducted throughout his lifetime, please consider Peter B. Hales, *William Henry Jackson and the Transformation of the American Landscape* (Philadelphia: Temple University Press, 1988).

12. Allison N. Kemmerer, John N. Stilgoe, Adam D. Weinberg, *Reinventing the West: The Photographs of Ansel Adams and Robert Adams* (Andover, Mass.: Addison Gallery of American Art, 2001), 10. It is also worth noting here that Emmet Gowin and Robert Adams photographs were first shown together at the Museum of Modern Art in 1971, in an exhibition then curated by Peter Bunnell, years before he moved on to become curator of photography at The Art Museum, Princeton University, where he deepened his commitment to the artist's work and became a close friend of Gowin's. This spring, along with the publication of this book, Gowin's photographs are being exhibited at the Yale University Art Gallery in conjunction with joint exhibitions of Robert Adams's *What We Bought: The New World* photographic survey, produced in Denver, Colorado, from 1970–74, and Lewis Baltz's *Park City* photographic survey, which documents the construction of a major housing development in Park City, Utah, in 1978–79. Both of these surveys have been acquired for the Yale University Art Gallery's permanent collection, along with a substantial body of Emmet Gowin's aerial photographs.

13. Yosemite became "Yosemite State Park" in 1864 and incorporated as Yosemite National Park on October 1, 1890. The National Park Service was created by an act of Congress on August 25, 1916 (National Park System Timeline, *www.cr.nps.gov/history/timeline.htm*).

14. The Addison Gallery of American Art acquired three mammoth plate photographs by Watkins in 1995, each titled *Malakoff Diggings, North Bloomfield Gravel Mining Company, ca. 1869–72*. Two of them were recently included and illustrated in the exhibition monograph of Watkins's photographs: Douglas R. Nickel, *Carleton Watkins: The Art of Perception* (San Francisco: Harry N. Abrams, 1999). The exhibition was organized for the San Francisco Museum of Modern Art by Douglas Nickel, a former Princeton student, now associate curator of photography in Sandra Phillips's fine department of photography at SFMOMA.

15. *Carleton E. Watkins: Photographs 1861–1874*, ed. Jeffrey Fraenkel, with an essay by Peter E. Palmquist (San Francisco: Fraenkel Gallery in Association with Bedford Arts Publishers, 1989), plates 44, 45, 46, 47, and 55. The Addison Gallery of American Art also possesses an album of Watkins's "Imperial plate" photographs of Yosemite, which is formally described as *"Yo-Semite Valley" Photographic Views of the Falls and Valley of Yo-Semite in Mariposa County, California, 1865–66*, on its title page. The album contains views of Yosemite Falls similar to those cited in the Fraenkel Gallery publication, which contains the following poem from Walt Whitman in its frontispiece under the title "The Calming Thought of All": "The coursing on, whate'er men's speculations / Amid the changing schools, theologies, philosophies / Amid the bawling presentations, new and old / The round earth's silent vital laws, facts, modes continue."

16. Chahroudi, *Emmet Gowin: Photographs*, 36 and 49.

17. Ibid., 57.

18. Frederick Sommer and Nancy Solomon, *Sommer—Images* (Tucson: Center for Creative Photography, University of Arizona, 1984), 14. It is worth noting that Max Ernst stares from within his double-exposed Sommer portrait on page 14 to Sommer's *Arizona Landscape, 1943*, on page 15, a photograph similar to one earlier described in this essay and taken in 1945.

19. *Callahan*, ed. with an introduction by John Szarkowski (New York: Aperture, Inc., in association with the Museum of Modern Art, 1976), 121–23. To consider a fuller range of images the artist made of his wife over many years, please see *Eleanor: Photographs by Harry Callahan*, ed. and designed by Anne Kennedy and Nicholas Callaway, with an essay by James Alinder (New York: Callaway Editions and The Friends of Photography, 1984).

20. Chahroudi, *Emmet Gowin: Photographs*, 54.

21. Ibid., 55.

22. From a conversation between the author and Richard Andrews in January of 2002.

23. Robert Decker and Barbara Decker, "The Eruptions of Mount St. Helens," *Scientific American* 244, no. 3 (March 1981): 68. It is worth mentioning here that many other publications dealing with issues of scale and perception have proven influential to artists, notably another *Scientific American* publication, the Phillip and Phyllis Morrison and the Office of Charles and Ray Eames, *Powers of Ten: A Book about the Relative Size of Things in the Universe and the Effect of Adding Another Zero* (New York: Scientific American Library, 1982), which combined text, mathematics, drawings, and photographs to explore the material world from subatomic matter to the outreaches of the universe. A film version of this project was also widely distributed.

24. At the same time that Gowin was actively photographing Mount St. Helens, other noted photographers such as Frank Gohlke and Terry Toedtemeier were doing likewise, each producing compelling bodies of work that merit broader attention.

25. Chahroudi, *Emmet Gowin: Photography*, 79.

26. *Venus, Jupiter & Mars*, ed. John Weiss, 18.

27. Toby Jurovics, *Emmet Gowin: Aerial Photographs*, (Princeton, N.J.: The Art Museum, Princeton University, 1998), 8. This earlier exhibition focusing on some of the aerial photographs Gowin had made from 1986 onward presented thirty hand-toned prints from the artist's personal collection, eleven of which were illustrated in an image sequence at strong variance with the one with this publication.

28. Ibid., 9.

29. Another interesting photographer's project related to the Nevada Test Site images Gowin has created is Richard Misrach with Myriam Weisange Misrach, *Bravo 20: The Bombing of the American West* (Baltimore: Johns Hopkins University Press, 1990), 9, with references therein to the FAA's restriction of airspace for military purposes—"In 1985 the FAA finished a two-year survey of Military Special Use Airspace and came to the amazing conclusion that half of all airspace over the continental United States is in some way reserved for the military. . . . In Nevada the FAA has been especially generous to the Defense Department: 70 percent of the sky is military-use airspace." The book also contains Misrach's proposal to create a Bravo 20 National Park.

30. For a fuller account of what American servicemen and civilians experienced in working and living in environs of the Nevada Test Site during the development of our country's nuclear arsenal, those interested might wish to consider a reading of Carole Gallagher, *American Ground Zero: The Secret Nuclear War* (Cambridge: MIT Press, 1993 [hardcover]; New York: Random House [softcover], 1993).

31. Jonathan Williams, *Harry Callahan* (New York: Aperture Foundation, Inc., 1999), 74.

32. In 1999, after directing the Yale University Art Gallery for a year, the author had the pleasure of furthering his study of Emmet Gowin's work when Daniell Cornell, the Gallery's Florence B. Selden curatorial fellow, proposed organizing an exhibition and publication entitled *Alfred Stieglitz and the Equivalent: Reinventing the Nature of Photography* (New Haven: Yale University Art Gallery, 1999). As presented publicly, it juxtaposed twelve of Stieglitz's *Equivalents* photographs owned by Yale's Beinecke Rare Book and Manuscript Library with thirty-two photographs in the Gallery's collection by other twentieth-century photographers who had been influenced by Stieglitz in their work. The project included a pair of Gowin's aerial photographs, which were chosen by Cornell from a larger trove of the artist's prints that the author and Cornell selected and recommended to the Gallery for purchase and addition to its collection. Both this photography project at Yale and the recent Gowin aerial photography project the author earlier noted at Princeton provide evidence of the strong curatorial talent now emerging from teaching museums in American universities.

33. (Washington, D.C.: National Gallery of Art, Callaway Editions, 1983), plate 12.

34. Ibid, plate 15.

35. Ibid., plates 56–67.

36. Ibid., pp. 205–7, from the original essay, Alfred Stieglitz, "How I Came to Photograph Clouds," *Amateur Photographer and Photography*, 19 September 1923.

37. Ibid., 206.

38. Ibid., 206.

KEYS ARE STRONGER THAN THE DOORS THEY OPEN

A DIALOGUE WITH EMMET GOWIN

PHILIP BROOKMAN

The following dialogue is excerpted from a conversation between Philip Brookman and Emmet Gowin in Newtown, Pennsylvania, November 12, 2001.

PHILIP BROOKMAN: Nature has been an important part of your photographic work for some time. When did you first get interested in looking at the landscape?

EMMET GOWIN: It's hard to say, but let me go to one moment that tells about how I changed. When my wife's grandmother, Rennie Booher, died in 1972, something happened in me. And within that year her oldest son and one of her daughter's husbands died, leaving me the oldest male member of the family. I couldn't have been more than about twenty-five. Something in that winter season turned my thoughts from the family that had supported me, had been my subject for so long, to what was still there—the place they had been rooted in so strongly. Edith's grandfather had been a farmer. That hillside he farmed had been out of use for twenty-five years. It had overgrown and become something quite different. I made a circular photograph looking through some dogwood and pine trees, *View of Rennie Booher's House, Danville, Virginia, 1973*. And from that vista I felt how beautiful the place was, how wonderful it was to be there, to taste my own experience. Their lives had been poured into that piece of land and the land was what was left. This was really tied into my life.

PB: Did this experience make the landscape seem more alive?

EG: Very quickly I became a custodian of that place. I planted apple trees, a few chestnuts, and pecans. I felt it wanted my response and I felt myself change in relationship to it. No longer would it be an ideal or abstraction of a landscape, but a particular living example.

PB: Did you have any feelings for that place before?

EG: I was born about a mile and a half up the road. My parents knew Edith's parents, but I was two years old when we left. Even when we came back, it was a very vague connection. When I was fourteen, fifteen years old, growing up in Chincoteague, Virginia, I realized that nature was a more interesting classroom than the classroom. Watching eagles build their nests and watching the ducks gather their resources to start a new life, that was just so much more interesting than what I was learning in school. It was at that moment I realized I wanted to be an artist, whatever that was. An artist, I thought, was someone who spent most of their time experiencing real, living things firsthand. An artist's task, then, was to report on what they experienced.

PB: How did your work as an artist lead you to a more specific interest in environmental issues? What led you to photograph the landscape from above?

EG: I've never experienced myself as two people, an activist and an artist. What defines my activism is that I'm hungry to go and find out what the world is really like. I ask, "How do I feel when I stand in this place?" Even before I went to Mount St. Helens, people were saying of my pictures, "This looks like it was taken from an airplane." So I must have been inclined to this point of view. My friend, photographer Frederick Sommer, always taught that the unknown is more friendly than you think, and I was already attached to the idea that to learn, you needed only to be open, that what is hidden will be revealed. When I was commissioned to photograph in Washington State in the spring of 1980, I made 8 x 10" photographs of positive landscapes, beautifully crafted agriculture. That was just how my emotions internalized it; agriculture was something beautifully crafted, positive. Now the eruption of Mount St. Helens was the big event that spring and I had seen that landscape in thousands of photographs before seeing the real thing. In spite of all those pictures, seeing Mount St. Helens freed me. Seeing that landscape for the first time from the air was a revelation. In spite of all those images, the real landscape felt completely new and unused. I was stunned.

PB: Did you photograph it right away?

EG: Immediately. But this becomes a kind of footnote because even as we took off from Seattle to fly to St. Helens, I photographed gravel pits, the bay of Tacoma, and the wakes of ships in the water. As soon as I got into that perspective, I could hardly sit still. Everything seemed open, unused, and fresh. I didn't know why I wanted those gravel pit pictures but I was immensely drawn to them.

I also learned then it was useless to tell the pilot what to do. I was always too high or too low but it was pointless to say, "go higher" or "go lower," because by the time you got there you were in such a different location that you could never return to where you had been. You had to accept what was below you, just as it was in that moment. That was a very important lesson.

PB: How do you keep seeking a new perspective, like the one you found the first time you photographed from an airplane?

EG: I want to verify what I find, in terms of how I feel and think about the world. I want to honor "the world as it is" and embrace imagination at the same time. Not everyone sees the same world. I know this, at least in a small way, because I know I'm not the same person I used to be. When I see something today that I value, that I thought was unimportant years ago, then I can confirm the change. Only as we change do we see; and only as we see does our behavior change. Here, an early story in the Book of Genesis interests me. At one time, in my own understanding, the story of Cain and Abel seemed to me to be the story of the first murder and little more. The two sons of Adam and Eve had two separate worldviews. Cain, the agriculturist, makes an offering of the "fruit of the land," which I now see as linking Cain to what Joseph Campbell describes as a nature-oriented mythology, that of an earth-cultivating people. Nature religions, with their multiple deities, were definitely opposed by the new monotheists. Let me quote Campbell exactly: "Now, the biblical tradition is a socially oriented mythology. Nature is condemned. In the nineteenth century, scholars thought of mythology and ritual as an attempt to control nature. But that would be magic, not mythology or religion. Nature religions are not attempts to control nature but

to help you put yourself in accord with it. But when nature is thought of as evil, you don't put yourself in accord with it, you control it, or try to and hence the tension, the anxiety, the cutting down of forests, the annihilation of native people. And the accent here separates us from nature." Of course, good stories say more than they tell, but I can still recognize this fundamental conflict in our contemporary attitude to nature.

PB: The trajectory in your work goes from looking at your world up close—your family, the kids, the house, all very personal—to looking at the world from far away, from an airplane looking down at the Hanford nuclear site, for example. What is the connection between the personal album and the more distanced picture? Both allow us to see ourselves in a different way.

EG: I don't see anything that I don't see through a high degree of emotional connectedness. This is true of the family or my aerial photographs. When I go to a place like Hanford, Washington, for the first time, I go reluctantly. In 1986, I went to Mount St. Helens—I thought it would be my last visit—and couldn't do some of what I wanted because of a big storm that sat over the mountain. Almost in self-defense I thought, "I'll go over and look at Hanford. It certainly can't hurt me to find out what it's really like." I was apprehensive about flying over a space that seemed like it should be restricted or important to national defense. I was amazed how easy it was to get an airplane and go. Looking at the landscape below, I sensed that something dramatic in the nation's history had happened there. Of course I now understand that the triggers to the atomic bombs used at Hiroshima and Nagasaki had been made there. But even then, the most recognizable feature was the ghost of a city, the old Hanford city site where approximately 30,000 people had lived and worked.

It looked like it had been removed by a neutron bomb; nothing left but the ground plan and the sturdiest of a few buildings. And there was the Columbia River in all its glory and beauty, turning, on its way to the sea, something it had been doing for millions of years. At the same moment, the sunlight on the grasses was so beautiful that I came home with an absolutely churned sense of conflict over how beautiful this landscape felt, while so undeniably terrible; how forgiving the sunlight is to all the things that have happened there. It was a strange, powerful feeling. I felt I could never be the same.

PB: Did you have to have a certain distance from that place to see and understand it?

EG: No, I think I understood it in the airplane. I could see it in the light as the light touched the ground. I told myself that this is probably one of the most poisoned places in the world. How can it be beautiful? It was as if the light didn't care and the sun didn't think.

PB: A lot of the photographs you make from the air rely on that kind of tension between beauty and the devastation that's happened on the ground. Does that feeling of tension come from your first examination of the Hanford site?

EG: I think our fascination for what is terrible is great. Our need for beauty is great. It's not just willfulness on my part that causes those things to coexist in the same world. There is a tension formed between something that's taken hundreds of millions of years to create and the degree to which it can be destroyed in just a matter of moments, days, or decades. You can't think in a trivial way about these relationships. And oddly, instead of wanting to run away from what is granted a terrible thing to know, I wanted to know more and to hold it as an image. I then

make a print to bring out as much beauty as I possibly can, because something in me still has a huge degree of respect for what it is and at the same time for what it once was. Forgive me if I have labored to make it illusive, or difficult to understand, but I believe that difficult images bring us all closer to a shared experience.

PB: You see something and you want to know more about it. How do you do the research to understand the political and environmental issues? How do you go from your work as photographer to doing research, and putting that back into your work?

EG: I go and do something intuitively, just like I went to watch the eagles and the ducks build their nests. I go to educate my own feelings. It's me that's changing, that's what really matters. So, in speaking truth to the light that falls on a terrible place, I can also speak truth to power; I don't see those things as being separate. By measuring these landscapes, I'm looking at things that most people will never see. It's a kind of strange public service.

PB: So much of photography is about confirming what we already know, creating evidence to confirm what we think we know. This is so different from your methods.

EG: I hope that my process centers on the need to confront that which I don't know or understand. To see what I've never seen is interesting.

PB: Is it your intention to make art that is abstract on one level and real on another? Can you describe how you balance the two?

EG: I don't willfully intend to make it abstract. It's just that I probably have a different appetite for detail and a different relationship to the landscape than someone who has never experienced it or doesn't care. So what may look extremely abstract to someone else may look extremely descriptive to me. What I am always trying to do is to realize the thing that is out there by placing it in the frame of a camera so its real substance isn't wasted or trivialized. As a young artist, I was in love with modern art, with Cézanne, Matisse, and Mondrian, so it's not strange to me that I want to turn the frame in such a way that something compelling occurs. Twentieth-century art has allowed me to see things in a cryptic way. I love the butterfly's wings, which disappear when folded and when open leave this brilliant, intense pronouncement of nature, "here I am." As we examine our relationship to things—all that is invisible, indirect, or distant to us—we get a more proper understanding of how all life is intimately interrelated.

PB: I know you use a lot of chemistry, the alchemy of photography, to make beautiful prints, to abstract what you see through the printmaking process. How important is the act of seeing and taking a picture compared to printing it, creating the work of art in the darkroom?

EG: The use of color in my photographs goes back to when I had photographed in Petra, Jordan. Without giving it any thought I was still a black-and-white photographer. After I photographed these wonderful carved rock monuments and came home and printed them in the traditional tonalities I used to print Mount St. Helens and other things, I realized that it just fell short of the astonishing quality of the place. I knew I could do better. In the seventies I had taught myself a lot of the nineteenth-century photographic processes. I learned something about chemistry and toning and then, over the years trying to do subtle things, I made a few real discoveries. So color became indispensable to make it right.

PB: What do you mean, "to make it right"?

EG: I did not tone the pictures from Hanford at first. But slowly I began to experiment. I was getting a bigger vocabulary of how I could give color to images, and the color seemed to honor the living beauty of the thing itself, the place itself.

PB: What first took you to the Czech Republic?

EG: In the spring of 1992, my son Elijah and I went to the Czech Republic. The photographer Josef Koudelka had been to visit our classes at Princeton the year before, and he spent the night with us. We talked and he wanted to see my work, especially my most recent work. Within minutes, after just turning two or three pictures, he said, "You should see this place where I have been working in northern Bohemia." He said simply, "You should see this." I think he knew I would be capable of feeling it. That was my introduction. Later, I realized that an image I had liked in a book was in fact a satellite photograph of the acid rain damage, almost a million acres, in Czechoslovakia. Though it's hard to read, you can actually see the blue-gray plumes of smoke traveling north from the power plants. There are seven big power plants that the Soviets imposed on the Czech people during the Cold War. The general area of the strip mine is almost thirty kilometers long and, when the coal is reached, two hundred feet deep. The landscape has been sacrificed for cheap energy; energy that was undervalued, coal taken at a discount. And it was more cost effective to simply tear away two hundred feet of overburden to get at the main coal seam. In the process, over a hundred small villages were destroyed; and the whole social fabric reorganized. Micro-cities were created with high-rise apartments. It provides a model of how life has changed; they moved people forcefully off the land where they could have grown their own food, and put them into apartments where they pay rent. The only job left is in the mines. And they know very well that it's at the total expense of their health that they're doing this.

PB: How were you able to work in the Czech Republic? What were the logistics?

EG: I had introductions to people in the photographic community, the environmental movement, and the Ministry of the Environment. After three or four days of trying unsuccessfully to find a contact in Prague, I realized that a year would not be enough. The one essential clue that Josef had given me was that there was an airstrip right beside the mine, just outside the town of Most. And while I had no authorization, my experience in America said I could probably find a flight. So we just went there. They were taking people up for skydiving drops, and when the pilot was free he came over and asked, "What can I do?" We patched together all the bits of language we had between us. He was happy to take me and said, "Ask your son if he wants to come. There's plenty of room." This, mind you, is a small Czech skydiving plane with no seats and only grass for a runway. Elijah looked at me so seriously and said, "Dad, two generals don't take the same airplane." Fair enough. And in an hour's flight I had a quick sketch, an overview of the mine. I had a sense it was something I cared about, something I needed to do. This was the most beautiful spring I can remember anywhere, a dark, luminous, windy March sky creating contrast between these huge cooling towers and young cherry trees in bloom. It still brings back staggering memories of shafts of sunlight piercing a deep cloud and opening up a piece of space. The pictures have that light. And the second time, Edith and I went together. It was the end of January 1994. With a little bit of rough weather and snow squalls all around us, dark, dark clouds, I chose the

camera that had the widest view so we could stay closer to the ground.

PB: What did you learn from the pilots about the roots of the problems there?

EG: The thing I remember best is their outpouring of generosity and desire to help me. They perceived me as someone who had come to bear witness. For example, they made sure I understood that one hill, although it looked innocent, had been the station for the Soviet long-range intercontinental ballistic missiles. They would say, "I was forbidden to fly here. I want you to see it. It feels good to fly here." Their sense of collaboration was really moving and I could not have kept them from telling me these stories. They knew they lived shorter lives because of the air they breathed. They knew that parents did everything they could to get children out of the cities and into the country, away from what they called the "black triangle." They were so clear about their own story; to them it's very local, very personal.

PB: The Czech pictures are different from many of your other aerial photographs, more focused on the issues of pollution and mining. You print them bigger, you show the horizon, and they reveal a more clear orientation for the viewer. Is this conscious on your part?

EG: When I made these pictures, I don't think I was one dot less of a lyric visual poet, which is how I think of myself. The land still seemed graceful and beautiful under all this ugly duress. But I suspect that because I had catalogued so many sites where atrocities had taken place, tensioning reality and beauty, because I was a stranger there, and just because of the scale of the site itself, these pictures are more open. I can't explain why they have so much of the horizon, which I feel is descriptiveness. When I

began to take the circular pictures back in 1967–68, I had this one lens that fit a 4 x 5" camera and I put it on an 8 x 10". One thing I felt then was I wanted to show more. Is that the case with my Czech pictures? Maybe it is. I probably did not want to leave anything out. I wanted to take things as they were. After living with these pictures, they have grown dear in my affections.

PB: How do you see your pictures of the Czech Republic in relation to the other aerial photographs? Do they relate to the pictures of Hanford or the Nevada test site?

EG: The one thing I learned from my experience is that it's not some stranger doing this to us. When I visited the Czech Republic maybe I could say to myself, "This was done to the Czech people by the Soviets, by the bureaucracy." Maybe that's also the proper way to understand what's happened in America. But when I look at the American landscape, I also feel with great sadness that we did this to ourselves. Here we have an image of what we chose to do to ourselves. Yet, we are instructed by these lessons; we are experiencing the consequences. The Czech soil is surely just like American soil. If northern Bohemia had a sister state, it would be Pennsylvania, with all its mining, underground fires, and polluted streams. You need only to adjust for the time frame.

PB: Are these universal pictures? Do you see your work in the Czech Republic as seeking some truth?

EG: I would be angry with myself if I said a picture was something which it was not, just to get the right spin. But the interpretation of any picture is the task of us all. "Truthfulness" is something that will grow out of the understanding that people bring to and find in the image itself. "Truthfulness," in this case, requires imagination, and it requires patience. Perception is a human creation

and, as Wallace Stegner says, "is not created overnight." Still, I like to think of what James Agee called "the cruel radiance of what is," or what the Buddhist monk called "returning to the ever so." There are few times in our lives that we get to hold fast to something, because it all seems so relative, irregular, or personal. But to hold in your hand, to hold in your heart, some feeling of the "ever so" is very powerful. It shakes our emotions and it pushes our feet deeper into the ground. That's what I am seeking.

PB: How do you relate the lyric poetry of your work to the styles and methods of other artists whose concerns are equal to yours?

EG: I don't think that way. I think experientially. I try to approach everything I do in terms of firsthand experience. My work is close to that of some artists by choice of lifestyle or approach to life. I embrace the way they face life, their dedication and courage. But I don't say, "What has been the responsibility of one artist becomes mine." These are issues I think almost imperceptibly, immeasurably spring up out of my concern for Rennie Booher, who died in a house in Danville, Virginia, in 1972. I think every person in the world is like me, connected by the same strong threads to some place, just as I am attached to Danville. I have been able to detach for a moment from my one place and transport myself to others, and become as connected to them as if they were home. I'm not driven by the idea of the responsibility of the artist to the culture. I am more working from my empathy for what it is to have lived my life and how I feel about those connections, which are so vital. My friend Frederick Sommer said, "Aesthetics (which is nothing but sense perception, nothing but the finest aspect of our feelings) is finally the care of the home where all of us live."

PB: Do your pictures have the power to change our minds about how we care for our home?

EG: I am pessimistic about a picture's power to be the emissary of just one thing. What I hope is that the picture says, "Here I am, this is what I am like," and the person seeing the picture says in return, "You know a lot but you don't know half of what I know. In my life, there are experiences as grave or darker than what you know." The picture is like a prayer, an offering, and hopefully an opening through which to seek what we don't know, or already know and should take seriously. I don't expect a clear level of reciprocity. All important pictures embody something that we do not yet understand. In the process, we collect a few random yet vivid facts that we didn't know before. For example, a cluster of twenty circles of pivot agriculture, pumping away in the August heat, uses as much water as a city of two million people. New ideas help us to integrate our experience. I wouldn't have known that until I experienced it myself. This is something we all find ourselves saying.

PB: You talk about your photographs as offerings to the land. You are offering your ideas, participation, and expertise. Like Cain, you are making a kind of offering of nature, through your art, and questioning its meaning. Part of this has to do with the complex relationships between your work as a photographer, your aesthetics, and the environmental content of your pictures.

EG: Every picture is environmental. That is one of the overwhelmingly wonderful things about photography; no matter how much one intends to rid the picture of environment, which is to say living substance, something of it is nonetheless there. When I say a picture is like a prayer, it's because it is offered as a place where the heart can

stand, or better still, rest. It is not a call for action. It transcends a direct cause-and-effect relationship. It's a call for reflection, meditation, and consideration to be on a more intimate basis with the world. Let me read a poem by Frederick Sommer: "Reality is greater than our dreams, yet it is within ourselves that we find the clues to reality. Clues are essences and keys, and keys are stronger than the doors they open. Life itself is not the reality. We are the ones who put life into stones and pebbles. If we did not dream, reality would collapse." William Blake says much the same when he declares, "For every Space larger than a red Globule of Man's blood is visionary, . . . And every Space smaller than a Globule of Man's blood opens into Eternity of which this vegetable Earth is but a shadow."

And so the prayer is an open call to treat the earth, to think of the earth, as a brother or a sister, as the beloved.

PB: We can think of your pictures, then, as an invitation to dream?

EG: Yes. The astonishing thing to me is that in spite of all we have done, the earth still offers back so much beauty, so much sustenance. So much of what we need is embodied in it. If we treat things in accord with what we believe they're worth, then the value of the world is something that we imagine. The thing that we can do for the world is always expressed in terms of how we treat the world and each other, the quality of our behavior.

ACKNOWLEDGMENTS

This book project and exhibition arose from a conversation with my good friend Philip Brookman, senior curator of photography and media arts at the Corcoran Gallery of Art, with whom I have collaborated on numerous occasions. The two of us often share thoughts on photographic acquisitions and programs at our two museums, and so it was not unusual to discover recently that we were both paying close attention to Emmet Gowin's aerial photographs. We readily agreed that it was high time for this growing body of work to be thoughtfully edited, sequenced, exhibited, and published in its full visual richness. The project would require a talented team of people willing to help bring the artist's vision fully to the fore, one it has been my privilege to assemble and fortify with the resources needed to do the best work we all could.

To say it has been a pleasure to collaborate with Emmet and Edith Gowin on every aspect of this endeavor is a true understatement, for the artist and his wife have put heart and soul and countless hours of effort into every detail of our work together, bringing forth great good will and generous help from many other people whom I wish to thank for their rich contributions of time, talent, and treasure.

Terry Tempest Williams, author, environmental activist, and good friend of the Gowins, was someone Emmet wanted from the very start to write for this book. One of her early books, *Refuge*, had moved him deeply and remained vividly in his consciousness. Williams enthusiastically accepted our invitation to participate in this project and has bracketed and fortified Gowin's words and aerial images with unique insights of her own and a passionate and caring voice.

Peter MacGill, director of Pace/MacGill Gallery and Gowin's dealer, also encouraged and supported this project from start to finish, as did Kim Jones, Pak So, and Mr. MacGill's entire staff. They cheerfully and efficiently coordinated myriad details with many of my good colleagues here at the Yale University Art Gallery (YUAG). Russell Lord, senior administrative assistant in the Gallery's Department of Prints, Drawings, and Photographs, deserves special recognition here at Yale, for he has been my constant companion throughout this adventure, the thoughtful human conduit who has helped coordinate all the text written for this book. I also am grateful for the effort of our associate registrar, Lynne Addison, the administrative support of Louisa Cunningham and Charlene Senical in our Business Office, and the good work of our curator and assistant curator of education, Mary Kordak and Ellen Alvord, who've been similarly bolstered by Susan Matheson, Paul Ha, Kathleen Derringer, Elizabeth Harnett, and Marie Weltzien in arranging public programs and information interpreting Gowin's photographs to audiences of all ages.

The physical production of this exhibition was particularly well orchestrated by YUAG's Diana Brownell and Clark Crolius, skilled art preparators, who along with Janet Zullo and Susan Cole, members of the Gallery's digital photography department, meticulously matted, framed, documented, and carried out the installation of the ninety-two photographs finally selected for the

exhibition. My able administrative assistants, Bernice Parent and Antoinette Brown, performed their usual magic in taking countless telephone calls and keeping me well scheduled with every appointment needed to help keep our team's work on track throughout its fruitful development. Suzanne Boorsch, the Gallery's curator of prints, drawings, and photographs, also deserves genuine appreciation, for she regularly welcomes my participation in the workings of her department. Two Yale undergraduates working in her department, Jessica Dimson and Mariana Mogilevich, have been exceptionally helpful to Russell Lord's work on Gowin's behalf. I want to thank, too, all the all other members of YUAG's staff, who give their all to each and every project this teaching museum undertakes.

YUAG has long enjoyed a special relationship with Yale University Press, and is very pleased to publish this book in association with the Press, whose new editor of arts and architecture, Patricia Fidler, recently arrived at Yale from Princeton, fully aware of Gowin's photographic accomplishments. She placed faith in this publication immediately and has worked closely with her editorial assistant, Michelle Komie, and Howard el-Yasin, manager of the Gallery's Museum Shop, to be sure this book is properly marketed to the broad audience it deserves.

Joyce Ippolito, a talented manuscript editor, has similarly brought her strong skills and meticulous attention to all the text in Gowin's book. The book itself was designed by Katy Homans, a distinguished alumna of Yale's School of Art. Robert Hennessey was also indispensable to the book's production, preparing the digital separations that Daniel Frank, Wendy Jordan, and the skilled printers at Meridian Printing used to print this volume to an unparalleled visual standard. Richard Benson, the dean of Yale's School of Art, himself a legendary printer of countless classic photography books, also lent his good advice to this

enterprise and welcomed Gowin warmly to his School's photography department to meet with students and faculty.

At the Corcoran Gallery of Art, in Washington, D.C., appreciation is not only due Philip Brookman for his fine interview with Emmet Gowin, but also for his frequent creative advice throughout our work together. He would like to pay particular thanks to Paul Roth, his assistant curator in the Department of Photography and Media Arts, as well as David Levy, the Corcoran's president and director, Jacquelyn Days Serwer, chief curator, and Susan Badder, curator of education, as would I. They all helped insure a fine presentation of Gowin's work in the nation's capital, and Badder was especially adept in formulating programs and educational materials for use by public school teachers and students in New Haven, Washington, D.C., and elsewhere. I would also like to thank two friends who offered me important information as I wrote my essay: Richard Andrews, director of the Henry Art Gallery, University of Washington, and Allison Kemmerer, assistant curator at the Addison Gallery of American Art, Phillips Academy, Andover.

Emmet Gowin joins me in warmly thanking the many people already mentioned, and would like to offer his particular gratitude to other individuals and organizations that have helped this body of aerial photographs come to life over the fifteen years of diligent work. Richard and Ronay Menschel, Judy Turri, William and Kay Wylie, Thomas Carbasi, Virginia and Michael Beahan, Whitney and Cathy Durrell, Glenn Scarboro, Richard Landis, Nancy Strong, Frank and Judith Norris, and Congressman James Greenwood have all been essential supporters. So, too, have been numerous pilots, whose insights and courage have made many of Gowin's photographs possible. The artist particularly wishes to acknowledge Chris Kniebes of Prescott, Arizona, and Peggy

McCormick of Greenwood, Mississippi, and to hold in memory Ray Gilkerson, of Kenewick, Washington, who died in his airplane doing the work he loved. Gowin also pays tribute to the Pew Charitable Trust's Fellowships in the Arts, for a generous fellowship that made possible his work in Kuwait and at the Nevada Test Site. He also fondly acknowledges Ron and Kimiko Hill for years of friendship and their introduction to Japan and creative work performed there. At Princeton University, where Gowin teaches, he would like to thank Peter Bunnell, the David H. McAlpin Professor of the History of Photography, and Toby Jurovics, the assistant curator of photography at The Art Museum, Princeton, for their initial exhibition of his aerial photography in 1998.

As you can sense, the artist has been guided, helped, and befriended by many people, but none more supportive than his own family members. In a recent letter, Gowin wrote, "These years of searching are dedicated to Edith, Isaac, and Elijah, my wife and children. Their love, and their patience with me and this work, entwines into the dearest of memories, an ultimate gift."

Good colleagues elsewhere have taken a strong interest in Emmet Gowin's aerial photographs and are sharing the gift of his art with audiences at museums throughout America. In working to arrange a tour of this exhibition, one still in formation as this book goes to press, I would especially like to thank the following hosting colleagues and institutions: David Dee, executive director of the Utah Museum of Fine Arts at the University of Utah; Robert Knight, executive director, and Ben Mitchell, senior curator, of the Yellowstone Art Museum; Bruce Katsiff, director

and CEO, and Brian H. Peterson, senior curator, of the James A. Michener Art Museum; Becky Duval Reese, director of the El Paso Museum of Art; Richard Andrews, director, Elizabeth A. Brown, chief curator, and Paul Cabarga, exhibitions manager, of the Henry Art Gallery at the University of Washington; James Cuno, Elizabeth and John Moors Cabot Director of the Harvard University Art Museums and Deborah Martin Kao, Richard L. Menschel Curator of Photography of the Fogg Art Museum.

No project of this scope and ambition could have come to life without enlightened patrons providing indispensable financial support along the way. Doing so on this occasion are a formidable group of Yale alumni and other friends of the Art Gallery and Emmet Gowin's art. Deep appreciation is offered to Jane Watkins '79, whose lead gift allowed this endeavor to commence in earnest last year, as well as to Anna Marie and Robert Shapiro '56, Julia and Harrison Augur '64, Raymond and Helen DuBois '78, Evelyn and Robert Doran '55, Carolyn and Gerald Grinstein '54, Eliot Nolen '84 and Timothy Bradley '83, Lindsay McCrum '80, Richard and Ronay Menschel, Betsy Frampton, Carol and Sol LeWitt, an anonymous donor, the Mr. and Mrs. George Rowland, B.A. 1933, Fund, and the Heinz Family Foundation. This collective generosity has insured that every aspect of this book and exhibition could be presented just as we wished, beautifully and without compromise. For this and more, Emmet Gowin is truly grateful, as are all of us who have assisted him in realizing his vision of how we might view and consider our earth at this moment in time.

JOCK REYNOLDS

THE HENRY J. HEINZ II DIRECTOR
YALE UNIVERSITY ART GALLERY

This catalogue is published in conjunction with *Emmet Gowin: Changing the Earth, Aerial Photographs,* an exhibition organized by the Yale University Art Gallery in association with the Corcoran Gallery of Art and touring to the following institutions:

Yale University Art Gallery, New Haven, CT
April 23–July 28, 2002

Corcoran Gallery of Art, Washington, D.C.
October 26, 2002–January 6, 2003

Utah Museum of Fine Arts, University of Utah, Salt Lake City, UT
April 18–July 13, 2003

Yellowstone Art Museum, Billings, MT
August 23–November 30, 2003

James A. Michener Art Museum, Doylestown, PA
January 10–April 4, 2004

El Paso Museum of Art, El Paso, TX
May 2–July 18, 2004

Henry Art Gallery, University of Washington, Seattle, WA
August 7–November 7, 2004

Fogg Art Museum, Harvard University Art Museums, Cambridge, MA
dates to be determined

This exhibition and catalogue have been made possible by contributions from Jane Watkins '79, Anna Marie and Robert Shapiro '56, Julia and Harrison Augur '64, Raymond and Helen DuBois '78, Evelyn and Robert Doran '55, Carolyn and Gerald Grinstein '54, Eliot Nolen '84 and Timothy Bradley '83, Lindsay McCrum '80, Richard and Ronay Menschel, Betsy Frampton, Carol and Sol LeWitt, an anonymous donor, the Mr. and Mrs. George Rowland, B.A. 1933, Fund, and the Heinz Family Foundation.

Distributed by Yale University Press, New Haven and London

ISBN 0-300-09361-6
Library of Congress Control Number: 2002100334

COORDINATED BY RUSSELL C. LORD

EDITED BY JOYCE IPPOLITO

DESIGNED BY KATY HOMANS

DIGITAL SEPARATIONS BY ROBERT J. HENNESSEY

PRINTED BY MERIDIAN PRINTING, EAST GREENWICH, R.I., UNDER THE SUPERVISION OF DANIEL FRANK

BOUND BY THE RIVERSIDE GROUP, INC.